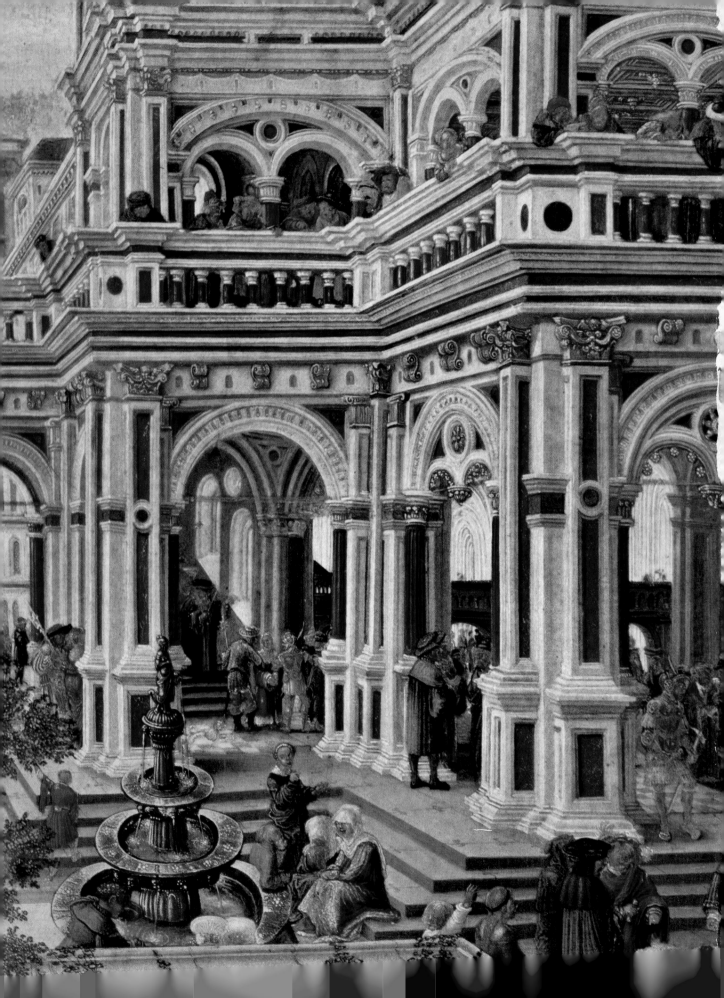

BUILDINGS OF EUROPE

RENAISSANCE EUROPE

With an Introduction by
JAMES LEES-MILNE

Edited by
HARALD BUSCH AND BERND LOHSE

With Commentaries on the Illustrations by
HANS WEIGERT

THE MACMILLAN COMPANY
NEW YORK
1961

TRANSLATED BY PETER GORGE

FIRST PUBLISHED, 1961

© UMSCHAU VERLAG · FRANKFURT AM MAIN 1960

PRINTED AND BOUND IN GERMANY

BY BRÖNNERS DRUCKEREI (INH. BREIDENSTEIN) · FRANKFURT AM MAIN

No European people are more jealous or more resentful of their past than the Italians. Their history haunts them like a nightmare and is for ever asserting itself. On all sides they see reproachful reminders of the great achievements of their forbears. It is the penalty which these heirs to a rich civilization cannot escape. All they can do is to improve upon the past. The consequences are that from time to time they are spurred to frantic emulation; and a rebirth of intellectual, scientific or artistic effort is the result.

As early as the eleventh century the Italians were looking across the intervening dark ages back to the glories of Augustan Rome. The Tuscan Romanesque architecture of their century may have been an unconscious, as it was certainly an untutored, attempt to follow the style of the ancients as though it had never been lost from sight. The Romanesque slid into the Gothic style which, however, the Italians never properly understood nor even liked. It is true that there are plenty of Gothic monuments in Italy. Architecturally they are inferior to the Gothic cathedrals and churches of northern Europe, even though they excel in the quality of their sculptural embellishments and all sorts of decorative treasure. We sense a continuous, ineffectual struggle throughout the middle ages to escape from Gothic bondage and revert to a classical expression of building. In the thirteenth century Nicola Pisano deliberately attempted to reproduce classical motifs in, for example, the pulpit of the baptistery at Pisa, and Arnolfo di Cambio in many altar tabernacles and tombs. These early essays were necessarily confined to fragments and did not embrace entire buildings.

More than a mere nostalgia for the greatness of imperial Rome was required to bring about new processes of thought and artistic inspiration. In the fourteenth century Petrarch first opened Italian ears to an entirely different philosophy of living to that which they were accustomed to. What we term Humanism meant a predominant interest in the affairs of the individual as opposed to the mediaeval concern with abstract theological argument. This Humanism was strengthened in the fifteenth century by the rediscovery of the classical writers of antiquity. The movement was accompanied by a revolt against ecclesiastical tyranny over men's minds. And once this tyranny was relaxed men's eyes suddenly learnt to look upon the physical world with fresh understanding. The poet Aeneas Silvius, later Pope Pius II (1458–64), was, for example, the first to appreciate the beauties of landscape and nature. Alberti, the universal man, in that his interests covered every species of science and art, was the first to write about and elucidate the architecture of the ancients. With the dawn of the fifteenth century the Renaissance had arrived in Italy.

Italian Renaissance art and architecture were the sequel to and expression of the new philosophy. For the first time in the annals of Christianity religion ceased to be the exclusive inspiration of artists and architects. Not until the late sixteenth century, after the terrible upheaval of the Reformation had roused the faithful to cherish what the godless were overthrowing, did religion once more become the mainspring of art. Then the Catholic Church was to reaffirm its paramount influence through a new manifestation of art, which we term the Baroque style – a style which belongs to a later period than that under review. Meanwhile men were unashamedly enjoying the delights of physical existence which artists were investing with the old pagan attributes. The plastic arts, which do not accord with the ascetic spirit of mediaeval Christianity, were now given full rein in the painting of mythological as well as of religious subjects, in the sculpture of the nude, and in the architecture of classical forms.

There is perhaps no *volte-face* in the whole history of art more compelling and more complete than that brought about by the architecture of the Florentine Brunelleschi. This astonishing man, born in 1377, was, as Vasari put it, "given to us by heaven to infuse correct form into architecture". At one blow, so to

speak, the Gothic style was overthrown and the antique reinstated. We must not, of course, suppose that the Brunelleschian classical was, in spite of Vasari's enthusiastic claim, of that academically correct sort which later generations were to perfect. It was none the worse for its comparative primitiveness. It is even the better, for it displays a spontaneity, a freshness and a linear purity which no succeeding classical architect has ever achieved. The originality of Brunelleschi's San Lorenzo and Cappella Pazzi is overwhelming. These buildings express the spirit of his own time rather than that of the ancients. They are logical and geometrical in conception and execution. Alberti, his compatriot but a younger man, admittedly evolved a rather more correct style because he was more deeply versed in the rules by which the ancients worked. His Palazzo Rucellai, in which three orders are used, was considered by his contemporaries and succeeding generations the pattern of what a classical building should be.

The movement so faultlessly started in Tuscany spread to Lombardy, where at first it was expressed in a wealth of detail less pleasing than sophisticated. If Michelozzi's Capella Portinari in San Eustorgio at Milan evinces the verticality which was Brunelleschi's interpretation of the classical, albeit encrusted with strips of carved candelabra, winged angel heads and dolphins, the famous façades of the Certosa di Pavia and of the Cappella Colleoni at Bergamo teem with a jumble of decorative motifs like the windows of a provincial jeweller's shop. There is no apparent limit to nor correlation between the superabundant sculptural relief, which is, as it were, still subject to the exuberant emotionalism of Gothic art. Bramante towards the end of the century moderated this hysterical propensity to embellish the surfaces of Lombardy churches, as we may judge from his Santa Maria della Grazie in Milan. Around the year 1500 he moved to Rome where he built in a purer style still and, as the result of first-hand study of ancient remains, inaugurated what is called the High Renaissance of architecture. As the paragon of classical fitness, entirely reliant for effects upon basic architectonic forms, his Tempietto at San Pietro in Montorio has no parallel. What Bramante had achieved for classical architecture in Rome, Sansovino, to a lesser extent, was to achieve in Venice.

The last phase of Italian Renaissance architecture coincided with the daring experiments of Michelangelo and the Mannerists, which ultimately led to the Baroque of the seventeenth century. Even so the Renaissance style did not pass into total eclipse. In Andrea Palladio and Vincenzo Scamozzi, who were contemporaries of the Mannerists, the tradition established by Brunelleschi and developed by Bramante found followers. The Palladian style, consciously based upon the extremely circumscribed doctrines of the Latin engineer and author, Vitruvius Pollio, survived both the Mannerist and Baroque eras to re-emerge in the Neo-classical of the eighteenth century.

Outside Italy the course of Renaissance architecture is not always easy to determine. In several European countries a revival of classical building methods was hardly experienced at all before the eighteenth century. In the northern countries especially a very bastard version, a sort of hang-over from the mediaeval, was the customary echo of the Italian style. In France alone the Renaissance took a fairly recondite turn. In the sixteenth century French architects travelled direct to Italy to study the antique for themselves. Italian architects for their part went to France. During the repeated invasions of Italy victorious French troops despoiled her cities with considerable profit to the art of their own country. After a rich and undiscriminating period in which Italianate details were applied haphazard to Gothic structures, a number of truly classical architects arose in France soon after the death of François I. Bullant, Delorme and Lescot in the second half of the sixteenth century, and the Mansarts in the seventeenth, raised buildings which are essentially French, but fundamentally in the classical idiom. Many of them are masterpieces of European architecture. In other words, the innately sceptical and anti-clerical character of the French was quickly attracted by the pagan spirit of the Renaissance.

In Spain the situation was the very reverse. The Spaniards have always been the most devout race in Europe. The presence of the infidel Moor in the peninsula was a constant spur to their militant Catholicism.

The vigilant Inquisition rallied the native population under one banner and kept Humanist unorthodoxy well at bay. Mythology and paganism were held at a discount. There are few absolutely Renaissance buildings in Spain. The Palace of Charles V at Granada is very frequently quoted as an example because it is practically the only one. The sixteenth century witnessed the appearance of innumerable buildings in the Plateresque – a kind of ornamental Moorish-Gothic style – and the seventeenth and eighteenth centuries, because of the devotional character of the people, in the Baroque. In Portugal too, pure Renaissance buildings can be counted on the fingers of one hand. The Chapel of the Conception at Tomar is one of them.

Buildings in post-Reformation Germany seldom assumed true classical forms. In spite of a strong inculcation of Humanism, of which Erasmus, Reuchlin and Melanchthon were no unworthy prophets, German Renaissance artists did not assimilate the classical spirit. Dürer, Holbein and Cranach remained Gothic. Owing to Lutheranism there was little ecclesiastical building in the sixteenth century, and owing to the Thirty Years War practically none before the late seventeenth century. Sustris's Michaelskirche in Munich is a notorious exception, because, being a Jesuit church, it is cosmopolitan. Even so the façade could never be mistaken for a Latin composition. Domestic building before the age of the German Rococo is typified by tall oriel windows and immense stepped gables, studded with dormers.

The same sort of architecture characterized the Low Countries, certainly until the middle of the seventeenth century. A flamboyant, topheavy, over-ornate style was the Renaissance of the Netherlands until the influence of Rubens made itself felt. It is seldom given to an individual to alter and direct the whole course of a nation's style, either in painting or in architecture. Rubens did so in both these mediums. The impression which Rubens's house in Antwerp made upon his compatriots was extraordinary. To these northern people the rather gross and ample structure seemed the indubitable interpretation of the antique. In fact it was the outcome of the artist's careful study of the *cinquecento* palaces of Genoa, imbued with his peculiar brand of monumentality. By the middle of the seventeenth century Low Country architecture became more subtle and distinctive. Incidentally, it was to have considerable influence upon English architecture owing to the political sympathy between Britain and the Netherlands and the long refuge of Charles II's court at the Hague. After the Stuart Restoration men like Winde, May, and Pratt built houses, with pitched and hipped roofs of a low, lateral type which they had first witnessed in the Low Countries at a time when their native land was convulsed in Civil War.

To England the Renaissance had come comparatively late. The conservative and island kingdom was deeply entrenched in mediaevalism; it was always slow to accept foreign influences. When, however, Humanism crossed the channel in the reign of Henry VIII it flourished straightway. Grocyn, Linacre, Lily, More and Colet may not have travelled direct to Italy; but they reverently sat at the feet of the illustrious Italophil, Erasmus, and imbibed his teaching. The reign – at least the early part of it – was accompanied by a thrill of learning as scholars discovered to their pupils the authors of antiquity, and poets composed sonnets and lyrics in the Petrarchan metre. Gradually too the secret of classical architecture was revealed. At first it amounted to little more than the imposition of scant classical detail upon old Perpendicular structures. The change was very gradual. The explanation is not far to seek. Acceptance of the Renaissance was hindered by the Reformation. The young, enlightened Catholic King, who welcomed foreign intellectuals and artists to his court, soon turned into the middle-aged, philistine heretic, who deeply resented the intrusion of Continental and, above all, Roman influences. Henceforth the majority of his loyal subjects came to identify the newfangled classical taste in the arts with outlandish manners, Papistry and the Spanish menace. It was something hostile, strongly to be resisted. So this particular style of architecture under the Tudors for long remained tentative and transitional. In any case building was confined to the domestic, for no more churches were needed by the Reformed religion. Instead vast country palaces were undertaken by new families who had waxed rich on the appropriated lands of the old monasteries.

At the same time it is a mistake to suppose that English artists persistently cut themselves off from foreign ideas through fear of the whore of Babylon and the Spanish Armada. On the contrary, as these bogies lost their early terrors, both clients and architects (if the master-masons of Elizabeth's and James I's reigns can be so denominated) avidly pored over the uncouth woodcuts of Serlio's *Architectura*. They desperately tried to reproduce Italian gateways and doorheads as embellishments to their manor-houses. It is true that, owing to the close religious and commercial bonds with the Low Countries and Northern Germany, the pattern books of Vredeman de Vries and Dietterlin, with their grotesque and horribly distorted patterns, were just as popular and more readily consulted. For almost a hundred years Britain looked, in an uncomprehending manner, to these dubious interpretations of the antique for inspiration and guidance. As we all know, the earliest Englishman to make serious first-hand study of Roman remains and of Italian Renaissance architecture was Inigo Jones.

Not until 1622 when the Banqueting House in Whitehall was completed did the first really classical building arise on English soil. The Queen's House, Greenwich, begun before but finished later, followed suit. It is noteworthy that these and other buildings by Inigo Jones, which loudly proclaim the rules of ancient architecture, have their provenance, not in the works of Italy's High Renaissance but in the Vicenzan palaces of the mid-sixteenth century Palladio. England's classical architecture was never to benefit from the pure linear verticality of Brunelleschi's or the plastic horizontality of Bramante's works. On the contrary, it began where the Italian Renaissance left off. Paradoxically enough, its richness of invention and strength of purpose were derived from the other's paucity and weakness in these respective qualities.

In spite of Inigo Jones's longevity and universal scholarship and in spite of the revolutionary change of taste which he brought about, the buildings he left behind were remarkably few in number. In addition to the two already referred to, his only documented buildings to survive intact are the Marlborough House Chapel and part of Wilton House. His pupil John Webb left many noble projects on paper, but hardly more executed works than those of his master. On his death in 1674 an abrupt, but brief term was put to the Palladian school of architecture in Britain. For nearly half a century the genius of Christopher Wren reigned supreme. Wren and his followers have been described as Baroque architects, but in relation to their Italian contemporaries this designation has little meaning. In fact they looked to the France of Louis XIV rather than to papal Italy for inspiration. Their works doubtless represent the first national style of building to be absolutely free from both the Gothic tradition and the Vitruvian culture. During this interlude the influence of Inigo Jones was negligible. Its revival in early Georgian days is a remarkable contingency in the history of British architecture, and opens another entirely different chapter.

James Lees-Milne

RENAISSANCE MAN (ills. 1, 18, 36). The portrait of *Pippo Spano* (ill. 1), a condottiere of the Florentine Republic, shows the active man of the new age, sure of his own worth, his feet firmly on the ground. It has all the vigour and realism of the Renaissance. Even Donatello's St George (ill. 18) is adapted to this new concept. Both, the active condottiere and the calm, critical humanist (ill. 36) are part of the general picture of the time.

PRELIMINARIES (ills. 2, 3, 4). The history of art moves like a pendulum. For the Middle Ages, its poles might be called "Classic" and "Mystic". The Classic element seeks perfection and calm, the Mystic strives for images of redemption in the infinite. In art, this longing finds expression, between 1300 and 1400, in a dynamic verticalism. In the Classic phases there is at times a close approach to Antiquity, often by copying and re-creation. There had been many a proto-renaissance, an anticipation of the real Renaissance; one around 1200, when a strange harmony appears in Gothic art, and again around 1350. In the early thirteenth century, Germany and France developed a Classic manner of their own, while Italy copied Antiquity. Frederick II, a keen student of Greek philosophy in its Arabist form and at times distinctly opposed to Christianity, built a palace at Capua, in Southern Italy, with a bridgehead (1223–40) in the form of a triumphal arch surmounted centrally with a figure of himself and decorated with reliefs of his victories. The personification of the city of Capua by a female figure and the head of Jupiter (ill. 2), are entirely in the Antique tradition. There is no trace of a Christian theme.

At the Emperor's Castel del Monte (ill. 3) in Apulia – unlike most castles on a regular ground plan – a Gothic doorway is framed by fluted pilasters with Corinthian capitals, which, like the cornice, are copies from Roman buildings. To Frederick II, the Classic style was the Imperial style, because he saw in it a symbol of the continuation of the Imperium Romanum, the Holy Roman Empire. Jakob Burckhardt was the first to call the Florentine Late Romanesque buildings of the time around 1200 the "Proto-renaissance", that is, the first Renaissance. A characteristic example is the Baptistery (ill. 4). Its black and white marble façade certainly has a "Classic" air. In the Renaissance, the baptistery, thought to date from Roman Antiquity, was considered a source of inspiration to the architect.

FILIPPO BRUNELLESCHI (ills. 5, 6, 7, 9). Brunelleschi has been called the father of the Renaissance. Born in Florence in 1377 and the son of a notary, he had a good education, was apprenticed to a goldsmith, and was accepted fully into the Goldsmith's Guild in 1398. In 1401, he took part in the competition for the second bronze door of the Baptistery. But the order went to the more conservative Ghiberti. In Rome, Brunelleschi studied the remains of Classic buildings. Together with the mathematician Manetti, he "invented" central perspective, or, more accurately, he penetrated its intuitive beginnings with his scientific mind. As an engineer, he advised on fortifications. It can be said of him that he truly approached the ideal of the time, the *uomo universale*, the universal man. He died in 1446. One of his great technical achievements is the dome of Florence Cathedral (ill. 5). It is inspired by the domes of the Near East. The system of construction used in Florence was invented by Brunelleschi in 1418, when he and Ghiberti had been entrusted with the design of the cupola. It rib construction is essentially Gothic and belongs to the past, rather than the coming, epoch. But the ribs are hidden in a double shell, and there are no supporting arches. Brunelleschi had done without centering – an achievement of the highest order at the time.

His next building, the Ospedale dei Innocenti (ill. 6) – the Foundling Hospital – is one of the most important examples of Early Renaissance architecture. The row of arcades, the broad cornice and the pedimented windows are like the final renunciation of Gothic verticalism. But the cornice is the artist's own creation, rather than a slavish copy of Antiquity; the delicate detail and the flat relief are characteristic of the Early Renaissance, the Quattrocento. Weightiness and strong plastic contrasts did not come until the High Renaissance, at the beginning of the sixteenth century. The Ospedale dei Innocenti served as a model for many later hospitals.

In contrast to the Northern hall churches of the time, S. Lorenzo (ill. 7) is a return to the form of the basilica, which predominated from the beginnings of Christian architecture until well into the twelfth century. Its principal characteristic is the nave rising above the aisles with the clerestory. Instead of Gothic rib-vaulting leading the eyes upwards, there is now a straightforward termination to the nave. The models were the basilicas of the Romanesque protorenaissance.

The Renaissance thus began with a retrogressive step, a look into the past. New, positive impulses did not come until the middle of the Quattrocento.

The Pazzi Chapel (ill. 9) was built by Brunelleschi for Andrea de Pazzi. It was completed before the financial ruin of the Pazzi family in 1478.

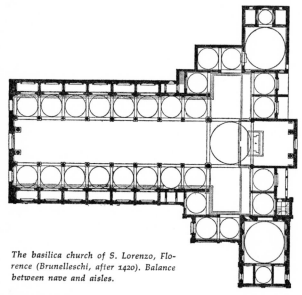

The basilica church of S. Lorenzo, Florence (Brunelleschi, after 1420). Balance between nave and aisles.

Beneath a dome, that seems to float, a central compartment is flanked by two smaller, barrel-vaulted rooms. Entrance and altar, against all tradition, are along the length of the rectangle. The plan recalls Byzantine churches. The ribs of the dome, whose base is pierced by round windows, are Gothic. All the other forms – the coffering, the arches, the

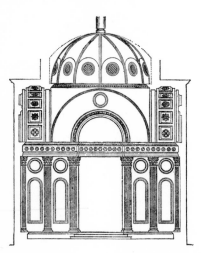

Cross section of the Pazzi chapel (Brunelleschi, 1429). San Lorenzo, Florence.

pilasters, the cornice and the medallions with their glazed clay figures – extol Classic calm. The medallions in the pendentives of the dome show the Four Evangelists, those under the cornice the Twelve Apostles. They are the work of Luca della Robbia (1400–82), who was the first to use coloured pottery in Italian Renaissance sculpture.

LEON BATTISTA ALBERTI (ills. 14, 15, 22, 23). Brunelleschi dominated the first, Alberti (1404–1472) the second generation of Quattrocento architects. He was the personification of the Renaissance ideal, the *uomo universale*, and impressed his contemporaries as a man driven by demons. At twenty-four, he was a doctor of law, wrote a treatise that was like an anticipation of the Age of Enlightenment in the eighteenth century, arranged competitions between poets, tried to raise a Roman barge with an invention of his own, later devoted himself to mathematics and natural science, was turned into an artist by the sight of the fragments of Ancient Rome, cultivated all three arts, painting, sculpture and architecture, and wrote a book on each. His Palazzo Rucellai (ill. 22) became fundamental in palace architecture. Lodovico Gonzaga, the ruler of Mantua, entrusted him with the design of the church of S. Andrea (ill. 14), whose dome – only finished by Juvara in the eighteenth century – makes the interior rather lighter than Alberti intended. The building is something quite outside its time. The combination of aisle-less nave and dome, so characteristic of the Baroque, did not occur again until

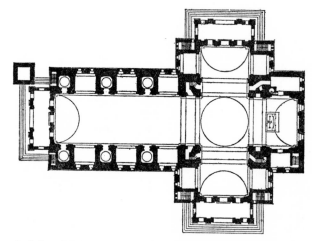

S. Andrea, Mantua, by Leon Battista Alberti (begun 1470). The aisles have been transformed into side chapels.

the end of the Renaissance, at Il Gesù, in Rome, which marks the transition from Renaissance to Mannerism.

The coffered barrel vaulting above nave, choir and transept is probably inspired by the Roman *thermae*. In contrast to medieval cross-vaulting, it appears a static element. The short transverse barrels in the recesses are openings in the wall rather than separate rooms, and therefore do little to detract from the effect of one undivided space, which was the aim of Antiquity and again of the High Renaissance. There are no columns, only vast blocks of masonry articulated by pilasters. Walls of such dimensions had not been built since the Romanesque.

The façade (ill. 15), also, anticipates the distant future. There is no parallel until Palladio's Venetian churches.

THE PALAZZO (ills. 20, 22–25, 90, 99). Medieval architecture is essentially church architecture. Profane structures, castles and palaces, are mere derivations. In the Renaissance, sacred and profane buildings assume equal importance. First, the palazzo developed forms of its own. The medieval patrician house, or the town hall, was a block with here and there an odd tower, to which the inhabitants withdrew during the frequent sieges. Battlemented towers with look-outs (ill. 20) increase the impression of security. The ground floor was usually an open hall or contained shops. The palazzo and, later, the residences of kings and princes, developed out of this basic form. As leading families became less bellicose, towers and battlements were superseded by projecting cornices (ill. 22). Rough-hewn, or rusticated, stone blocks – later smoothed – were used to give a martial air (ills. 23, 25). This type of masonry was copied from the Roman aquaducts of the Campagna, the walls of the Forum Augustus, and the Hohenstaufen castles. At first, the façade was only interrupted by cornices, with twin-arcaded windows rising from them. Leon Battista Alberti also used pilasters (ill. 22) of a different order on each storey, thus causing a division into a number

(ills. 23, 25), had nothing superimposed. The High Romanesque used blind arcades and pilasters, the Late Romanesque applied whole series of layers.

In the palaces on the Capitol, in Rome, Michelangelo used so-called giant orders, which rise from the ground to the height of the façade. These became the general rule of the Baroque, because they unify the building – an aim that asserts itself towards the end of any phase in architecture. The private palazzo is a cube with a pillared court (ills. 24, 90, 99), the cortile, derived from the Hellenistic courtyard, the peristyle. These palaces, to their patrician owners, were the manifestation of their wealth and learning, monuments to their greatness, and thorns in the eyes of their rivals. Cosimo de'Medici said that, in fifty years, only buildings would be left of his family's wealth and splendour.

BRAMANTE (ills. 27 below, 28, 29, 82, 83) was born in Urbino, c. 1444. He was a painter, master of perspective, wrote works on architecture and fortifications, invented new methods of vaulting and composed eighty sonnets. He built palaces and a large number of churches, which, without exception, are designed on a central plan.

The Palazzo Strozzi, Florence (Benedetto da Majano, after 1489).

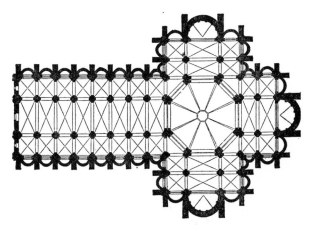

Pavia Cathedral (Christoforo Roachi, 1487). A 'Classic' interpretation of space, without the orientation of the Gothic interior, is not unusual in the Late Gothic. Like the High Romanesque triapsidal churches of the Rhineland (St. Maria im Capitol, Church of the Apostles, Cologne), such buildings come very close to the concept of a central plan.

of separate fields. This is the basic principle of all early composition. It was not generally accepted until the High Renaissance. The Palazzo Farnese (ill. 90) was begun by Antonio da San Gallo. The top storey, towards the courtyard, was added by Michelangelo. Again, there are Doric, Ionic and Corinthian orders. The combination of Greek column and architrave and Roman arch – the so-called Roman system – is derived from the Theatre of Marcellus in Rome.

At the Palazzo Rucellai (ill. 22), Alberti has only superimposed one layer. At the Palazzo Farnese, San Gallo has used two – arcades and columns – on the central storey, as has Michelangelo above, where narrow strips of pilasters have been placed in front of wider ones. A similar process occurred in Romanesque architecture. The earliest Renaissance façades, like the Palazzo Pitti and the Palazzo Strozzi

Ludovico il Moro, Duke of Milan, had the newly erected choir of S. Maria delle Grazie demolished to build himself his family's mausoleum (ills. 27 below, and 29) to Bramante's design. The Duke fell from power before it was completed. With the original nave, only, left standing the building resembles the tri-apsidal churches of the High Romanesque all in Cologne, Great St. Martin, The Apostles and St. Maria im Capitol which also combine a central plan with a nave.

The typically Lombardic detail on the façade of the apse (ill. 29) may not have been Bramante's intention, and is possibly the work of his successors.

At the sacristy of S. Maria presso Satiro (ill. 28), the small octagonal tower rises from a square base. Like the tower of the Baptistry at Florence, it has a flat octagonal dome. There are curved recesses in the corners on the ground floor; on the upper floor the inner wall has been dissolved into eight twin arcades. Bramante, like Brunelleschi, has used pre-Gothic motifs. The lavish use of sculpture is a concession to Lombardic taste; only in his Roman buildings did he begin to rely on pure architecture for effect.

Some works of art are a beginning, or a continuation; others are a completion, perfect in themselves. Amongst these are the High Renaissance churches built on a central plan. More so than any of them, perhaps, the Tempietto, the little round chapel in the coutyard of S. Pietro in Montorio (ill. 82), on the site of St. Peter's Crucifixion. It is Bramante's maturest work: a cylinder, closed by a dome. The lantern is not original. The lower portion of the building is enclosed by sixteen Doric columns, with corresponding pilasters along the wall. The Tempietto is undoubtedly inspired by the round temples of Antiquity. In the perfect balance of all its components, it is like the ideal image of Renaissance Man – a creature happy, harmonious and self-sufficient.

Bramante's design for St. Peter's, Rome, speaks a similar message. All cathedrals had been re-built in the Middle Ages, except the principal church of Catholic Christendom. Its form had remained unaltered since the fourth century. Its reconstruction was first planned in the fifteenth century, when foundations were laid for the choir of a new basilica. In the High Renaissance, the champions of a central plan

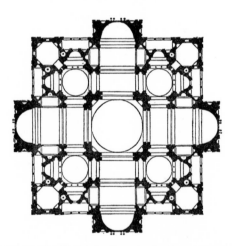

Bramante's plan for St. Peter's, Rome (1506). A sum of equal parts.

won the day. Bramante (see drawing) had intended a Greek Cross – surmounted by a dome – with similar structures on a smaller scale at the four corners. This would have resulted in a number of more or less independent rooms of equal importance. To have realised this Renaissance principle of a perfectly balanced interior is Bramante's great achievement.

LATE GOTHIC CHURCHES (ills. 38, 39, 41, 42, 54, 55, 58, 60, 61, 81). At its peak, in the thirteenth century, the Gothic was international. Architects and sculptors from all over Europe went to Chartres, Rheims and Amiens to marvel at the richly sculptured cathedrals that seemed to rise into the sky, oblivious to all laws of gravity. Inspired by French churches, they created Westminster Abbey and the cathedrals of Burgos and Cologne.

In the fourteenth century, national characteristics became more predominate, and by the fifteenth, in the Late Gothic, a number of national styles had emerged. The most marked separate development of the time is the Early Renaissance in Italy, which showed a complete break with the Gothic and eventually assumed European importance.

In England, also, the Gothic went its own way, with curvilinear tracery, which was to have its influence on the Continent – as were the sober shafts of the Perpendicular stellar and fan vaulting. The two last-named features are specifically, and exclusively, English. The culmination of this entirely separate English development, is King Henry VII's Chapel at Westminster Abbey (ills. 41, 42). It was built between 1503 and 1519, and replaced the Lady Chapel at the extreme east end of the Choir. It is aisled, with five chapels between the buttresses. The walls are almost completely dissolved into perpendicular tracery and glass. The vaulting no longer springs from a column, as in ill. 39, but is suspended from transverse arches, in accordance with the Late Gothic longing to disguise and overcome, rather than underline, method of construction. The abundance of tracery makes the ceiling appear a seething mass. On the outside, the buttresses have been formed as octagonal turrets (ill. 42).

Here, we have the highest sophistication and, with the accent on suspended rather than upward striving elements, perhaps the signs of exhaustion. Yet the tomb of the King and his consort, Elizabeth of York, already belongs to the Renaissance. It is the work of Pietro Torrigiani (1472–1528), of Florence, and marks a step in the artist's journey through Europe to Spain. The black marble monument was created between 1512 and 1518. With its bronze figures and Renaissance decoration, it is the first example of the new style in England.

Germany, too, went her own way. It led from the basilica to the hall church. In the former, the nave rose above the aisles, and had its own source of light in the clerestory. In the hall church, nave and aisles are of equal height. There is equal emphasis on all parts. The vaulting, covered with a network of tracery, leads the eye to look in all directions (ill. 38), in contrast to French Cathedrals, where there is one, all-compelling focal point, the altar. The hall church already occurs in Westphalia and Austria in the thirteenth century. By the fifteenth, it had come to dominate the form of the urban Parish Church, which had replaced the Cathedral as the leading task in architecture. The most extensive building of this kind, in red brick, is the Marienkirche, in Danzig (ill. 38). With its west tower, and its subsidiary towers that surround it like halberds,

it was the chief monument of this city, founded by the Teutonic Order after 1310 and later a member of the Hanseatic League. Building dragged on throughout the fifteenth century. The flags and altars in the church – gifts of guilds and leading families – are like a vivid illustration of Danzig's history.

The hall church type was also gaining ground in Spain. Whether this is an independent development, or due to the influence of Dutch and German masters who were working there in the Late Gothic, is hard to say. Another feature of the art of the Iberian Peninsula, at that time, is the use of Mauresque forms, the so-called Mudejar style, a mixture of French Gothic forms and Islamic ornament. The result is a profusion of carpet-like patterns (ill. 81). Arcade openings and parapets (ill. 55) are filled with ornament; window frames, as at Tomar (ill. 58), are almost choked by it. Even where Italian forms are borrowed, as in the church of the Convento dos Jeronymos at Lisbon (ill. 54), they are overloaded with a network of small-scale decoration. The church has a remarkable history. It was built on the site of the house where, in 1497, Vasco da Gama spent the night on the eve of his journey round Africa. In 1499, on his return from the Indies, he was received in the same house by King Manuel I – Portugal's most powerful king, who conquered Brazil, and after whom the art of the whole epoch was named – who had vowed to found a convent if the journey should prove successful. Work was begun the same year. King Manuel I, his successor, and Vasco da Gama are all buried in the church. It is a hall church, with net-vaulting supported by octagonal columns (ill. 54).

In Germany, some of the best known transitional buildings of the time are the tower of St. Kilian's, Heilbronn (ill. 60), and the Fugger Chapel (ill. 61) in Augsburg. St. Kilian's,

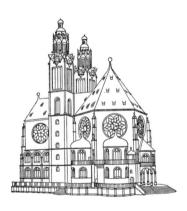

Regensburg, 'Schöne Maria', wood model. After 1350, a reaction against the Gothic, and a return to the Romanesque occurred in the north, as well as in Italy. Some of the most famous examples of central plans were St. Gertrud's, Hamburg, and the parish church at Alt-Ettal. St. Gertrud's has been destroyed, but an original wood model of the 'Schöne Maria', Regensburg, survives.

the parish church of Heilbronn, a late thirteenth century building, was enlarged in the fifteenth and sixteenth centuries. The tower (begun 1513) is the work of Hans Schweiner, a highly individualistic master who was put in charge of building operations in the same year. The profusion of Romanesque and Italian forms is almost Baroque. The contrast between Italian clarity and the German longing for the mysterious and obscure could hardly be

more marked. It is scarcely possible to distinguish the tiny Classic pillars with their wreathed shafts on the cornices of the first and third storeys. The strangest feature are the masks (left, centre storey) and the monsters facing each other above some of the arcades. They are like memories of the Romanesque, when such figures were placed on the façade to ward off demons. It has been said before that the end of the Gothic is marked by a return to the Early Middle Ages, to Romanesque forms. As in the work of Brunelleschi, there is a retracing of the Gothic path, a restoration that precedes the revolution of the Renaissance.

THE NORTHERN GABLED HOUSE (ills. 44–47, 114, 117, 136, 148, 149, 160, 161, 178–180). The Italian palazzo forms part of the street, but preserves its identity. The Northern gabled house differs from its neighbours in its more lavish decoration. Its inhabitants stand out less as individuals from their fellow citizens than their Italian contemporaries. The palazzo is self-sufficient and monumental, the gabled house speaks by virtue of its neighbours (ill. 44 still has Gothic tracery, though built 1531, and ill. 45). The connection between Late Gothic (ill 44, right) and Mannerist houses is particularly noticeable in Antwerp (ill. 44, left) which had surpassed Bruges in importance by the sixteenth century. In the Gothic, gables are crowned with pinnacles, in the Renaissance with obelisks. In addition there is a more horizontal emphasis in the cornice. The Knochenhaueramtshaus, the house of the Butchers' Guild in Hildesheim (1529), is still a traditional timber structure (ill. 46). While the stone house usually follows the style of the age, the timber house, both in construction and decoration, is essentially conservative and preserves a tradition that goes back to prehistoric times. The town house is descended from the peasant house, because the earliest town dwellers cultivated the soil. Gradually, their place was taken by artisans and merchants. The narrowness of the town, confined within its fortification, made upper floors a necessity. To gain more rooms, and to protect the wood of the lower storeys below from rain, each floor was made to project further.

The Knochenhaueramtshaus is the most monumental of all German timber buildings. An arched gateway – a relic of the peasant house – leads into a corridor, running through the entire width. The first floor consisted of one large room for the meetings of the Guild. Each storey decreases in height.

In wood-carving, prehistoric ornament – especially plaitwork – lingers on. At the Knochenhaueramtshaus, Southern motifs are used for the first time. At the Willmann house, in Osnabrück (ill. 47), the dominating feature is the rosette, of Mesopotamian origin, surrounded by Germanic plaitwork bands and Romanesque billets, and separated by a Classic astragal, lest there should not be enough diversity! In the Thirty Years War, 245 houses were demolished for firewood in Hildesheim. The surviving 400 were mostly destroyed by bombs during the last war.

Stone houses have their most lavish decorations reserved

for the gable. Here, the ornament is developed from the Mannerist strapwork and scroll work of the cartouche. As in the Essighaus in Bremen (ill. 148), it often spreads all over the façade and dominates the lines of the obelisk-crowned gable, the favourite motif of Mannerism, which loves upward movement.

There is still some of this exuberance in the house of the philosopher Leibniz (ill. 149) in Hanover, though it was not built until after the end of the Thirty Years War. The building was the work of H. Alfers; the decoration was designed by P. Köster. The projecting bay almost dissolves into ornament.

In Italy, town halls are blocks with a horizontal emphasis; in the North, they retain their link with the gabled house. Usually, they stand alongside the market square, sometimes they also face it with the narrow gabled end of the façade; a house amongst the houses of the citizens. Occasionally, they are free-standing structures, like the formerly moated town hall at Gouda (ill. 114), in Flanders. Its third storey, enlivened by a wealth of turrets, gables and finials, makes it the very antithesis of Italian Renaissance horizontalism, and a triumph of inherited Gothic principles. The Renaissance outside staircase was added in 1603. A typical German example is the town hall at Rothenburg-on-the-Tauber (ill. 136). Of the two parallel blocks, one belongs to the Gothic, and has a tower, the other, of 1572, is a Renaissance building, begun by Jakob Wolff the Elder, of Nuremberg, and completed by Hans von Annaberg. The rusticated loggia was added in the seventeenth century. The turret on the gabled end of the façade deliberately introduces a note of asymmetry, in adaptation of a Late Gothic motif. Thus, in German architecture, organic growth, rather than geometry, is the guiding principle. The loggia of Cologne town hall (ill. 161) by contrast, is a Dutch variant of the Italian Renaissance. The Renaissance had little following in Germany. Had it been otherwise, the town council of Cologne would not have asked artists from Lièges, Namur and Antwerp to take part in a competition for enlarging the original fourteenth-century building. The winner was a master trained in the Netherlands, Wilhelm Vernuiken, of Kalkar. His hall is two bays deep and five bays wide. The similar Convent Christi at Tomar (ill. 160) remains essentially Italian. At Cologne, the spandrels have been filled with figures. A further concession to Mannerist verticalism are the tall plinths of the columns and the *aedicula* with the figure of Justice above the central arch.

The most monumental Northern town hall is at Antwerp (ill. 117). It was built 1561–1565, and is the work of Cornelis Floris, one of the most influential ornament engravers in Northern Europe. It is a long, four-storeyed building with an arcade below the roof. It seems almost as if the North had succumbed to the horizontalism of the South. But the obelisks and gables of the centre portion are a triumph of the Gothic tradition, of Mannerist verticalism. In the uppermost niche is the Madonna, the Patron of the city, below the figures of Wisdom and Justice, which were a favourite allegory in secular Renaissance art.

Geometric symmetry, the plain monumental wall, did not prevail in Germany until after 1600, when, at last, the real nature of the Italian Renaissance began to be understood. The most striking proof of its final acceptance is the town hall in Augsburg (ills. 178–180). It was built by Elias Holl (1573–1646), the architect of a number of important buildings in the city. He was the first Renaissance artist to write his autobiography. In his own words, he had "made a journey trough Italy, and seen the buildings in Venice". He returned in 1601. His first designs for Augsburg town hall still recall North Italian loggias; they are like memories of Palladio's Basilica and Sansovino's Library of St. Mark's. But all his designs – the sixth was accepted – have as their principal feature the plain wall, which was to be the main German contribution to the Early Baroque. Like Herrera's Escorial, Holl's building speaks through its noble proportions. Holl overcame German Mannerism, as Herrera had risen above the confusion of the *estilo mudéjar*.

The plan, extremely simple, governs the façade. Each storey contains one vast room, running from end to end. These halls are flanked by staircases, surmounted by domed turrets. The corners are filled by smaller rooms, completely square, with parapeted roofs. Such lucidity was something entirely new in German architecture. Holl's other buildings already show traces of the Early Baroque. But everything was cut short by the Thirty Years War. In 1625 there was no money left, in 1629 Holl had to go, because, in the words of a contemporary chronicler, he would *"nicht in die päbstliche Kirche gehen, die wahre Religion verleugnen und, wie mans genennt, sich nicht bequemen wollte"* – "not enter the Church of Rome, renounce the true faith and", – as we would call it today – "toe the line".

CASTLES (ills. 65–79, 110–112, 126, 130, 131, 134, 137, 151, 154, 155, 172, 173 above, 174). The increasing use of artillery in the fifteenth century made the medieval fortified castle obsolete. At the Château of Amboise (ill. 76) the mighty round tower on the left still recalls medieval feuds. The main building was begun by Charles VIII (1483–98), who engaged twenty-two Italian artists and craftsmen, amongst them painters, goldsmiths, stone masons, cabinet makers and gardeners. Most of the palace has been destroyed, and no trace remains of their work. In the sixteenth century, it was decided to continue along Mannerist lines, in a specifically French version, with a roof interrupted by dormer windows and tall finials.

In 1560, Amboise was the scene of a plot by the nobility and the Calvinists against the King, who is said to have massacred twelve-hundred of the conspirators. Three years later, the palace saw the conclusion of peace between the King and the Calvinists.

The Albrechtsburg, at Meissen, and Schloss Hartenfels, at Torgau (ill. 66), are the last German castles built on mountain peaks. At Hartenfels – the first extensive secular building in Germany since the Imperial palaces of the Romanesque – the forms are essentially Gothic, yet the detail, even on the compact Gothic gable, belongs to the

Renaissance. The spiral asymmetric staircase, a legacy of the Gothic, occurs in a similar form at Blois, in the wing re-built by Francis I immediately after his accession in 1515 (ill. 67). The staircase is not merely decorated on the outside with flat reliefs in the Italian manner – as at Torgau, to whose builders Blois was in all propability unknown – but it also has a Renaissance parapet round the roof.

At Blois, the most important contribution of the French Court to the architecture of the Renaissance before the Louvre, Francis I only built one wing; in Chambord (ills. 74/75) he commissioned a huge palace, the Château de Chambord, built amidst lonely swamps in a park surrounded by twenty miles of wall, which used to be des-

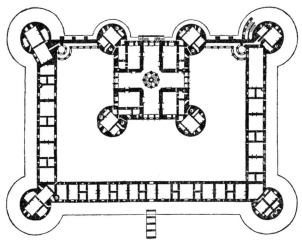

The château de Chambord (after 1526). A formal lay-out, in adaptation of the – originally strictly functional – plan of the fortified castle.

cribed as a hunting box. It was the King's favourite residence. With four hundred rooms, extensive stables, kennels and falcon lofts, it was the biggest monument to Francis' enthusiasm for buildings. There is some contradiction between the dramatic Mannerist roof above the centre portion and the well-articulated Renaissance façade. For the first time, there is an interior, which, in contrast to the medieval castle, has been conceived as an ordered arrangement of rooms.

The King's third palace was the Louvre, the royal residence in Paris (ill. 68). The original building, in its main portions commissioned by Philippe Auguste (1180–1223), had a fortified tower and a donjon which stood until the seventeenth century. Since 1546, re-building had been in charge of Pierre Lescot. The south-west corner was first completed. Here, Lescot has given the French Renaissance its specific character: a long front, interrupted by pavilions, surmounted by segmental gables. This type of façade was retained in France until the nineteenth century. The pavilions have columns, the walls between, pilasters. The third storey is decorated with reliefs by Jean Goujon, who also collaborated with Lescot at the Fontaine des Innocents (ills.

70, 71). Both Pierre Lescot and Jean Goujon thoroughly understood the Italian Renaissance, and yet were able to give it an essentially French character. A national style, both festive and rational, could thus develop.

The Louvre did not become the world's largest royal palace until later. Louis XIII and Louis XIV had completed the square main courtyard. Louis XIV also had invited artists from all over Europe to take part in a competition for the east front. Bernini submitted a design, but the Baroque had little chance against French Classic. Catherine de Medici (1560–89) began the Tuileries, in continuation of the western part of the Louvre. They were completed under Napoleon I and Napoleon III. To-day, the Louvre covers an area three times the size of the Vatican. Apart from the famous museum, it contains the French Treasury.

Francis I's fourth palace was Fontainebleau (ills. 130, 131). Thanks to the work of Italian artists, it became the cradle of the French Mannerist version of the Renaissance. The huge palace was meant to surpass everything of its kind. It consists of several wings, arranged around courtyards, with Renaissance façades and lay-out, but rather un-Italian pavilions above the roof line, and dormers. The architects were Gilles le Bretons and Pierre Chambiges the Elder, who created the Cour de Cheval Blanc, the Court of the White Horse, named after the plaster cast of the Marcus Aurelius statue on the Capitol. It forms the principal façade towards the city. Delorme's once famous horseshoe staircase was re-designed in the seventeenth century by Lemercier.

The special significance of Fontainebleau lies in the decoration of the interior (ills. 130, above and below), the work of the predominantly Italian School of Fontainebleau. It was begun c. 1530. In 1531, the king engaged Rosso Rossi (1494–1541), and in 1532 Francesco Primaticcio (1504–1570). Both were natives of Florence and highly experienced in the control of armies of stucco workers, fresco painters and wood-carvers; they had distinguished themselves in the decoration of the Palazzo del Tè and the town palace of the Gonzagas in Mantua. Rossi grew up in the school of Michelangelo; Primaticcio was a pupil of Guilio Romano, who had worked under Raphael.

Rossi's first commission was the decoration of the king's gallery, the first of its kind and a feature of most later palaces. Though nearly 200 feet long, it is less than 17 feet wide. There is wooden panelling, with a wide frieze of painting and sculpture above. The basic motif is the cartouche. Frames sprout everywhere – a characteristic feature of Mannerism. Strapwork, fruit, putti and male and female figures of every size and shape, are not meant to symbolise anything, but merely exist to satisfy a boundless expressive urge. Rossi began, Primaticcio completed, the work. The two Italians, in their anxiety to keep up with the French striving for grace and elegance, completely forgot all about the terribilità, the overpowering drama, of Michelangelo, their teacher and spiritual ancestor.

The nobility and the rising aristocracy followed in the wake of the Court. Azay-le-Rideau (ills. 73, 79, below) was built

1518–1527 by a commoner, Gilles Berthelot. The needle-sharp turrets, the pinnacled dormer windows, the slender shafts on the bay towards the courtyard, are clear evidence of the coming triumph of Mannerism. There is rather too much petty detail. But, for the first time, straight parallel flights of steps replace the spiral staircase. The architect was probably Etienne Rousseau.

Like Chambord, Rigny-Ussé has a roofline dissolved into a profusion of turrets and chimney stacks (ill. 77).

The Château at Chenonceaux (ill. 78), the country house of a commoner, Thomas Bohier, Minister of Finance, is built above the river Cher. The windows of the second storey have segmental gables – a feature as Italian as the entablatures of the dormer windows. Horizontal lines still dominate.

Fontaine-Henry (ill. 79, above), mirrors all the conflicts of the time between the importation of the Italian Renaissance and the Mannerist resurrection of Gothic elements. The projecting central portion above the entrance is compact and horizontal. But the windows on the right have Late Gothic ogee arches, and steep, typically French roofs with narrow dormers rise on the left. As at Chambord, the French love of movement, of the picturesque, has triumphed over Italian discipline. Indeed, this happens everywhere, except in the Louvre and at Blois. The Italian Renaissance in its full significance was not properly understood until the seventeenth century.

In Germany, Mannerism came much later, and with much less impact. Italian models were accepted more or less unchanged, except for a wealth of small-scale ornamentation. The tone is set, therefore, by the ornate buildings of Lombardy rather than by the severe Florentine palazzi. The castle at Heidelberg, and the Fürstenhof at Wismar (ills. 69, 72) are Italian in their well-balanced proportions. At Wismar, the triple arcades with their caryatids and pilasters, the triangular gables filled with medallions, and the relief along the cornice of each storey, are Lombardic in character. The casts for the terracotta medallions came from the famous workshop of Statius von Düren, in Lübeck. The lowest frieze, in limestone, shows the Humanist theme of the Trojan War, and the Christian of the Prodigal Son.

Heidelberg castle lies on a mountain above the river Neckar. In the course of the sixteenth century, it gradually changed from a fortified castle into a palace of great splendour.

The Ottheinrichsbau (ill. 69) is illustrated opposite the Louvre. Though both represent the Renaissance in its purest from in their respective countries, they have distinct national characteristics. At Heidelberg, the upper storeys decrease in height, there are broad sculptured friezes, supported by pilasters, Ionic and heavily rusticated on the ground floor, Corinthian, decorated and richly carved, on the floor above. The ground floor windows have triangular pediments, the others are surmounted by Classic motifs of Humanist connotation. The proportions are of a harmony hitherto unknown in German Renaissance architecture.

To supplement orders with a wealth of detail is typically German, although some of the decoration shows French and Dutch traits. There is certainly nothing Italian about the use of the picturesque as an aid to pure architecture. Amongst the artisans were a certain Anthony, who may have been German, and one Alexander Colins, from the Netherlands. The architect is unknown. Ottheinrich may well have had a hand in the designs. He stood far above his ill-educated fellow princes, was the patron of several artists, and acquired a large art library, to which he added two editions of Serlio's treatise on architecture while the new palace was building.

For the first time since the Middle Ages, Germany had an architecture that was a mirror of Man as he stood on Earth, rather than an expression of his striving to transcend this world. The Ottheinrichsbau is thus a firm statement of Humanism, of a philosophy that knew no frontiers, and yet had its own form in every country.

After the death of Ottheinrich, the addition of two gabled pent-houses made the Castle look even more German. They were burned in the fire of 1689, when the armies of Louis XIV set aflame a large strip of the frontier region to have a protective devastated zone between Germany and France. But the building appears more organic as it is now. As a ruin, it has certain romantic qualities, which, in the last century, made it so dear to the hearts of many Germans. The Friedrichsbau – also burned out – was "restored" by Karl Schäfer after 1900. The Ottheinrichsbau, fortunately, has been left alone, and is still in its original state. Germany's biggest town palace, in Munich, was built by the Bavarian Court between the sixteenth and the nineteenth centuries, in place of the Neuveste, a fortified castle created after the rising of 1384. Unlike later Baroque palaces, the Munich Residenz is in the heart of the city. Under the Elector William, it was a loosely grouped series of palazzi. From 1611 onwards these were linked and arranged around six courtyards.

The earliest portion is the Antiquarium (ill. 155), commissioned by Albrecht V (1550–79) for his collection of Classical Antiquities – the first north of the Alps – and built 1559 by Ecke, to the designs of J. Strada, of Mantua. In its present form, it is the work of Friedrich Sustris, to whose designs it was altered between 1586 and 1600. The paintings on the ceiling are by another artist from the Netherlands, Peter Candid. There are over a hundred views of Bavarian castles and cities, allegoric scenes and a wealth of strapwork and other decoration based on Italian engravings.

The Grottenhof (ill. 154), also by Friedrich Sustris, followed later. The painted ceilings are supported by Tuscan, or composite, columns. The courtyard, according to old engravings, was at one time a formal garden. Antiquarium and Grottenhof are the parts least damaged by the raid of 1944, and could therefore be restored to something like their original state.

German Renaissance palaces, true to the German dislike for lavish, outward ostentation, appear at their most elaborate towards the arcaded courtyards. At the Plassenburg

(ill. 65), in Kulmbach, Franconia, a rather plain ground floor façade makes the two upper storeys, arcaded and covered in relief, appear all the more ornate. At Spittal an der Drau, at the former Royal stables – now the Mint – in Munich, and on the Graz Landhaus, the entire wall towards the courtyard is dissolved into arcades (ill. 110–112). Occasionally, (the Pellerhaus, Nuremberg, ill. 145), Italian arcading has been adapted to German patrician houses. At the Schallaburg, in Lower Austria, where it runs through two storeys, with caryatids on the upper, it has become completely German in character (ill. 151).

At Frederiksborg, the Danish royal palace, the international Renaissance has merged into the national character more than anywhere else (ills. 134, 137). The courtyard is flanked by two blocks with Northern gables, whose sides are formed by typically Mannerist strapwork. The towers – a theme much beloved by the architects of the North – are grouped asymmetrically and have helms of several storeys, in the manner of Hanseatic church spires. Frederiksborg was at one time the summer residence of the kings of Denmark, who, until 1840, were also crowned there. It is now the Museum of Danish History.

The Alhambra (ill. 98), Granada, was built for Charles V between 1526 and 1568, by Pedro Machuca, who had been to Italy where he had met followers of Bramante. The round courtyard is modelled on Hadrian's villa. It is placed into a rectangle. Another, smaller, and also rectangular, courtyard leads into it. Its pure Renaissance forms, so unlike the prevailing Mannerist Mudéjar style make the Alhambra the most "Classic" palace in Europe.

The Escorial, Phillip II's palace near Madrid (ill. 173, above, 174), is modelled on the Spanish feudal castle. Like the latter, it has a tower at each corner. The long, austere walls also enclose a monastery and a church. Here, Phillip – whose reign saw Spain's first great losses, the defection of the Netherlands and the rout of the Armada – wanted to live as a monk rather than as king, to personify the complete union of state and Church. There are sixteen courtyards 2673 windows, 88 fountains and 100 miles of corridors. The palace is as joyless and ascetic as the king. There is not a trace of the Mannerist love of decoration. But in its severe simplicity, the Escorial is already the beginning of the Early Baroque, which was to introduce movement and variety of an entirely new kind. The Escorial was designed by Juan Batista de Toledo in 1559. After his death, in 1567, until 1584, Juan de Herrera was in charge of the work.

The almost equally stern Castle at Aschaffenburg (ill. 172), in Germany, was built 1605–1614 by Georg Ridinger, of Strasbourg, for the Elector of Mainz. It forms a square, with four towers that recall fortified castles. Late Gothic and Mannerist asymmetry is completely overcome. The only concession to Mannerism are the gables – one on each side – with their obelisks. Aschaffenburg, self-sufficient and severe, is the last statement of the sixteenth century. The palace of the Baroque was to replace the closed courtyard with the open *cour d'honneur*.

MICHELANGELO (ill. 83–85, 88–91). Though at heart a sculptor, Michelangelo could not find fulfilment in sculpture alone. His first great work of architecture was the Medici Mausoleum (ills. 88, 89) at S. Lorenzo, opposite Brunelleschi's Old Sacristy (built 1428). Michelangelo had been working on the designs for the Medici Mausoleum since 1520. He was both its architect and its sculptor. The two seated figures are Giuliano (d. 1516) and Lorenzo de'Medici (d. 1519), the statues on their sarcophagi Night and Day, Evening and Dawn. Sculpture of this kind had already occured on Hellenistic tombs, just as mausoleums were nothing new in Christian churches. But the splendour of the Medici Mausoleum surpassed everything known before. It is an expression of the spirit of the Renaissance, of the will to perpetuate the fame of a ruling family. Only a small portion of Michelangelo's plans was carried out.

The square interior is vaulted by a dome, supported on pendentives. The articulation of the walls has all the severity, the power and substance, the *gravità*, that distinguish the Roman High Renaissance from the light and playful manner of the Quattrocento. There is an air of tension, of unresolved conflict, about everything. The windows seem hemmed in, the sculptures (ill. 89) lack the *joie de vivre* of the Renaissance. The time for the unreflecting enjoyment of this world is over. Life is an eternal conflict, the struggle between longing and destiny. That is the message of the sculptures of the Medici Mausoleum, and, indeed, of all Mannerist art.

St. Peter's was commissioned in 1547. Michelangelo changed Bramante's plan (p. X) by making a few very large rooms out of a wealth of small compartments, entirely in the spirit of the High Renaissance (plans and ills. 84, 85). Bernini's bronze tabernacle of 1633 seems heavy and op-

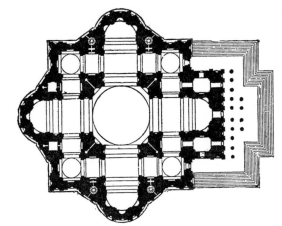

Michelangelo's plan for St. Peter's, Rome (1547). A variation of Bramante's plan. All parts are subordinate to the centre.

pressive, and yet almost disappears under the huge dome. Columns have been replaced almost throughout by heavy piers. To the worshipper, lost in this vastness like a grain of sand in the desert, the building seems a symbol of Infinity.

Bramante had planned a semi-spherical dome. Michelangelo elongated it, and thus made it more dynamic, more Mannerist (ill. 83). After his death, the dome was completed to Michelangelo's plans under Giacomo della Porta.

Mannerist dynamism, triumphant over Renaissance calm in the dome, also prevails in the plan. In 1607, it was decided to elongate one of the arms of the church into a nave. It was completed, to the designs of Carlo Maderna, before 1612. Michelangelo's staircase in the Bibliotheca Laurenziana, commissioned by Pope Clement VII and begun by Michelangelo in 1523, has always been considered the beginning of Mannerist architecture (ill. 91). Again, the forms do not spread freely, but are hemmed in, almost compressed. The enormous coupled columns are placed into narrow recesses, and these, in turn, are flanked by blind windows. The consoles below are like clenched fists that cannot open.

At the Palazzo Farnese in Rome (ill. 90), begun in 1514 by Antonio da San Gallo, Michelangelo added the top storey to the courtyard façade. Doric, Ionic and Corinthian columns combine in one building. Here, too, in architecture as in painting and sculpture, Michelangelo had been a powerful new impetus.

RENAISSANCE AND MANNERIST CHURCHES

(ills. 14, 15, 61, 82–87, 96, 97, 100, 101, 106–109, 122, 123, 138, 139, 166, 177). The principal works of the High Renaissance, the Tempietto (ill. 82) and St. Peter's (ills. 83–85), have been discussed under Bramante and Michelangelo. A third church built on a central plan is S. Maria della Consolazione, in Todi (ills. 86, 87). The Tempietto is small, St. Peter's later had a nave added. At S. Maria della

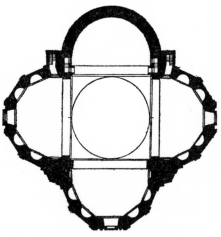

S. Maria della Consolazione, Todi (c. 1520). A work of Bramante pupils.

Consolazione, the central plan survives in all its clarity. The centre is a square, surmounted by a dome. There are four apses. It is not a building that might be a narrow passage into another world. The beholder will experience it in its most perfect form from the centre, standing still and letting it work upon him. The walls are transversed by

horizontals, the dome is not yet a centre of movement as at St. Peter's. Calm and balance rule everywhere.

Mannerism came with the Counter Reformation. After 1607, St. Peter's was given Maderna's nave. Il Gesù, the church of the Jesuits in Rome (ills. 106, 107), became the prototype of most seventeenth century churches. It is the work

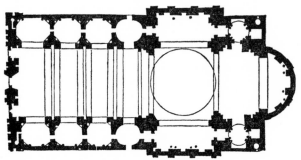

Vignola's Il Gesù, Rome (1568). A development of Alberti's concept: the dark nave is subordinate to the light-flooded crossing.

of Giacomo Vignola, was begun 1568, roofed 1576, and consecrated 1584. By then, a design by Giacomo della Porta had replaced Vignola's façade. The German Jesuits had gone back to the Gothic which, to them, was the only true style for churches. At Il Gesù, by combining a nave of three bays with a dome, Vignola achieved a synthesis of balance and orientation, of the earth-bound and the transcendental. Leon Battista Alberti, in S. Andrea, Mantua (ills. 14, 15) had already anticipated a solution of this kind. As Michelangelo's concept of St. Peter's is to Bramante's, so is Il Gesù to the nave: a sum total of separate parts is transformed into a unified whole. The aisles, formerly almost self-contained, have become side chapels, subordinate to the nave. There is rhythm and unity throughout.

Il Gesù points to the future. In the North, Mannerism was essentially conservative, and throve on the continuation of the Gothic. In France, its most important building was S. Etienne-du-Mont, Paris (ills. 122, 123). The choir was begun 1517, the nave 1540. The nave is only slightly higher than the aisles, making the building not unlike a hall church. The piers and rib vaulting continue the High Gothic tradition, the walls are completelly transparent. The roodloft by Pierre Biard, is a mass of tracery, including the typically Mannerist spiral staircase. But the façade (1607), holds few memories of the Gothic and has the curved pediments characteristic of the French Renaissance.

In Germany, Renaissance church architecture begins with the Fugger chapel, in the Carmelite church of St. Anna, Augsburg (ill. 61). The memorial chapel of a patrician family, it can be compared with Michelangelo's Medici Mausoleum. J. V. Sandrart, the German Cellini, wrote about the Fuggers in 1675: "The noble house of Fugger has encouraged the arts, and sustained the artists". The chapel was commissioned in 1509 and consecrated nine years later. It lies at the western end of the nave, forming a kind of choir to the west. The dome, decorated with a network of

XVI

Gothic lierne ribs, is supported by Venetian Renaissance pilasters. The relief panels, with the figures of Georg (d. 1506) and Ulrich Fugger (d. 1510) are based on drawings by Dürer. The altar, with a free-standing group of the Pietà, is the work of Hans Dancher, as are the predella panels. Peter Vischer's screen, ordered for the chapel, went instead to the Nuremberg Rathaus. A contemporary chronicler describes the chapel as "in the Italian manner, not seen before". Heavy war demage was repaired in 1948.

At St. Michael's, Munich (ills. 108, 109), the Renaissance in its Mannerist version is fully established. The church was built for the Jesuits – the vanguard of the counter-Reformation – by Duke Wilhelm V. Its chief architect was Wolfgang Miller. Whether he also designed it, on the basis of Italian plans supplied by the Jesuits, is uncertain. It was begun in 1582, and completed in its first version six years later. In 1590, the tower above the crossing collapsed. The portions east of the nave were re-built after a model by Friedrich Sustris, and consecrated 1597. The coffered barrel vault of the nave is supported by screen-like piers, which enclose side chapels and galleries. Sustris added a transept; his plan for a dome did not materialise. Nave arcades, common in Bavarian Late Gothic churches, combine with Italian forms. The most strikingly Italian feature is the three-storeyed gabled façade, with recesses for sculpture and blind windows. Our illustration shows the figure of St. Michael, between the red marble portals, and statues of the Wittelsbach rulers – the principal allies of the Counter Reformation – above. The Jesuit College to the west of the church later became the Bavarian Academy of Sciences. Like the church, it was very badly damaged in 1944 and was later restored in simpler form, without – amongst other detail – the stucco decoration.

Comparsion between the castle church at Augustusburg, in Saxony, and the sacristy of Jaén Cathedral (ills. 96, 97) gives some idea of the international character of the Renaissance. Augustusburg was built by the Elector August as the first palace on an entirely geometric plan. The galleries – a characteristic feature of Protestant churches – run across three storeys. They are separated by internal buttresses, decorated with a Doric order on the ground floor and Ionic orders on the floors above. The highly original pattern on the ceiling appears to be derived from metalwork designs.

The sacristy at Jaén has similar segmental arches, and the same type of ceiling. There are cupboards for vestments between the columns on the left.

In contrast to these Renaissance buildings, national characteristics again predominate in the parish churches of Bückeburg (ills. 138, 139) and Wolfenbüttel, the only German Protestant church buildings of the sixteenth century. The aim is a synthesis of Gothic and Renaissance. The naves are a Gothic version of Northern hall churches – the Gothic was simply considered the church style *per se*, the Renaissance was rejected as "pagan". Just as Lutherans only very gradually developed their own form of worship and, in contrast to Calvin's followers, still allowed considerable space for the altar, no church building with specifically Protestant features – apart from galleries – evolved in the sixteenth century. The unknown architect of Bückeburg church used Gothic rib-and-panel vaulting, supported by Renaissance columns and typically Gothic buttresses. There is Early Gothic tracery – by no means unusual in the Renaissance – on the round-headed windows, the walls carry wooden galleries.

On the façade, the sculptured buttresses, extended beyond the cornice by obelisks, are like an affirmation of Mannerist verticalism, from which the heavy sculptured gable and the round windows can detract very little – the less so, because of their strangely elongated surrounds.

Palladio's Venetian churches (ills. 100, 101) are discussed in the chapter on the master's work.

Amongst Portuguese monastic buildings, the Convent Christi, at Tomar, ranks next to Belém in importance. The city of Tomar was built under the protection of the Order *"de cavalleria de Nostro Senhor Jesus Cristo"*, the Knights of Christ, founded 1314 by King Diniz. In 1523, it was turned into a monastic order, the castle was considerably enlarged, and the number of cloisters was increased from four to eight. Ill. 160 shows one of these cloisters, built 1557–62.

The Late Renaissance culminates, and ends, with the church of the Escorial, near Madrid (ill. 177). Vignola had evolved an ideal plan, based on 22 designs submitted by Italian artists to Phillip II. But the work went to Juan de Herrera, the second architect in charge of the entire palace. Herrera's church, like St. Peter's, Rome, is based on a central plan, which, as at St. Peter's, is extended westwards by a vestibule, with a monk's choir continued in the form of galleries along the entire building above. Off one of these galleries, communicating with a royal box, is the king's bedroom. Similar court churches followed at Barcelona, Versailles and Dresden. Charles V and Phillip II lie buried in the crypt below the High Altar. Throughout the building, the forms are of a severe grandeur, entirely in keeping with the monastic spirit of the place.

PALLADIO (ills. 100–103). Classic art found its fulfilment both in the masters of Mannerism and in Palladio's own specific version of the Late Renaissance. By emphasizing basic laws of form, following objective rather than personal values – in contrast to Michelangelo and the Baroque – he has approached the spirit of Antiquity more than any other architect. Certainly, the increased splendour, the heightened contrasts of form, the rich play of light and shade, are his own individual contribution. Yet his work is the triumph of the Renaissance, pure and undiluted, even in Northern Italy. He put function before decoration, anatomy before dress.

Palladio was born in 1508, in Vicenza, and died, in Venice in 1580. He has made his native city famous by his Basilica, the Teatro Olimpico and his palaces. In the tradition of his time, he adopted a Humanist name, derived from Pallas, the Goddess of Art. He studied Vitruvius *De Architecture*

more thoroughly than any of his contemporaries, made detailed records of the Classic architecture of Rome, Dalmatia, and Provence, published *I quattro libri dell' Architettura – The Four Books of Architecture* – about his studies, and, in 1554, brought out another work, *L'Antichità di Roma*. Extremely versatile, he also built bridges, designed theatre settings, restored the Roman theatre at Vicenza, and created a new theatre in the hall of the Basilica. His principal works are palaces, churches and villas. His new façade for Vicenza town hall, the "Basilica" was begun 1549 (ill. 103, above). At the Palazzo Chieregati (ill. 103, below), also in Vicenza, clever use has been made of light and shade. The Baroque was to aim at similar effects. But there is as yet no movement, everything is static rather than dynamic. The Palazzo Chieregati was built 1566.

At S. Giorgio Maggiore (ill. 101), one of his two Venetian churches, a parapet forms a clear demarcation between dome and crossing, a projecting cornice between piers and arches. In Baroque architecture, these separate zones usually merge.

At Il Redentore (ill. 100), Palladio's other church in Venice, the Classic tradition is not merely followed, but continued. The motif of the pillared and gabled temple front is used twice. It is repeated in the two pilasters at the entrance, and again in four pilasters at the sides, as if inviting the eye to see it continued behind the main gable. Such effects already border on the Baroque, as does the colossal Corinthian order.

Ill. 102 shows Palladio's most famous villa, the Rotonda, at Vicenza. It is a perfect square, vaulted with a dome, and with a Greek temple front on each side. It is thus built on the plan of a Greek Cross, a form hitherto reserved for churches. There is something inappropriate about the building's likeness to a temple. Though the villa seems to belong to a god, it is, after all, only a country house. It also marks the decline of the pillar, which in the past had been first sacred, and then reserved for sacred buildings. Soon, it was to appear everywhere, until the nineteenth century used it on railway stations and banks. To us there seems

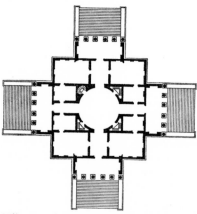

Palladio's Villa Rotonda, Vicenza (second half 16th century). All practical considerations are sacrificed to the formal plan.

an insoluble conflict between form and purpose in the Villa Rotonda.

We know little about Paolo Almerico, who had the Villa Rotonda built in the second half of the sixteenth century, but he must have understood Palladio's concept of Man. The Universal Man of the Renaissance, the *uomo universale*, is the real theme of this house. He is the culmination of Europe's second Classic age, the Renaissance, if we can see Greek Antiquity as the first. The third is the time round eighteen-hundred, the age of Goethe, who compared Palladio with Homer. Seen in this light, the Villa Rotonda is the purest expression of the Renaissance, next to Bramante's Tempietto (ill. 82).

Because he re-created Classic architecture at its purest, Palladio has come to be considered the father of the Classic Revival. He has had more influence than any other architect in history. Elias Holl began as an imitator of Palladio, Perrault created the façade of the Louvre in the same spirit. Frederick the Great of Prussia followed in the wake of France; in England, some of the finest seventeenth-and eighteenth-century architecture is simply described as Palladian. All Europe took up Palladio, when the force of the Italian and South German Baroque had exhausted itself, and calm and simplicity came into their own again. He was the great teacher of Classic Art until the middle of the eighteenth century, until Winckelmann and the dawn of archaeology.

RENAISSANCE AND MANNERIST ORNAMENT (ills. 17, 22, 28, 66, 71, 74/75, 77, 90, 99, 114, 122, 126–130, 133, 135, 140–142, 146, 148–150, 152, 153, 157, 159, 165, 171, 178/179). In the Gothic, the secrets of proportion and statics, of the art and craft of building, were passed by the spoken word from master to journeyman and apprentice. In the Renaissance, such information is passed on in books and engravings. The artist, in using books, now resembles the learned Humanist. While the Gothic still had its roots in the people, the Renaissance is based on a learned élite, the literati. A contrast develops between them and the mass, the illiterati. In the High Gothic, artists had gone to France, and the Gothic had become international. In the Renaissance, Italian patterns were exported everywhere, until France and Germany produced their own designers, who gave a national interpretation to foreign motifs.

Pattern books were of two kinds. The first taught the art of architecture, that is, the use of the three Greek orders, Doric, Ionian and Corinthian, and the two added by the Romans, the Tuscan and the Composite (ill. 17, drawing on p. XIX). Already Vitruvius endowed the Doric order with male, the Ionic with female characteristics. Doric, Ionic and Corinthian columns or pilasters are therefore often used on the same façade, one order on each storey (ills. 22, 90, 99). All five orders occur at Oxford, on the so-called Tower of the Five Orders, at the Bodleian Library (ill. 165). Ready-made designs were also available for cornices and whole entablatures. The frieze above the arcades on the

town hall of La Rochelle (ill. 142) is Doric, above the windows Corinthian.

All Renaissance books on architecture are based on *De Architectura*, written 23 B.C. by Vitruvius. The first printed edition in Latin was published in Strasbourg 1543, the first in German five years later, also in Strasbourg, by the

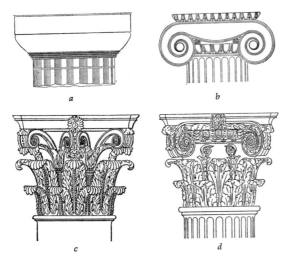

The changing forms of the capital: a) Doric, from the Theseion; b) Ionic, from the Propylaea; c) Corinthian acanthus capital; d) Roman composite capital.

Humanist Walter Rivios, under the title *Vitruvius Teutsch*. One of the greatest theoreticians was Sebastiano Serlio (1475–1552), whose book on architecture had a profound influence in France and Germany, where Hans Blum, basing himself on Serlio, brought out another book on orders, first in Latin, in 1550, then, five years later, in German.

The other type of pattern book at first supplied designs for jewellery. Later works are concerned with 'Classic' detail of every kind, particularly vases, putti and the acanthus leaf in many forms. All these motifs are found throughout Antiquity and the Renaissance, particularly on pilasters (ills. 28, 66, 127).

The first Mannerist ornament was Moorish. The Arabs had been the first to use plant motifs, albeit in a formalised version of their own, since Greek Antiquity. Mannerism, not bound by Nature, took up these forms. They predominate in the marquetry ornament of one of the rooms at Schloss Gottorp, in Schleswig (ill. 153).

Mannerism craved for decoration of every kind. Chimney stacks were wreathed in spirals, or capped (ills. 74/75, 77). The obelisk, in Egypt and Babylon a monument, is now used like a Gothic finial (ill. 114), often on gables (ills. 122, 140, 146, 148), to emphasise upward movement. One of the most important forms is the cartouche. The Italian School of Fontainebleau first used strapwork frames (ill. 126), as Mannerist as the supporting figures, usually S-shaped, with elongated bodies and small heads, or Goujon's nymphs (ill. 71). The coat-of-arms of the Dukes of Württemberg,

above the entrance front, on the palace at Tübingen (ill. 135), is framed by a circle, whose outline develops into a riot of strapwork. Strapwork, the most characteristic ornament of Mannerism, has no longer any connection with natural forms. Dentils, originally part of the cornice were much beloved by Mannerist architects, so much so that the façade at the Palazzo dei Diamanti, at Ferrare (ill. 150), is completely covered by them. At the town hall at Hannoversch-Münden (ill. 140), where the cartouche round the coat-of-arms engulfs the entire doorway, the dentils along the curve of the arch are like faceted precious stones.

At Bückeburg (ill. 159), the cartouche on the door radiates rather than encloses. Its movement is taken up and passed on by the figures of Mars and Venus. The eye can hardly distinguish anything amidst the confusion of ornament and sculpture. The mass of small detail, the mysterious play of light and shade, are typically German. Most of the forms are based on engraved designs by Wendel Dietterlin. The altar, at the castle chapel, Bückeburg (ill. 157), shows similar tendencies. Here, tasselled draperies have been carved in wood above the niches. The work was commissioned by the art-loving Count Ernst von Schaumburg-Lippe, and was obviously carried out by some of the leading woodcarvers of the day. Their names, unfortunately, have not been recorded.

In Germany and Flanders, strapwork was often used on gables. At the Leibnizhaus, in Hanover (ill. 149), it fills in right angles; in the Essighaus at Bremen (ill. 148), only the columns on the façade can contain it.

The interiors of town halls and palaces are amongst the most elaborate examples of sixteenth-century architecture. Here, too, Fontainebleau (ills. 130, 131) led. The ceiling in ill. 128 displays the fleur-de-lys of the Bourbons, surrounding a rosette, framed by a profusion of Classic motifs. At Heiligenberg Castle (ill. 129), the ceiling of the Knights' Hall is divided into a number of fields, separated by metal mounts and covered with grotesques, cartouches and plant forms.

The ceiling of the castle at Jever, in Oldenburg (ill. 133), is lake a compendium of sixteenth century ornament. The two main portions, framed by the favourite egg-and-dart motif, display cartouches, with figures radiating towards the corners. Germanic plaitwork, originally used to ward off evil, here serves as mere decoration. Ills. 141, 152, 153, 159 show what splendour the homes of guilds and patrician families could attain, never more so, perhaps, than in the Goldene Saal – the Golden Hall – at the Augsburg Rathaus (ills. 178/179). The room extends through three storeys and has two large and four smaller doors. There is a wealth of allegoric figures, of paintings and cartouches. The panelling has been covered with gilt and coloured stucco work. This splendid hall was meant to compete with the Doge's Palace in Venice, to which Augsburg was closely linked by trade. But all these Mannerist forms, cartouche, grotesque and strapwork – the products of phantasy rather than copies of nature – had eventually to give way to the naturalism of the Baroque.

THE ENGLISH COUNTRY HOUSE (ills. 120, 121, 162–164, 166, above, 167, 169, 175). In England, the most important type of building, the most formative element in the architecture of the sixteenth century, was the manor house. Tudor architecture is a national variant of Mannerism. One of its earliest examples is Hengrave Hall, in Suffolk (ills. 120, 121). It was built to the design of John Sparke before 1530, and replaces an earlier moated house, which had been sold in 1521 by the Duke of Buckingham to the newly ennobled cloth merchant Thomas Kytson. The hall faces the enclosed courtyard. The two pillars, without any function, the elaborate oriel window its wealth of putti around the coat-of-arms against the otherwise plain wall, the Gothic finials, the abundance of chimney stacks far beyond actual need, and the crocketed domes on the turrets are all characteristic of Mannerism. Nor is the use of two different materials – rubble and stone-coloured brick – in the Classic tradition. Hardwick Hall (ill. 169, below), built c. 1590, is a rectangular block with projecting bays. One of its most striking features is the large number of tall, mullioned windows.

Montacute House (163, below), perhaps the most outstanding building in this series of Elizabethan houses, was completed in 1601. The Mannerist tradition is evident in the tall three-quarter columns, which rise above the parapet, where they support heraldic figures.

Audley End, Essex (ills. 162, 169, above) was built 1603 to 1616. Its three wings are grouped symmetrically around two courtyards. The chimneys, lined up behind a parapet, and the turrets, are the only reminders of Mannerism.

Hatfield House, in Hertfordshire (ill. 164), begun 1608, is also built on an E-shaped plan. The pilasters, balanced on tall plinths, the balustrade and the turrets are typically Mannerist.

Kirby Hall, Northamptonshire (ill. 166, above), built by Thomas Thorpe 1570–75, combines Mannerist chimneys with a Palladian colossal order. At Cobham Hall, Kent (ill. 167), the horizontal line of the roof, no longer visible from below, is dramatically broken by the porch, in which all the ornament of the otherwise plain façade is concentrated. Cobham Hall already has many Italian features, and Inigo Jones, in 1620, could place it into the centre of his new Palladian scheme without any transition. The Queen's House, Greenwich, almost his first building, was begun two years earlier (ill. 175). Mannerism had come to an end. The future belonged to the followers of Palladio.

INDEX OF NAMES AND PLACES

Roman numerals refer to the text, Arabic numerals to illustrations.

ALBERT VON SOEST 141

ALBERTI, Leon Battista VIII, IX, XVI,
14, 15, 17, 22, 23

AMBOISE-SUR-LOIRE, Château XII, 76

AMBRAS, Castle, the Spanish Room XIX, (above) 152

ANET, CHATEAU, main gate 124
chapel 125

ANGERS, Maison d'Adam 49

ANTWERP, Town hall XII, 117

–, guild houses XI, 45

AREZZO, Santa Maria delle Grazie, the narthex 17

ARRUDA, Francisco de 59

ASCHAFFENBURG, Castle XV, 172

AUDLEY END XX, 162, (above) 169

AUGSBURG, Fugger Chapel XI, XVI, 61

–, town hall XII, XIX
Golden Hall 178/179
façade (rear) 180

AUGUSTUSBURG, Castle church, interior XVII, 96

AZAY-LE-RIDEAU, Château XIII
courtyard 73
river front (below) 79

BAMBERG, Cathedral, Carving, from a choir-stall 32

BASLE, Spiesshof, façade 113

BATTAGIO, Giovanni (above) 27

BELEM, Monastery XI
nave 54
cloisters 55
watch tower (Tagus estuary) 59

BIARD, Pierre XVI, 123

BLOIS-SUR-LOIRE, Château XIII
staircase 67
fireplace 132

BOITACA, D. 54

BOURG-EN-BRESSE, Choir screen 56

BRADFORD-ON-AVON, The Hall
(Kingston House) (above) 163

BRAMANTE, Donato IX, 27, 28, 82, 84, 85

BREMEN, Essighaus XII, XIX, 148

–, The Schütting 168

BRUGES, "Ancienne Greffe" 115

BRUNELLESCHI, Filippo VII, VIII, 5, 6, 7, 9

BÜCKEBURG, Castle XIX
chapel, interior 157
Golden Room, detail 159

BÜCKEBURG, Stadtkirche XVII, 138, 139

BURGHLEY HOUSE 119

BURGOS, Cathedral,
the crossing, from below XI, 81

CANTERBURY, Christ Church, Gateway 43

CAPUA, head of Jupiter VII, 2

CASTEL DEL MONTE, portal VII, 3

CASTAGNO, Andrea del VII, 1

CASTILHO, Joao de 54, 55

CERTOSA DI PAVIA, Carthusian church façade 31

CHAMBORD-SUR-LOIRE, Château XIII, XIX, 74/75

CHEMNITZ, Castle church, north portal 52

CHENONCEAUX, Château XIV, 78

COBHAM HALL XX, 167

COLOGNE, town hall XII, 161

COVENTRY, Ford's Hospital 48

CREMA, Santa Maria della Croce (above) 27

DANZIG, Marienkirche, ceiling X, 38

–, Rathaus, council chamber 158

DELORME, Philibert 124, 130, 164, 167

DONATELLO VII, 10, 13, 18

EBERT, the Younger 157

ECKE XIV, 155

ECKL, Wilhelm 110

ESCORIAL XV, XVII
bird's eye view (above) 173
monastery church 177
south front 174

ESSLINGEN, town hall, vestibule 62

FERRARA, Palazzo dei Diamanti XIX, 150

FLORENCE, Baptistery VII, 4

–, Biblioteca Laurenziana, interior XVI, 91

–, Cathedral, the dome VII, 5

–, Foundling Hospital (Ospedale dei Innocenti) VII, 6

–, Museo Nazionale, Donatello's S. George 18

–, Museo di S. Apollonia, Pippo Spano (fresco) VII, 1

–, Palazzo Pitti VIII, IX, 23

–, Palazzo Medici-Riccardi IX, 24

–, Palazzo Rucellai VIII, IX, XVIII, 22

–, Palazzo Strozzi IX, 25

–, Pazzi Chapel, interior VIII, 9

–, Santa Croce
Annunciation 10

FLORENCE, San Lorenzo
 interior VII, VIII, 7
 new sacristy XV, 88, 89
–, San Miniato, the tomb of Cardinal Jacopo di Portugal 12
–, Uffizi, courtyard 104
FLORIS, Cornelis XII, 117
FONDUTI DA PADOVA, Agostino dei 28
FONTAINEBLEAU, Château XIII, XIX
 Gallery of Francis I (above) 130
 Hall of Henry II (below) 130
 courtyard 131
 panelled ceiling 128
 interior, detail 126
FONTAINE-HENRY, Château XIV, (above) 79
FRANKFURT, "Steinernes Haus" 21
FREDERIKSBORG, Castle XV
 façade 137
 main entrance 134
GERHARD VON LEYDEN, Nikolaus 37
GHENT, Guild houses XI, 44
GLASTONBURY, The George Inn 118
GOUDA, town hall XII, XIX, 114
GOUJON, Jean XIII, 71
GRANADA, Alhambra, courtyard XV, 98
GRAZ, Landhaus, cortile XV, 112
GREENWICH, The Queen's House XX, 175
GUAS, Juan 53
HAARLEM, Butchers' Guild Hall 171
HAMLIN-ON-THE-WESER,
 The Pied Piper's House 170
HANNOVERSCH-MÜNDEN, town hall XIX, 140
HANOVER, Leibnizhaus XII, XIX, 149
HARDWICK HALL XX, (below) 169
HATFIELD HOUSE XX, 164
HEIDELBERG, Castle, Ottheinrichsbau XIV, 69
HEILBRONN, St. Kilian's XI, 60
HEILIGENBERG, Castle, The Knights' Hall XIX, 129
HENGRAVE HALL XX, 120, 121
HERRERA, Juan de XV, XVII, 173
HILDESHEIM, The Butchers' Guild House XI, 46
HOLL, Elias XII, 178–180
HOLT, Thomas 165
JAEN, Cathedral, sacristy XVII, 97
JEVER, Castle, detail from the ceiling XIX, 133
JOHNSON, Bernard 162
JONES, Inigo XX, 175
KALMAR, Castle (below) 173
KEY, Lieven de 116, 171
KIRBY HALL XX, (above) 166
KREBS, Konrad 66

KULMBACH, Plassenburg, "Schöner Hof" XV, 65
LALIO, Domenico de 112
LEMGO/Lippe, Hexenbürgermeisterhaus 147
LESCOT, Pierre XIII, 68, 70
LIÈGE, Episcopal Palace, courtyard 143
LIPPI, Annibale 95
LISBON, Sao Vicente da Fora 176
LITTLE MORETON HALL 51
LOMBARDO, Pietro 94
LONDON, Middle Temple Hall, screen (below) 166
–, Westminster Abbey, Henry VII's Chapel X, 41, 42
LÜBECK, Annen Museum, St. John the Apostle 19
LUCIANO, called de Laurana 16
LÜNEBURG, town house (detail) 64
–, town hall, council chamber (detail) XIX, 141
LYMINGE, Robert 164
MACHUCA, Pedro XV, 98
MAIANO, Benedetto da IX, 11, 25
MANTUA, S. Andrea VIII, XVI, 14, 15
MICHELANGELO BUONAROTTI IX, XV,
 83–85, 88–91
MICHELOZZO DI BARTOLOMMEO 13, 24
MILAN, Santa Maria delle Grazie IX, (below) 27
 the apse 29
–, Santa Maria presso Satiro, sacristy X, XIX, 28
MILLER, Wolfgang XVII, 108, 109
MONTACUTE HOUSE XX, (below) 163
MONTEPULCIANO, town hall IX, 20
MUNICH, The Residence XIV
 Antiquarium 155
 Grottenhof 154
–, The Mint (courtyard) XV, 110
–, St. Michael's XVII, 108, 109
MÜNSTERMANN, Ludwig 156
NEEDHAM MARKET, Parish Church, ceiling 50
NEISSE, Weighing Office XIX, 146
NUREMBERG, Pellerhaus XV
 courtyard 145
 fireplace 144
OSNABRÜCK, Willmann House XI, 47
OXFORD, Bodleian Library,
 Tower of the Five Orders XVIII, 165
–, Christ Church, staircase X, 39
PALLADIO, Andrea XVII, 100–103
PALMANOVA, from the air 80
PARIS, Fontaine des Innocents XIII, XIX, 70, 71
–, Louvre XIII, 68
–, Saint Denis, tomb of Louis XII XIX, 127
–, Saint-Etienne-du-Mont XVI, XIX, 122, 123

PAVIA, Cathedral, plan — IX
PERUZZI, Baldassare — 99
PILGRIM, Anton — 34
PONZANI, Antonio — 154, 155
PORTA, Giacomo della — XVI, 106
PRAGUE, Castle, interior — 35
PRATO, Cathedral, outside pulpit — 13
–, Santa Maria delle Carceri, façade — 8
PRIMATICCIO, Francesco — XIII, 130
RAPHAEL (Raffaelo Santi) — 92–93
REGENSBURG, "Schöne Maria" — XI
RIDINGER, Georg — XV, 172
RIETH, Benedikt (Benesch von Laun) — 35
RIGNY-USSÉ-SUR-LOIRE, Château — XIV, XIX, 77
RIMINI, San Francesco (Tempio Malatestiano), detail — XVIII, 17
LA ROCHELLE, town hall, courtyard — XIX, 142
ROME, Il Gesù — XVI, 106, 107
–, Palazzo Farnese — IX, XVI, XVIII, 90
–, Palazzo Massimo alle Colonne — IX, XVIII, 99
–, San Pietro in Montorio, Tempietto — X, XVI, 82
–, St. Peter's — X, XV, XVI, 83–85
–, Vatican, Stanza della Segnature, fresco — 92–93
–, Villa Medici, façade — 95
ROSSELINO, Antonio — 12
ROSSI, Rosso — XIII, 126, 130
ROTHENBURG-on-the-Tauber, town hall — XII, 136
S. THEGONNEC, Parish Church — 63
SAN GALLO, Antonio da — IX, XVI, 90
SANSOVINO, Jacopo — 105
SCAMOZZI, Vincenzo — 80
SCARMAZZI, V. — 111
SCHALLABURG, caryatids — XV, 151
SCHICKHARDT, Heinrich — 62
SCHLESWIG, Gottorp Castle, interior — XIX, 153
SCHWEINER VON WEINSBERG, Hans — XI, 60
SIMON VON KÖLN — 57
SPARKE, John — XX, 121
SPITTAL, Carinthia, Porcia Castle, cortile — XV, 111
STARGARD, town hall, façade — 33
STRASBOURG, Frauenhaus Museum, Nikolaus Gerhard von Leyden, self-portrait (?) — 37

SUSTRIS, Friedrich — XIV, XVII, 108, 109, 154
SYRLIN, Jörg, the Elder — VII, 36
TERZI, Filippo — 176
THORPE, Thomas — XX, (above) 166
TODI, Santa Maria della Consolazione — XVI, 86, 87
TOMAR, Convent Christi
 façade (detail) — XI, 58
 cloisters (Claustro de Joao III) — XII, XVII, 160
TORGAU, Hartenfels Castle — XII, XIX, 66
TÜBINGEN, Castle, portal — XIX, 135
ULM, Cathedral, portrait bust — VII, 36
URBINO, Castle, terrace — 16
VALDELVIRA, Pedro de — 97
VALLADOLID, San Gregorio, façade — 53
 Collegio de San Gregorio, courtyard — 57
VAREL, Oldenburg, Parish Church, High Altar (detail) — 156
VASARI, Giorgio — 104
VELTHURNS, Castle, the Princes' Chamber — XIX, (below) 152
VENICE, Library of St. Mark's — 105
–, Ca d'Oro — 40
–, Il Redentore — XVIII, 100
–, Palazzo Contarini — 26
–, Palazzo Vendramin-Calergi — 94
–, San Giorgio Maggiore — XVIII, 101
–, Scuola di San Rocco, façade — 30
VERNUIKEN, Wilhelm — XII, 161
VIART, Charles — 67
VICENZA, Villa Rotonda — XVIII, 102
–, Palazzo Chieregati — XVIII, (below) 103
–, Palazzo della Ragione (Basilica) — XVIII, (above) 103
VIENNA, St. Stephen's, organ base — 34
VIGNOLA, Giacomo — XVI, 107
VISCHER, Caspar — 65
VIVIANI, Antonio Maria — 155
WHITT, Giles de — 167
WISMAR, Fürstenhof — XIV, 72
WITTEN, Hans — 52
WOLF, Hans — 138, 157
WOLF, Jonas — 157
WOLFF, Jakob, the Elder — XII, 145

The new worldly Renaissance type is shown in this portrait. Pippo Spano, a Florentine condottiere. Fresco (c. 1450) by Andrea del Castagno. *Florence*, S. Apollonia Museum.

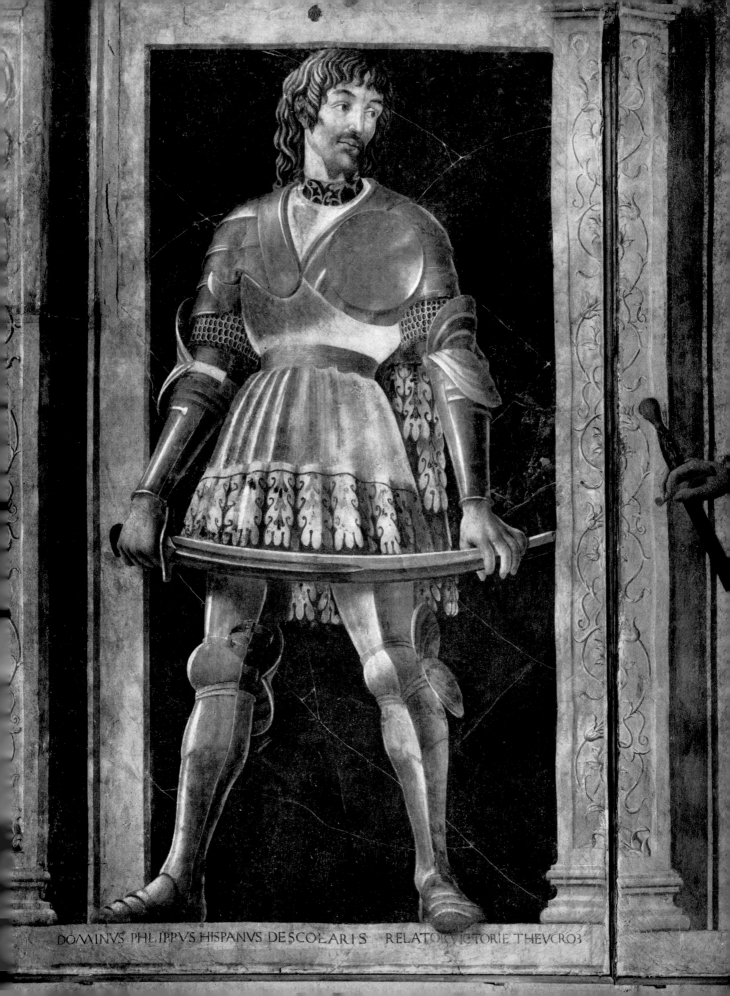

DOMINVS PHILIPPVS HISPANVS DESCOLARIS RELATOR VICTORIE THEVCRO3

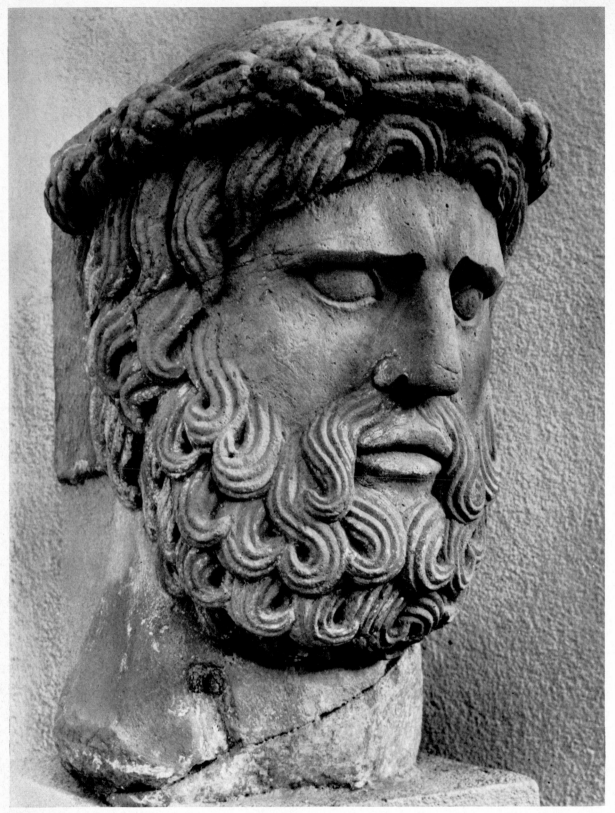

Aufsberg

Kerff

Capua. Der Jupiterkopf stammt von dem heute zerstörten Triumphtor,
das der Hohenstaufenkaiser Friedrich II.
1233–47 nach römischem Vorbild
über der Via Appia errichten ließ.

Capua. The Roman-style head of Jupiter comes from the triumphal gate
(now destroyed), erected 1233–47
by the Hohenstaufen emperor Frederick II
across the Appian Way.

Castel del Monte, Apulien. Lange Zeit vor Beginn der eigentlichen Renaissance:
Wiederaufnahme antiker Formen für Bauten des Kaisers.
Regelmäßig angelegt wie ein römisches Kastell, zeigt die Burg Friedrichs II.
am Portal Pilaster und Gesimse. (Um 1240.)

Castel del Monte, Apulia. Long before the beginning of the real Renaissance
classical forms came into use once more for the buildings of Frederick II.
The castle (c. 1240) with its pilasters and entablature on the portal
has the regular symmetrical design of a Roman fort.

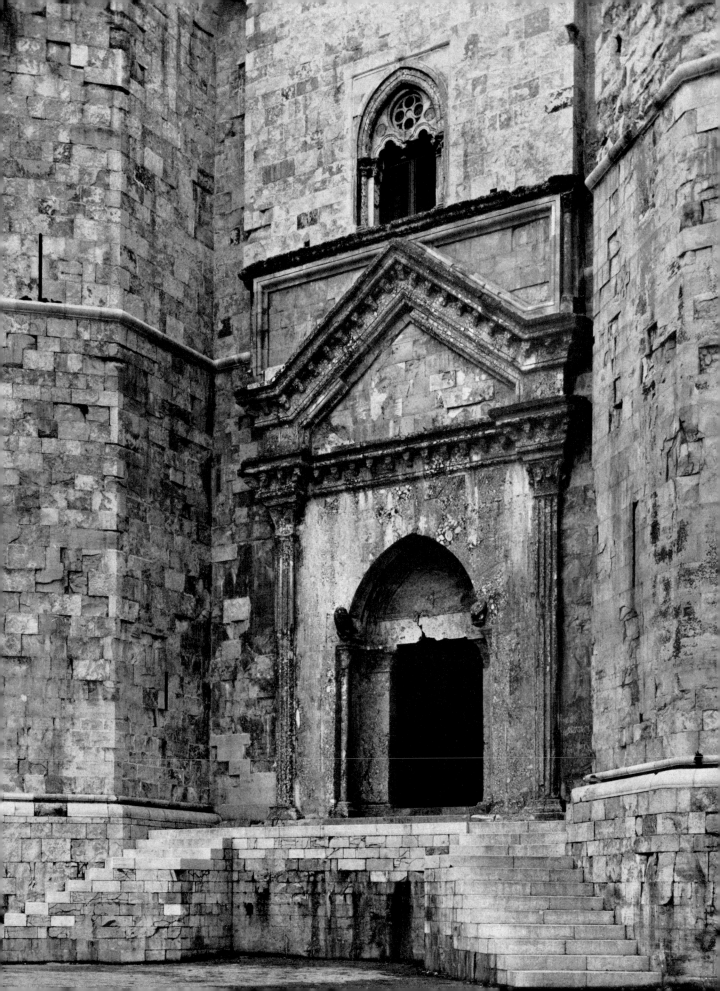

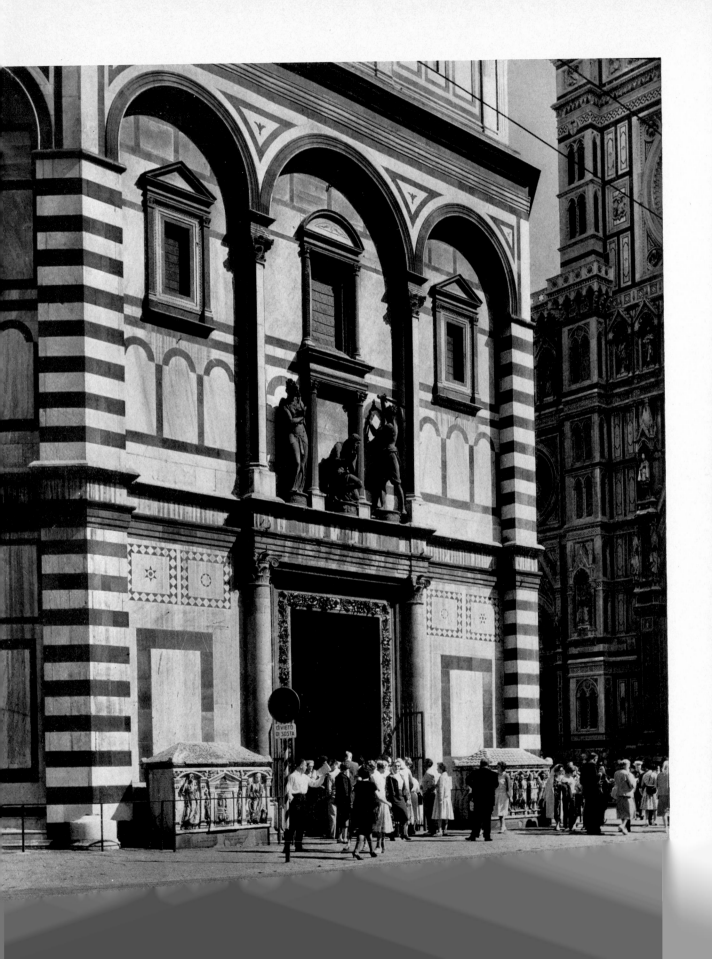

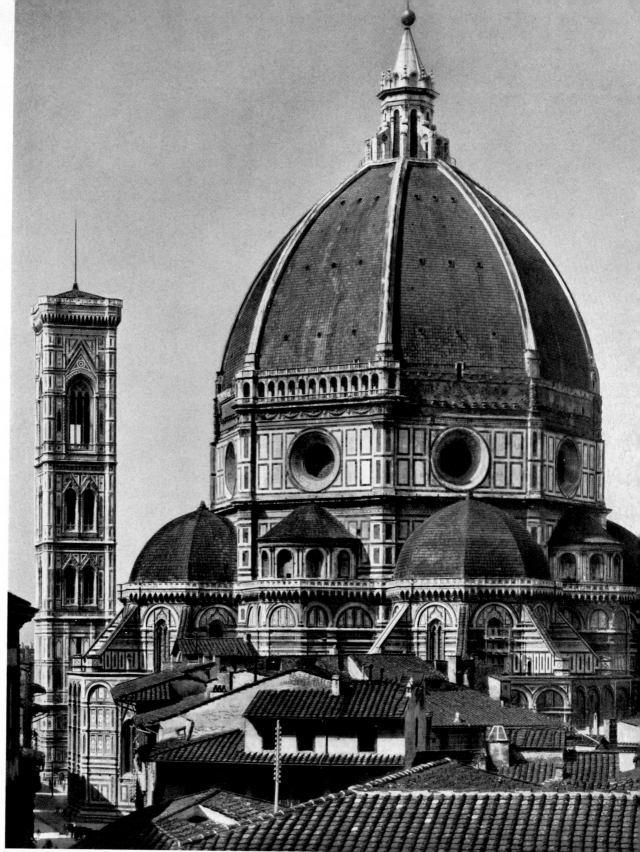

Alinari

Florenz. Das Baptisterium, aus der klassischen romanischen Zeit (um 1150), ist in seinen der Spätantike noch nahe verwandten Formen gleichzeitig ein Zeugnis der toskanischen Vor-Renaissance.

Florence. The Baptistery (c. 1150), of the classic Romanesque period, is at the same time, with its almost classical forms, an example of the Tuscan Proto-Renaissance.

Florenz. Die Domkuppel, von Brunelleschi 1419–36 in gotischer Rippenkonstruktion errichtet, zeigt Renaissancegesinnung in ihrer harmonisch ruhenden Majestät.

Florence. The cathedral cupola (1419–36), constructed with Gothic ribbing by Brunelleschi, shows Renaissance feeling.

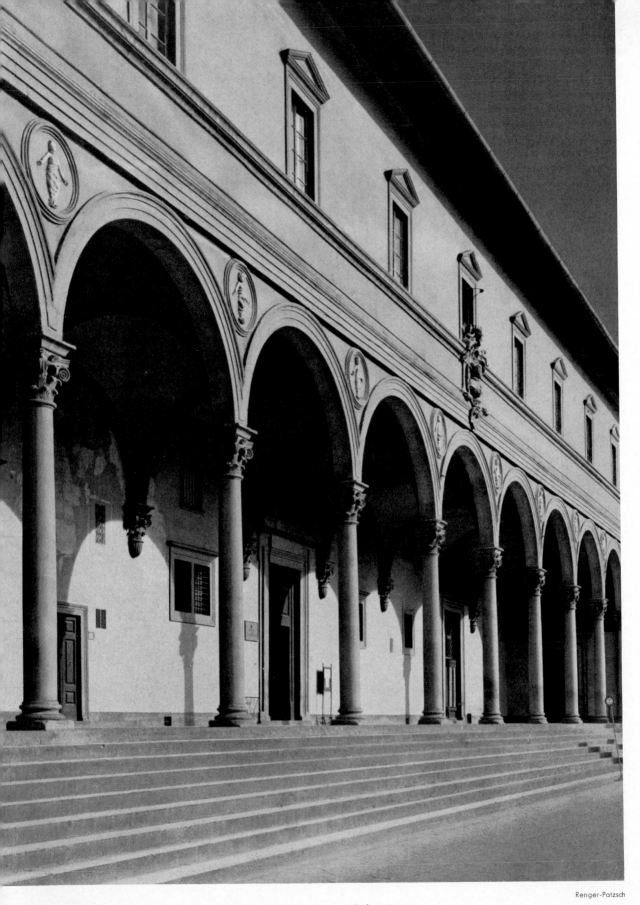

Renger-Patzsch

Florenz. Das Findelhaus (Brunelleschi, 1419–45) gilt als das erste Bauwerk reiner Frührenaissance
Antikische Loggia, breitgelagertes Gesims, rechteckige Fenster mit Dreiecksgiebeln.

Florence. The Foundling Hospital (Brunelleschi, 1419–45) is considered to be the first pure Early Renaissance structure.
Classical-style loggia, wide entablature, rectangular windows with triangular gables.

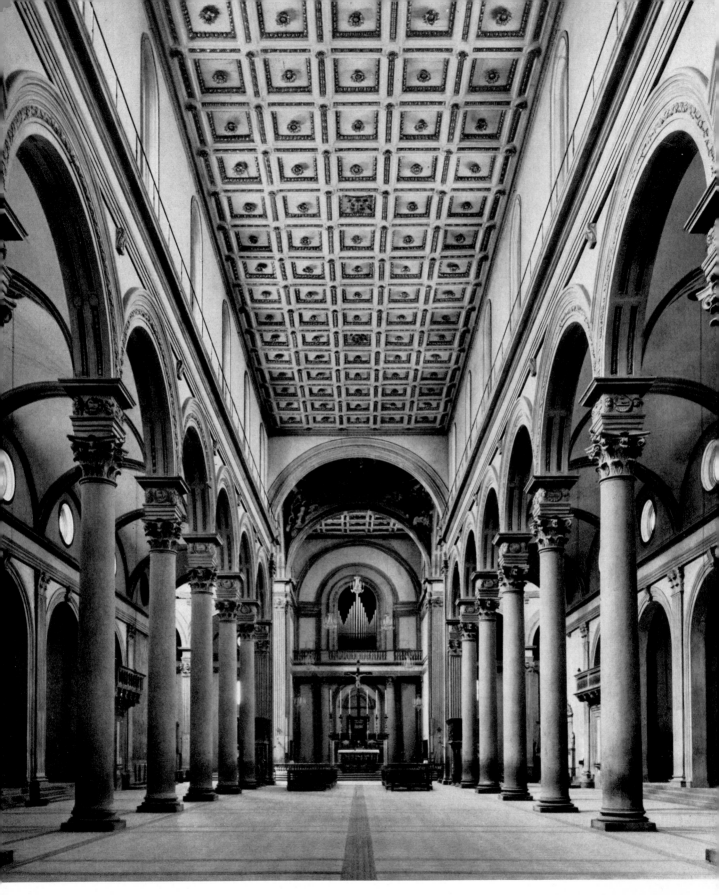

Florenz. Blick durch die Basilika S. Lorenzo, nach 1420 von Brunelleschi errichtet, der mit den korinthischen Arkaden
und der flachen Kassettendecke — unter Absage an die Gotik — auf die romanische Vor-Renaissance zurückgriff.

Florence. View of the basilica of S. Lorenzo (built post 1420, by Brunelleschi).
With its Corinthian arcades and flat panelled ceiling it shows a departure from the Gothic and a return to the Romanesque Proto-Renaissance.

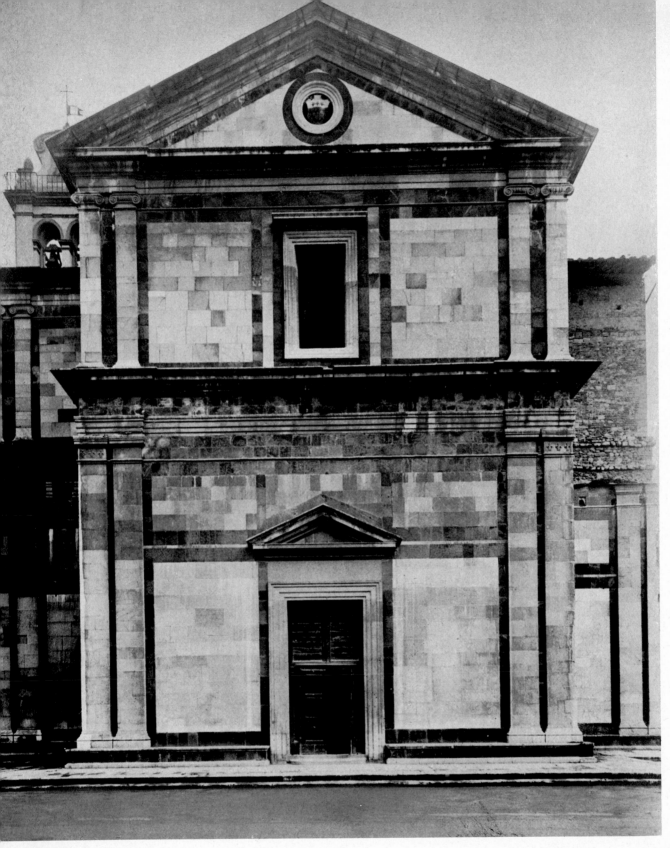

Prato, Toskana. Front der Kirche S. Maria delle Carceri (1485),
eines Zentralbaus auf griechischem Kreuz. Harmonie und Leichtigkeit
des Aufbaus, dazu schmuckarme Flächigkeit als Kennzeichen toskanischer Frührenaissance.

Prato, Tuscany. Façade of the central church of S. Maria delle Carceri (1485)
built on the plan of a Greek cross. Note the harmony and airiness
of structure and relatively plain surfaces — features of the
Tuscan Early Renaissance.

Florenz. Die Pazzi-Kapelle (Brunelleschi, 1429), ein Hauptwerk der Frührenaissance,
nimmt mit ihrer Kuppel über rechteckigem Grundriß
den Zentralbau der Hochrenaissance vorweg.

Florence. The Pazzi Chapel (Brunelleschi, 1429),
a major work of the Early Renaissance,
already anticipates the central plan of the
High Renaissance with its dome over a rectangular ground-plan.

8

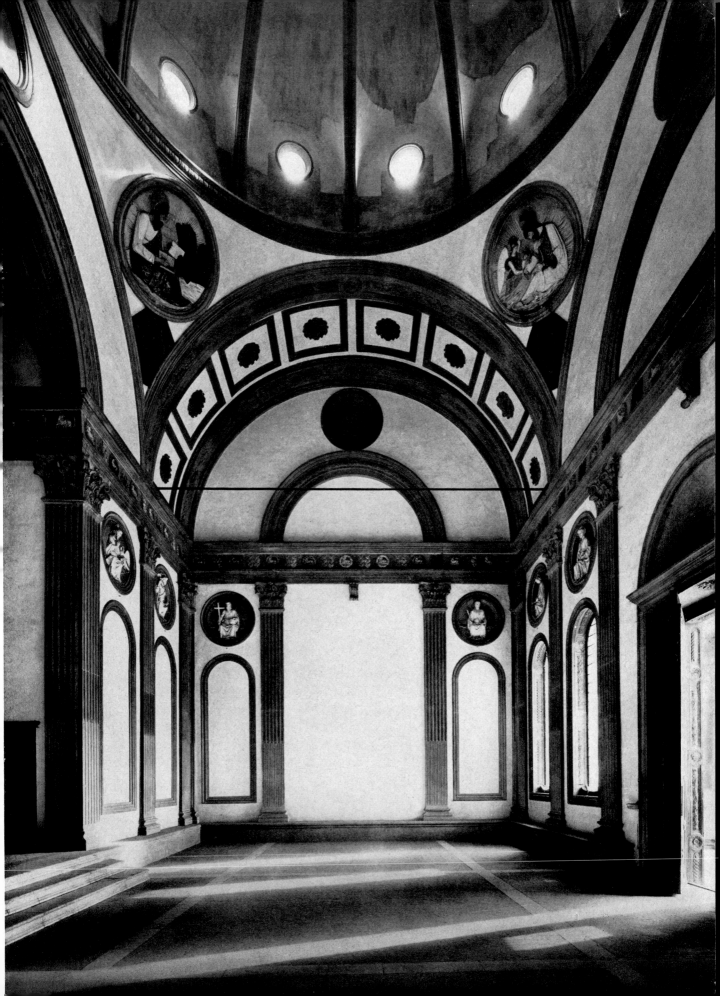

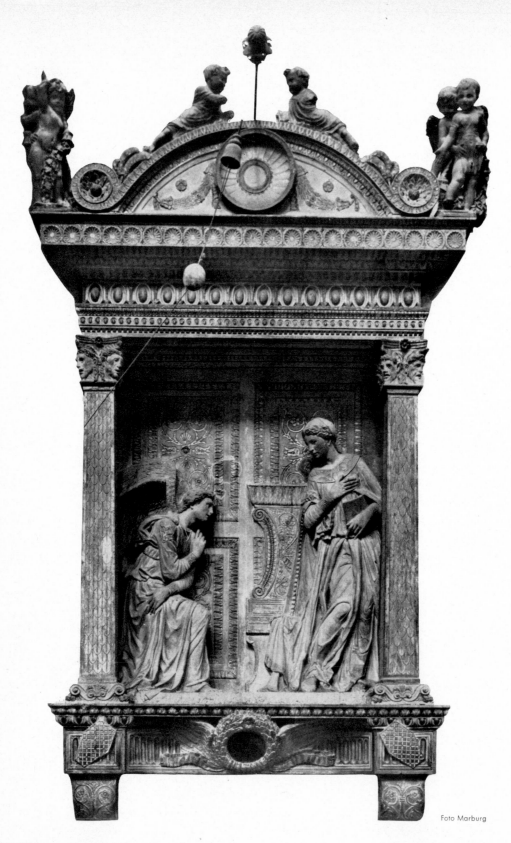

Foto Marburg

Jeiter

Florenz. Die Verkündung an Maria in S. Croce (Donatello, um 1435). In dem Tabernakel prunkt der Bildhauer mit der von ihm in Rom entdeckten antiken Ornamentik: Eierstäben, Rosetten und Blattwellen.

Florence. The Annunciation in S. Croce (Donatello, c. 1435). The lavish tabernacle sculptures were inspired by classical Roman motifs such as egg mouldings, rosettes and acanthus scrolls.

Arezzo, Toskana. Die Vorhalle von Santa Maria delle Grazie (Benedetto da Maiano). Die Säulen mit den aufgesetzten Kämpfern und das zart ornamentierte Gesims haben noch zu Ende des 15. Jh. die Grazie der Frührenaissance.

Arezzo, Tuscany. The narthex of Santa Maria delle Grazie (Benedetto da Maiano). As late as the end of the 15th century the columns, crowned with abutments and the delicate ornamentation of the entablature, have preserved the grace of the Early Renaissance.

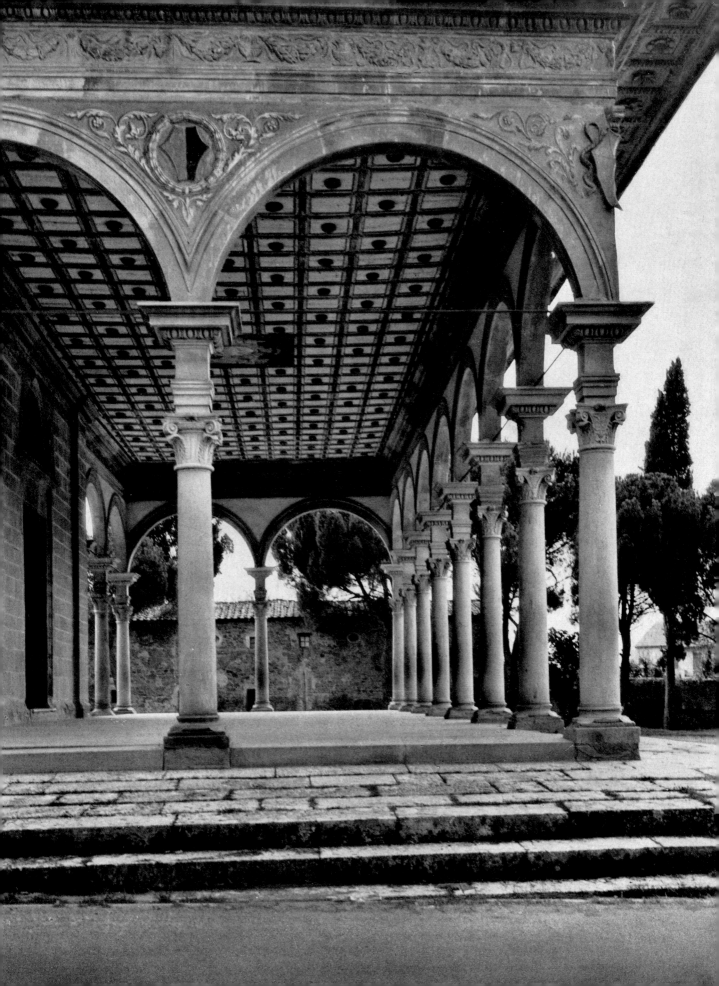

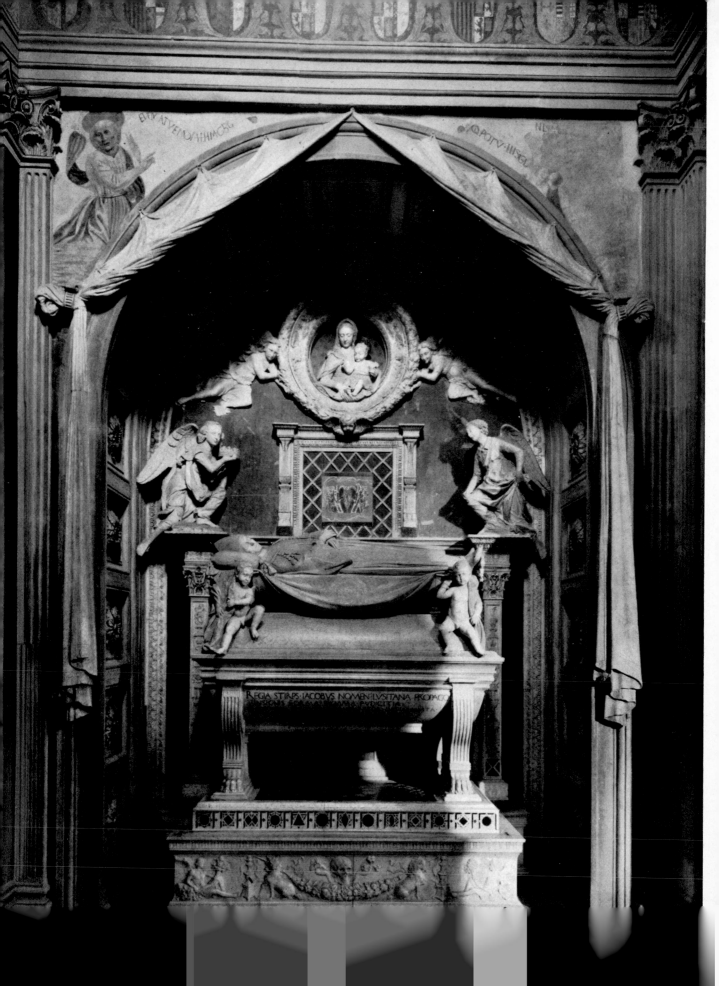

Zwei Hauptwerke der Architekturplastik im Zeitalter der Frührenaissance. Links: *Florenz*. San Miniato, Wandgrab des Kardinals Jacopo von Portugal
(Antonio Rossellino, 1466). Oben: *Prato*. Dom, Außenkanzel mit Puttenreigen, bestimmt für die Zurschaustellung einer Marien-Reliquie.
(1434–38, von Donatello gemeinsam mit Michelozzo.)

Two major works of sculpture in the Early Renaissance period. Left: *Florence*. San Miniato. Mural tomb of Cardinal Jacopo of Portugal
(Antonio Rossellino, 1466). Above: *Prato*. Cathedral. Outer pulpit decorated with symbolic child-figures.
(1434–38; Donatello in collaboration with Michelozzo.)

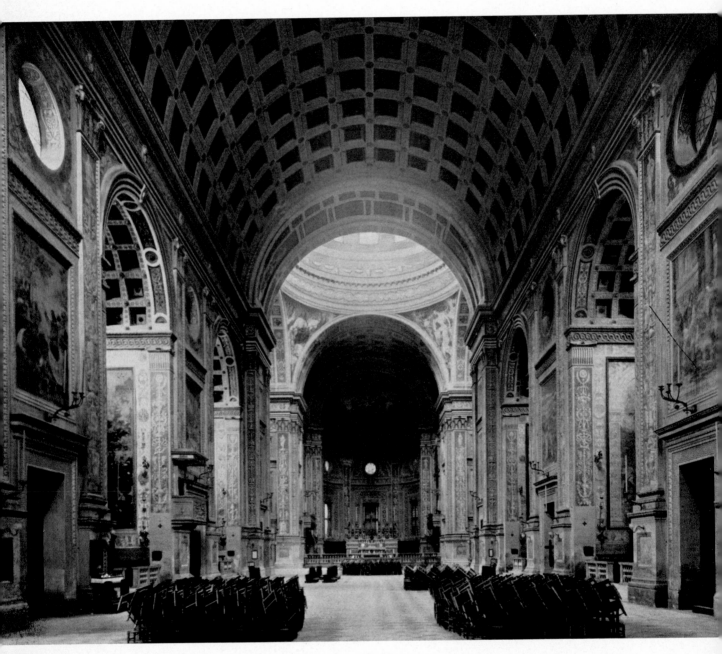

Mantua. Die Kirche S. Andrea, 1472 von Alberti begonnen, nimmt Hochrenaissance und Barock vorweg.
Sie bringt nach römischen Vorbildern die Verbindung eines einschiffigen, tonnenüberwölbten Langhauses mit einem Kuppelraum (oben).
Die Fassade (rechts) mit ihren durchgehenden Pilastern ist wie ein römischer Triumphbogen gebildet.

Mantua. S. Andrea, begun in 1472 by Alberti, an inspiration to the High Renaissance and Baroque.
Taking his model from Rome, the architect combined a single-aisled, rib-vaulted nave with a dome (above).
The façade (right) pierced by pilasters is in the form of a Roman triumphal arch.

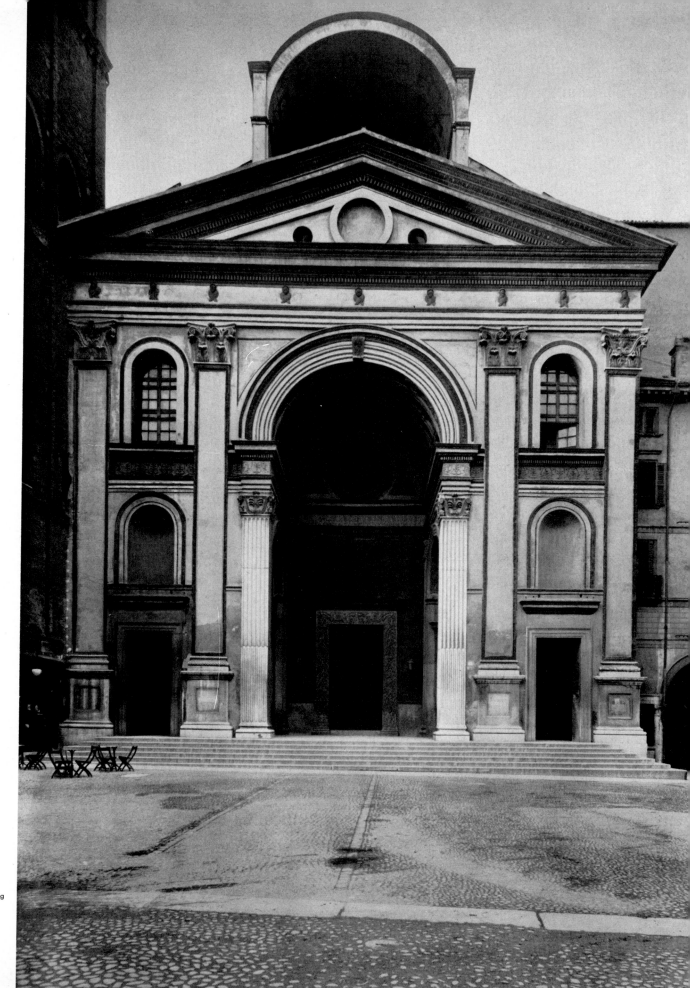

15

Alinari

Urbino, Mittelitalien. Kanellierte, d. h. geriefte Pilaster der Terrasse
am Herzoglichen Schloß, das Luciano (gen. de Laurana) um 1470 baute.
Der Mächtigkeit der Pilaster wegen hat man den Künstler als
„Vater der Hochrenaissance" bezeichnet.

Urbino, central Italy. Fluted pilasters
on the terrace of the ducal palace
built by Luciano (alias de Laurana) c. 1470.

Rimini, Mittelitalien. Antike Motive, souverän kombiniert.
Halbsäule und umkränzte Rundfenster an der Kirche S. Francesco,
die Sigismondo Malatesta nach 1445 durch L. B. Alberti
in den „Tempio Malatestiano" verwandeln ließ.

Rimini, central Italy. A supreme combination of classical motifs.
Half-columns and garlanded circular windows at the church of S. Francesco
transformed post 1445 by L. B. Alberti into the "Tempio Malatestiano".

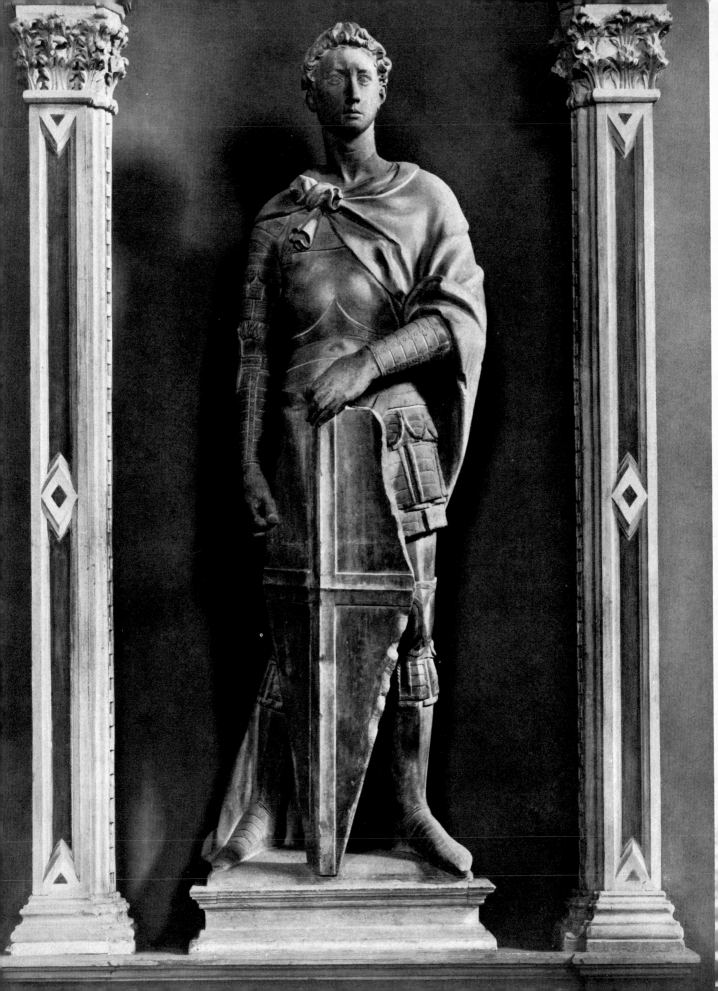

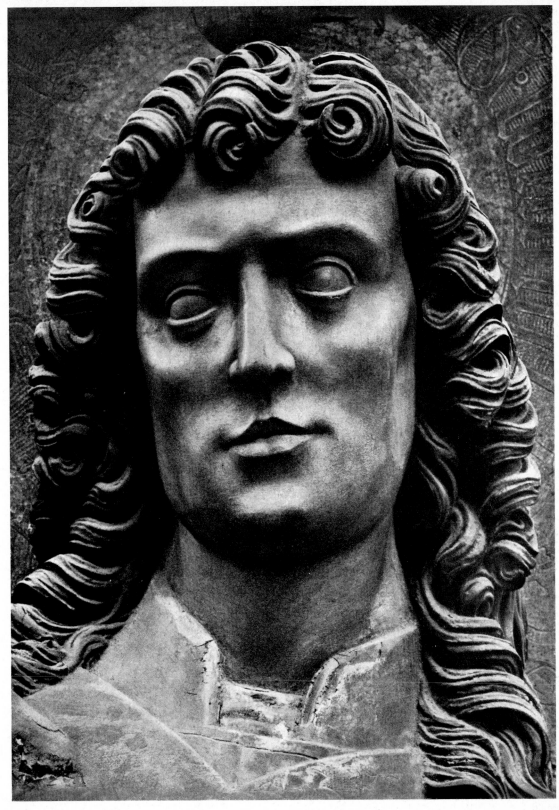

Castelli

lorenz. Museo Nazionale.
*Der hl. Georg des Donatello, um 1420.
*Der scharf beobachtende, nicht mehr Heiliges träumende Blick
*piegelt den Renaissance-Menschen.

lorence. Museo Nazionale.
*Donatello's St. George (c. 1420).

Lübeck. Annen-Museum. Der Evangelist Johannes (um 1510)
aus der Marienkirche zeigt die zu edler Harmonie beruhigte Klassik,
die auch im Norden, unabhängig von Italien, erwachsen ist.

Lübeck. Annen-Museum. The noble harmony of the classical line which
developed in the north independent of Italy is revealed in this sculpture
of St. John the Evangelist (c. 1510) from the Marienkirche.

Montepulciano, Mittelitalien. Das Rathaus (vor 1400), ein schlichter Block, abgeschlossen mit Wehrgang, Zinnenkranz und Turm, zeigt die Urform des Palazzo der Renaissance.

Montepulciano, central Italy. The town hall (pre 1400), a plain, compact block with battlements and tower, has in its form already the elements of the Renaissance Palazzo.

Frankfurt am Main. Das „Steinerne Haus" (1464), einer der damals noch seltenen Wohnbauten aus Stein.
Die ruhenden Flächen wie die waagerechten Fensterschlüsse und Gesimse zeigen den Norden auf einem selbständigen Weg zur Renaissance. (1944 zerstört.)

Frankfurt. The "Steinerne Haus", one of the rare stone examples of domestic architecture (1464). The calm dignity of the wall-surfaces,
the horizontal window-heads and sills, and the entablature show that the north had an individual approach to the Renaissance. (Destroyed 1944.)

1

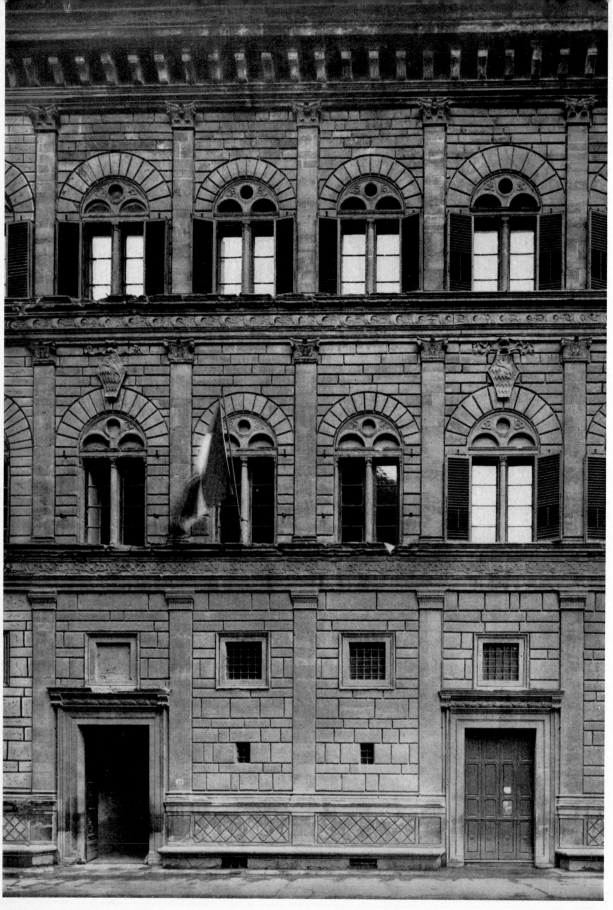

Florenz. Der Palazzo Ruccelai (Alberti, 1446) hat als erster Bau ein Kranzgesims als Abschluß, dazu über den geglätteten Quadern und den Querbändern eine senkrechte Gliederung durch Pilaster.

Florence. The Palazzo Ruccelai (Alberti, 1446), the first building to boast a great crowning cornice. Over the freestones and **the transoms** a vertical effect is obtained by the use of superimposed pilasters.

22

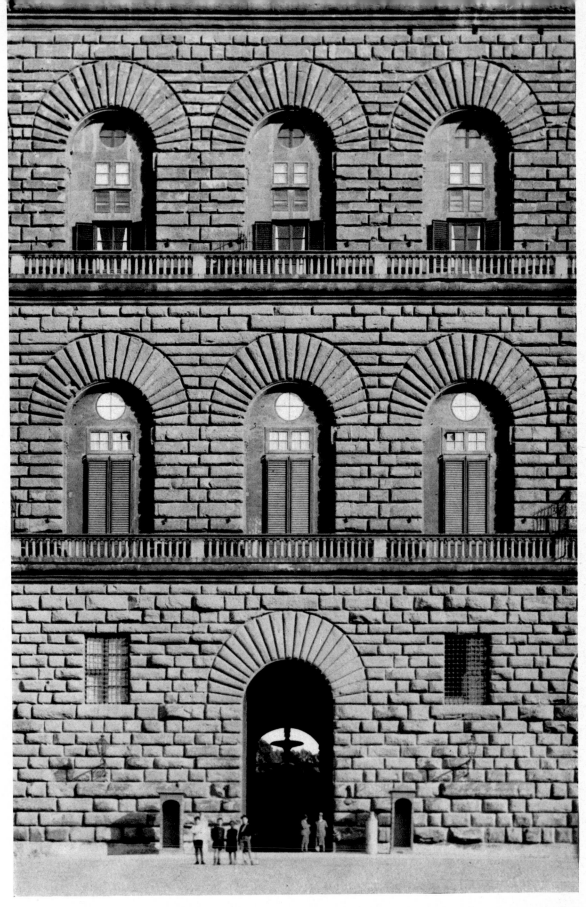

Florenz. Palazzo Pitti (nach 1460, Alberti zugeschrieben). Ursprünglich nur sieben Fensterachsen breit; 1550 stark verbreitert. Die mächtigen Fensterbögen und die Quarzit-Quadern geben ihm ein heroisches Antlitz.

Florence. Palazzo Pitti (post 1460, attributed to Alberti). Originally there were only seven windows across each storey but in 1550 the façade was considerably widened. The massive window arches and the quartz freestones lend it an heroic air.

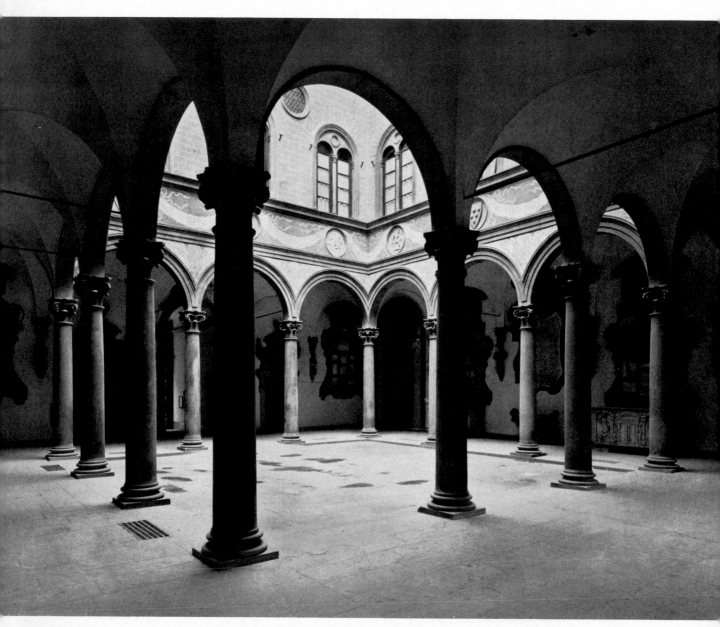

Florenz. Hof des Palazzo Medici-Riccardi, 1444 von Michelozzo für Cosimo de'Medici begonnen, 1657 an die Riccardi verkauft.
Der Arkadenhof, den die meisten Palazzi wiederholen, stammt von den Klosterhöfen ab.

Florence. Courtyard of the Palazzo Medici-Riccardi, begun by Michelozzo for Cosimo de'Medici in 1444, sold to the Riccardi family in 1657.
The cortile to be found in most Palazzi was inspired by monastic cloisters.

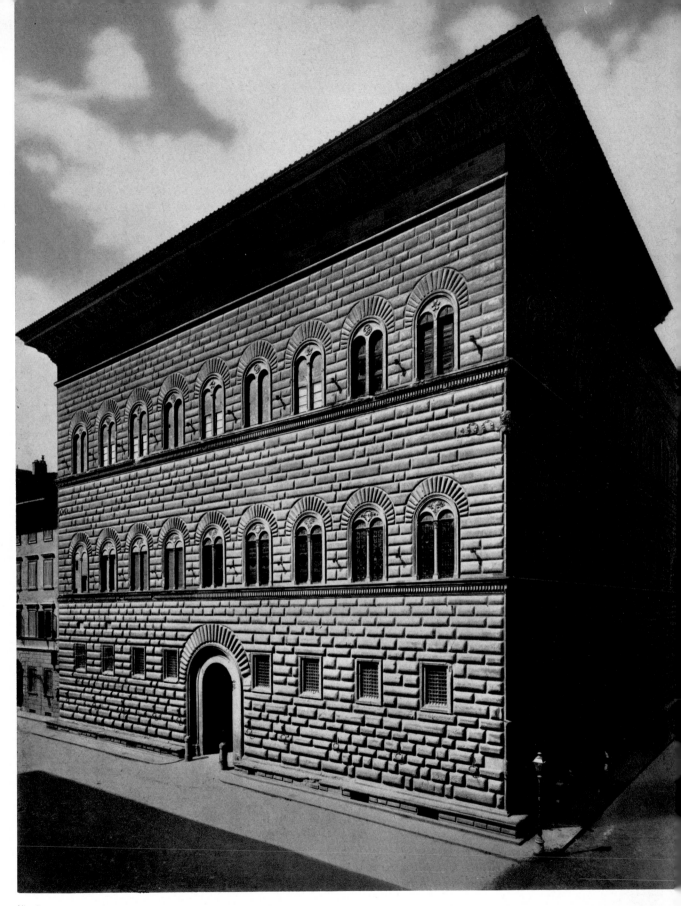

Florenz. Der Palazzo Strozzi (1489, wohl von Benedetto da Maiano). Nur durch die beiden Gurtgesimse
und das schattenfangende Kranzgesims gegliederter Block, ein Ur-Bau, der der Zukunft die Aufgabe der wieder reicher gliedernden Lockerung stellt.

Florence. The Palazzo Strozzi (1489, presumably by Benedetto da Maiano). With its two moulded string-courses and the shady crowning cornice,
it shows a new approach, though the task of achieving airiness through richer articulation is left to a future age.

Kerff

Venedig. Hofseite des Palazzo Contarini (1499). Der aus romanischer Tradition erwachsene Treppenturm und die Hausfront sind in ein venezianisch heiteres Spiel von Arkaden aufgelöst.

Venice. Courtyard of the Palazzo Contarini (1499). Arcades grace the façade and the spiral staircase in the Romanesque tradition.

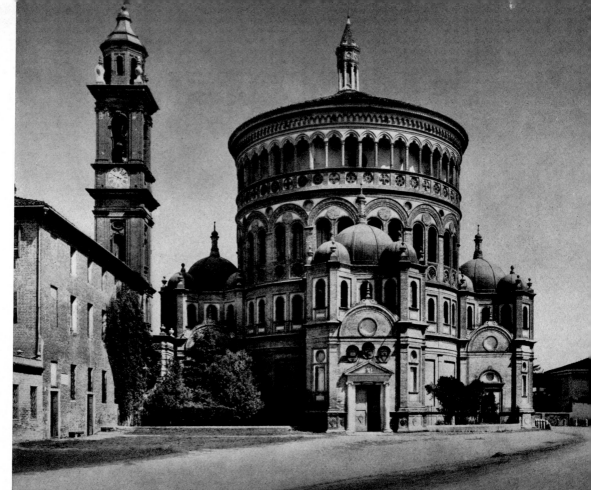

Crema, Lombardei.
S. Maria della Croce,
eine Wallfahrtskirche,
1490 im Sinne Bramantes
von Battagio begonnen.
Zentralbau aus
Backstein, außen rund,
innen achtseitig,
mit vier Anbauten.

Crema, Lombardy.
S. Maria della Croce,
a pilgrimage church,
begun by Battagio
in 1490 in the style
of Bramante. Central
plan executed in brick,
circular exterior,
octagonal interior,
with four additions.

Alinari

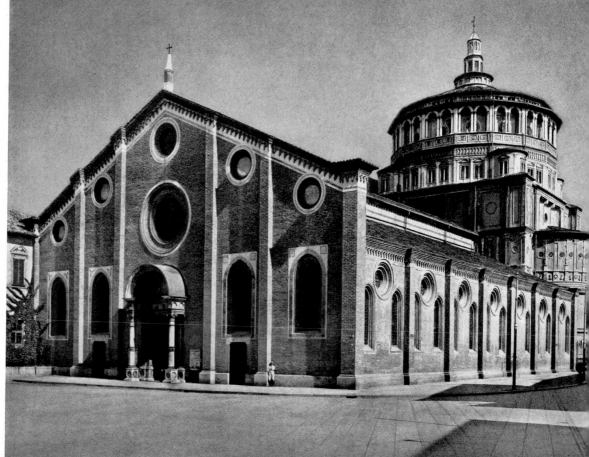

Mailand.
Dominikanerkirche
S. Maria delle Grazie.
Dem um 1470 noch
gotisch erbauten
Langhaus fügte
Bramante 1492–97 einen
Zentralbau an.

Milan. Dominican
church of S. Maria delle
Grazie. Central plan
church (1492–97) added
to Gothic nave (c. 1470)
by Bramante.

Alinari

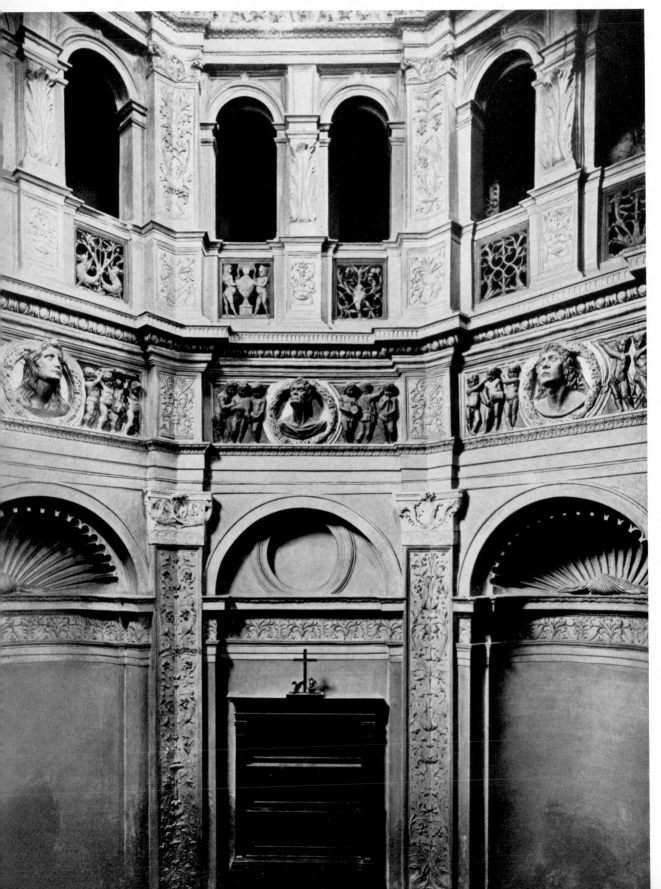

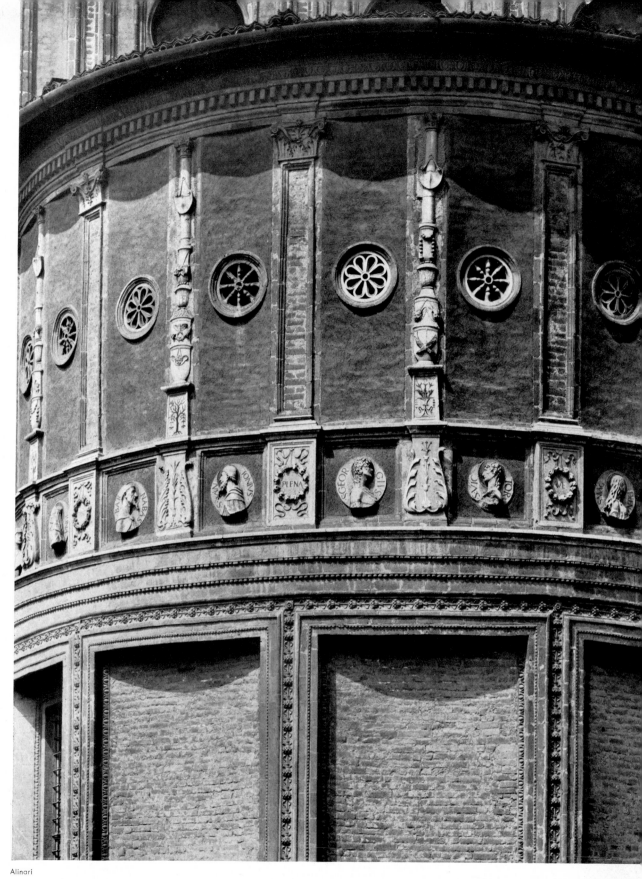

Mailand. Schmuckformen der lombardischen Renaissance, die stark auf den Norden eingewirkt haben.
Oben: Ost-Apsis von S. Maria delle Grazie (siehe S. 27 u.). Sockel mit Medaillons, Pilaster alternierend in Kandelaber übersetzt.
Links: Sakristei von S. Satiro (Bramante 1480–88). Fries mit Putten und Medaillons 1485 von Agostino dei Fonduti da Padova.

Milan. Ornamentation of the Lombard Renaissance which strongly influenced the north.
Above: eastern apse of S. Maria delle Grazie (cf. p. 27 bottom). Pedestal with medallions. Pilasters alternate with candelabras.
Left: sacristy of S. Satiro (Bramante, 1480–88). Frieze with symbolic child figures and medallions executed by Agostino dei Fonduti da Padova in 1485.

Jeiter

In Norditalien wirkt sich die Aufnahme des Antikischen vorwiegend im kleinförmigen Schmu
der die noch mittelalterlich erscheinenden Großformen überzieht. Links: *Venedig.* Scuola di San Rocco (15
Oben: *Certosa di Pavia.* Die Marmorfassade der Kartäuser-Klosterkirche (Ende d. 15. u. 16. Jh.), als Schauwand ausge

In North Italy, classical influences were to be found mostly in the field of ornamer
and architectural forms still preserved a medieval appearance. Left: *Venice.* Scuola di San Rocco (15
Above: *Certosa di Pavia.* The marble façade of the Carthusian conventual church, a remarkable fronti

Der harmonischen Geschlossenheit und „Richtungslosigkeit" der Renaissanceformen in Italien
entsprechen ähnliche Tendenzen in der Spätgotik des Nordens. Oben: *Bamberg.* Flächiges, in sich ruhendes Maßwerk vom Chorgestühl (vor 1400).
Rechts: *Stargard.* Abschwächung der vertikalen zugunsten der horizontalen Wirkung an der Giebelwand des Rathauses (Mitte 16. Jh.).

The harmonious compactness and "lack of direction" of Italian Renaissance forms is also to be found in northern Late Gothic.
Above: *Bamberg,* side-piece of a choir-stall (pre 1400). Right: *Stargard.* Weakening of vertical tendencies in favour
of the horizontal in the gable face of the town hall (mid-16th century).

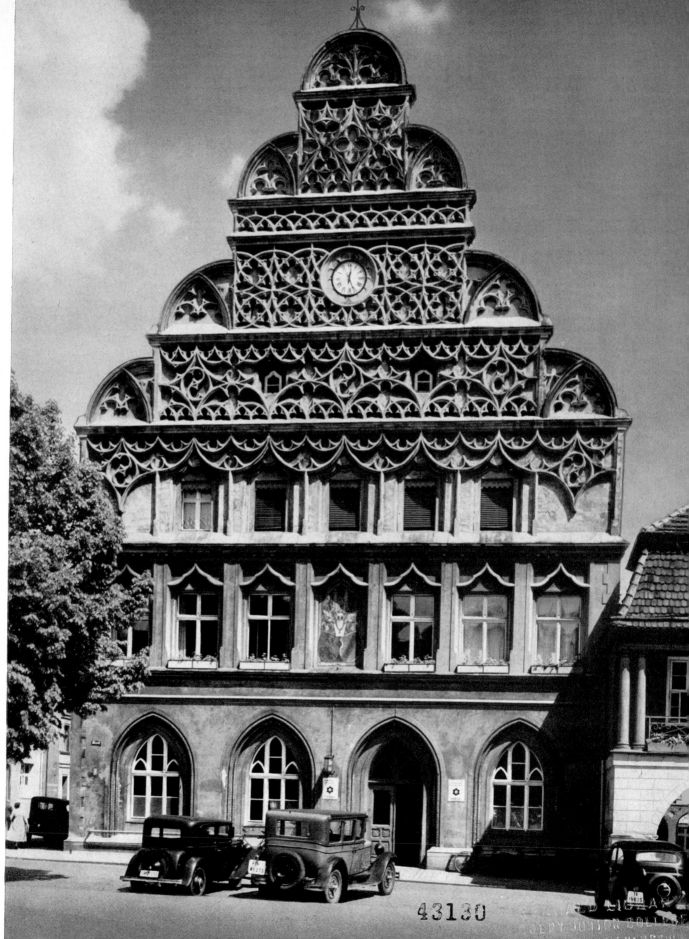

43130

Wien. Der Fuß (1513) der Orgel
in St. Stephan ruht auf verflochtenen
Hohlkehlrippen in Fischblasenform.
Als Selbstbildnis die Büste des
Meisters Anton Pilgram.

Vienna. The base (1513) of the organ
in St. Stephen's rests on
interwoven cavetto ribs.
The bust of the master Anton Pilgram
is a self-portrait.

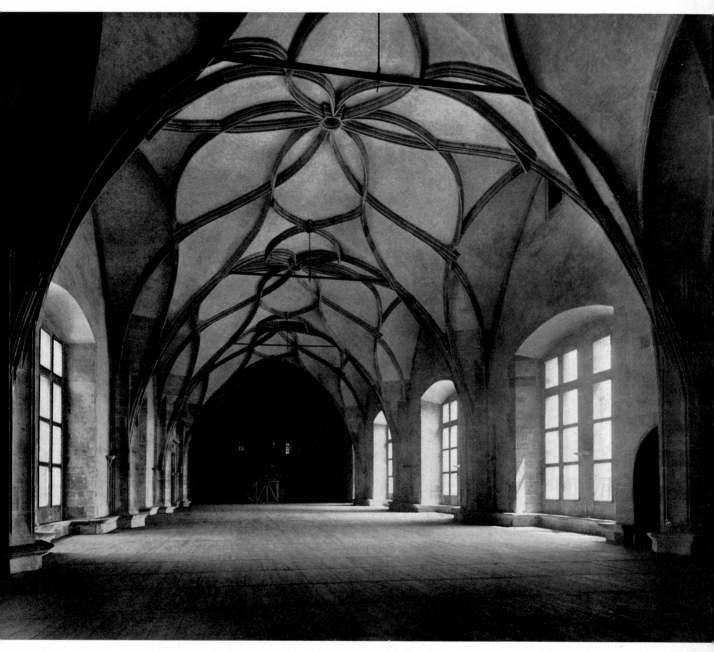

Prag. Der Wladislaw-Saal in der Burg (B. Rieth, 1484–1502), riesiger Krönungssaal der böhmischen Könige.
In der spätesten Gotik verlieren die Gewölberippen ihre gliedernde, tektonisch tragende Funktion und werden zu raumverbindenden Zierformen.

Prague. The huge Vladislav Hall in the castle (B. Rieth, 1484–1502), scene of the coronation of the Bohemian kings.
In the last phase of Late Gothic, rib-vaulting loses its architectural function and becomes a decorative form.

Das neue Menschenbild der Renaissancezeit — diesseitig, forschend, grüblerisch — auch im Norden.
Oben: *Ulm.* Der antike Philosoph Ptolemäus am Chorgestühl des Münsters. (Um 1470, Jörg Syrlin d. Ä.)
Rechts: *Straßburg.* Frauenhaus der Münsterbauhütte. Mutmaßliches Selbstbildnis (um 1470) des Bildhauers Nikolaus Gerhard von Leyden.

Above: *Ulm.* The ancient philosopher Ptolemy from a cathedral choir-stall (c. 1470, Jörg Syrlin Sr.).
Right: *Strasbourg.* Frauenhaus Museum. Probably a self-portrait (c. 1470) of the sculptor Nikolaus Gerhard of Leyden.

36

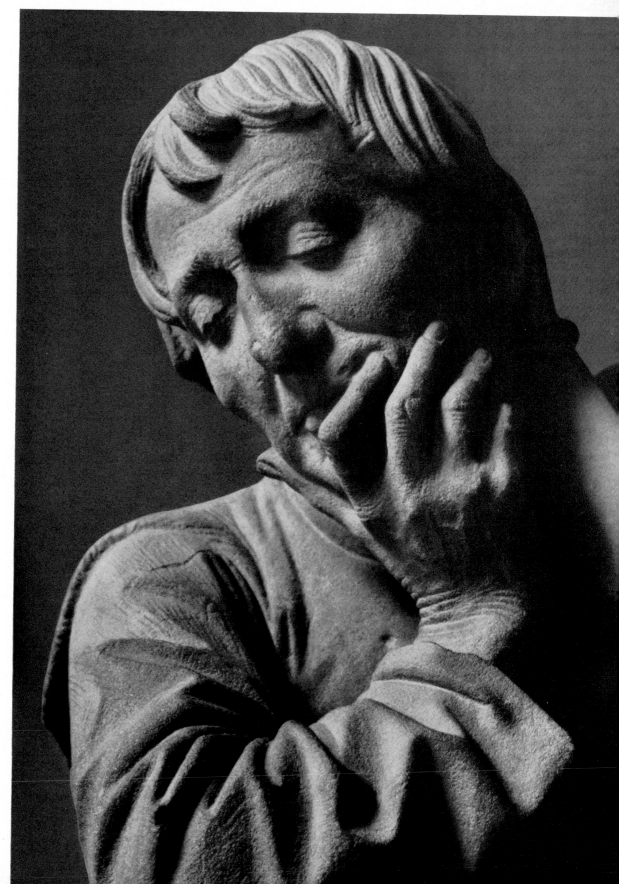

Kusch

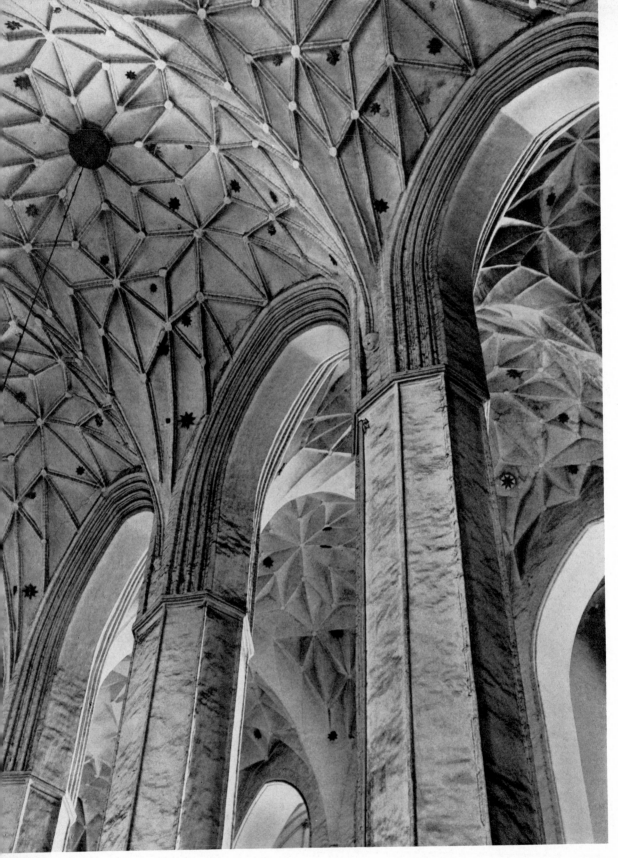

Danzig. Blick durch die Marienkirche.
Die Stern- und Zellengewölbe (1502)
vollenden das Wesen der Hallenkirche, deren Raum nicht gerichtet ist,
sondern richtungslos flutet.

Danzig. View of the Marienkirche. The star and cell-vaulting (1502)
complete the essence of the "hall church".

Oxford. Aufgang zur Halle von Christ Church. Das erst um 1635 geschaffene
Kelchgewölbe offenbart, in welchem Maße diese „spätgotischen" Formen
der Baugesinnung der Renaissancezeit entsprechen. (Treppe erst 1805)

Oxford. Staircase leading to the hall of Christ Church (founded in 1525).
Fan-vaulting on the central pillar (c. 1635):
a survival, or revival, of the original style. (Staircase 1805.)

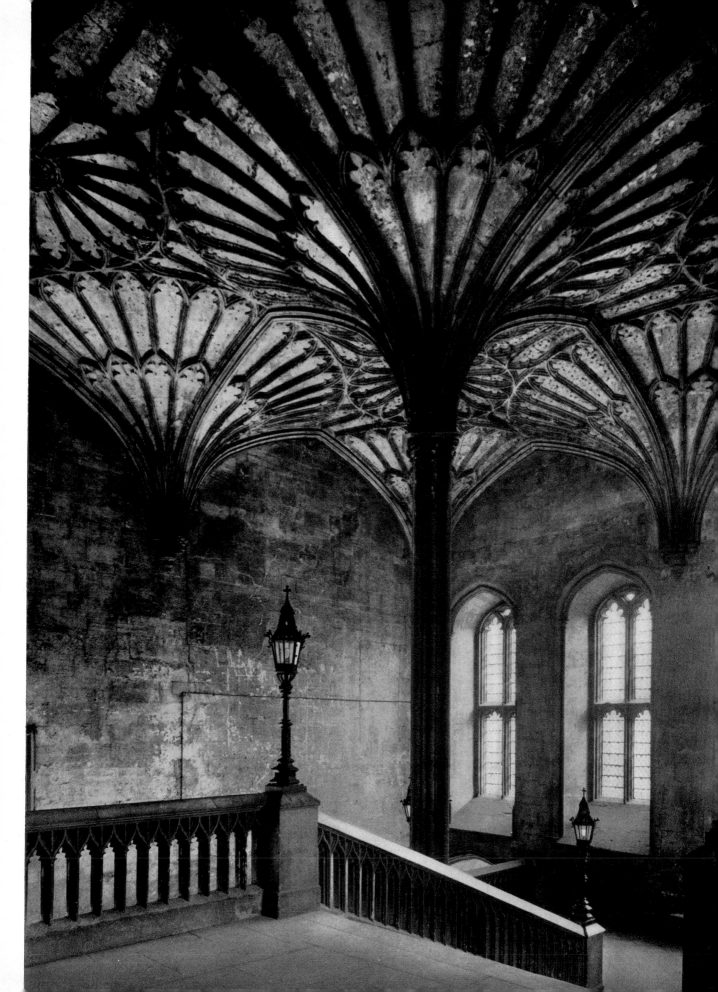

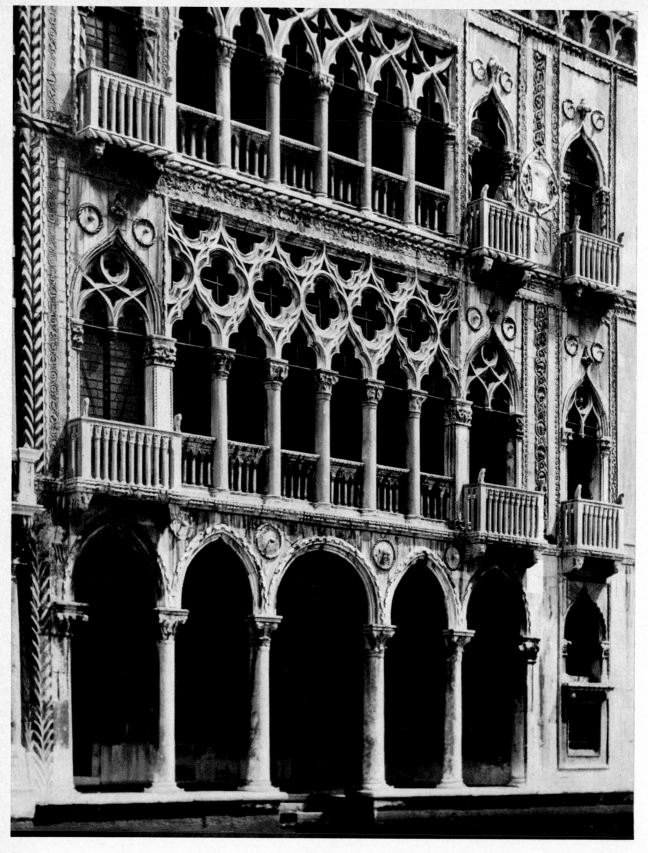

Kerff

Spätgotische Formen, die nur noch im Dienste flächiger Dekoration stehen. Oben: *Venedig*. Die Ca d'Oro (1421–40) am Canale Grande.
Rechts: *London*. Die gereihten Kelchgewölbe in der saalartigen Kapelle Heinrichs VII. (1503–19) stützen nicht mehr, sondern hängen herab.

Late Gothic forms, of decorative, no longer of structural importance. Above: *Venice*. The Ca d'Oro (1421–40) on the Grand Canal.
Right: *London*. The pendant fan vault in the hall-like Chapel of Henry VII (1503–19), no longer a support.
The Tomb of Henry VII (below) is the work of Pietro Torrigiani (1512–1518); the surrounding bronze grille by Laurence Imber.

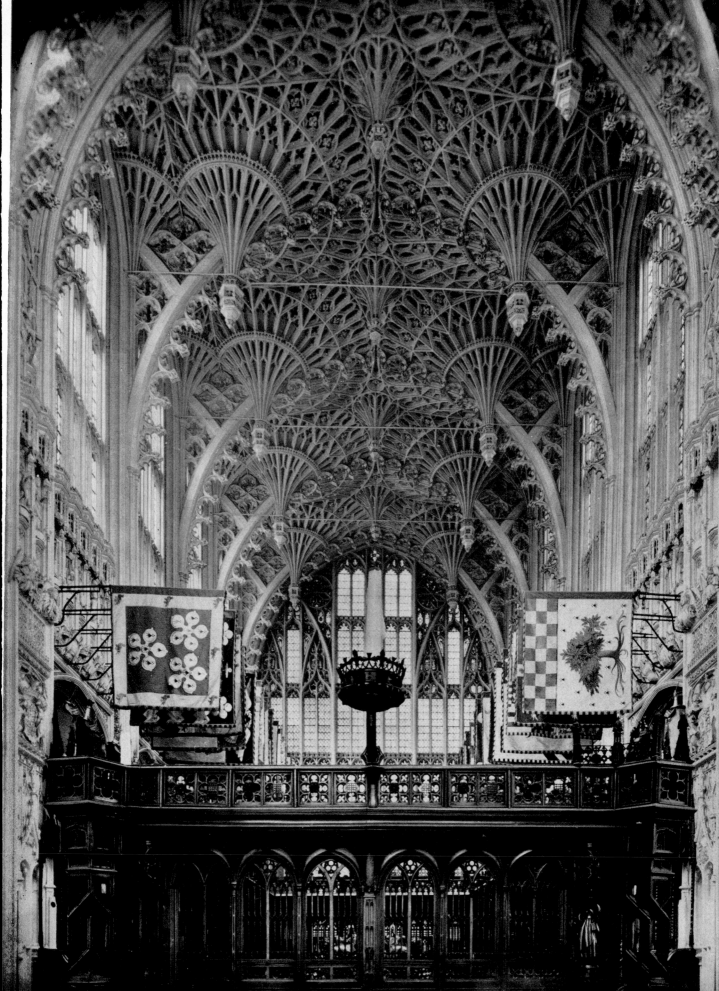

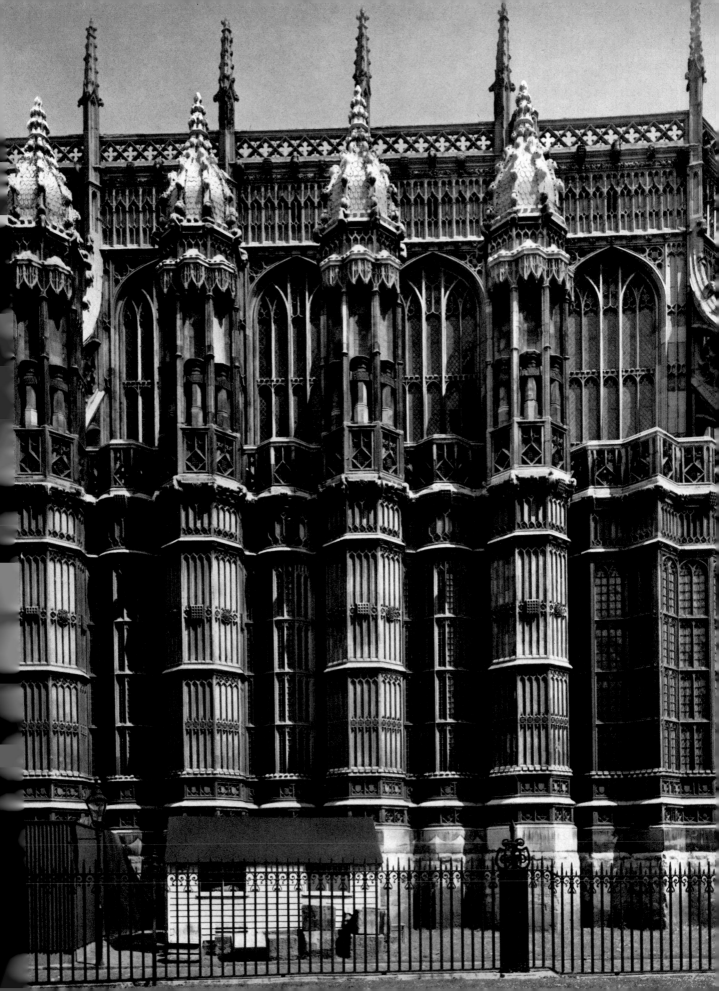

Kersting

Cash

Englische Baukunst zwischen Gotik und eigenständig wachsender Renaissance. Links: *London*, Kapelle Heinrichs VII. an der Westminster Abbey.
Die Strebepfeiler sind in Türmchen verwandelt, die in Kuppeln enden. Das enge Stabwerk hat raumschließenden Charakter.
Oben: *Canterbury*. Tor zur Christ Church (um 1500). Betonung der schließenden Wand und der waagerechten Bänder.
Dazu Rückgriff auf den Rundbogen – die Architektur einer Übergangszeit.

English architecture in the transitional stage between Late Gothic and genuine Renaissance.
Left: *London*. Buttresses of Henry VII's Chapel (1503–1519), Westminster Abbey.
Above: *Canterbury*. Gateway to Christ Church (c. 1500). A new emphasis on the horizontal, but also a return to the Norman arch.

Roubier

Der Bürgerbau im Norden
bleibt der aus dem Holzbau
überkommenen Grundform
— mit Steildach und Giebel —
verbunden.
Links: *Gent, Belgien.*
Häuser an der Graslei aus
den Jahren 1531, 1692,
um 1200 (v. r. n. l.).
Rechts: *Antwerpen.*
Zunfthäuser am Markt —
zwei (rechts) noch
spätgotisch (15. Jh.), die
anderen (16. Jh.) schon mit
rechteckigen Fenstern unter
manieristischen Giebeln.

In the north, domestic
architecture keeps closely to
the traditional form of the
timber house.
Left: *Ghent, Belgium.*
Houses on the Graslei
dating from 1531, 1692,
c. 1200 (right to left).
Right: *Antwerp.*
Guild houses in the
market-place, the two on
the right still Late Gothic
(15th century), the others
(16th century) with
rectangular windows beneath
Mannerist gables.

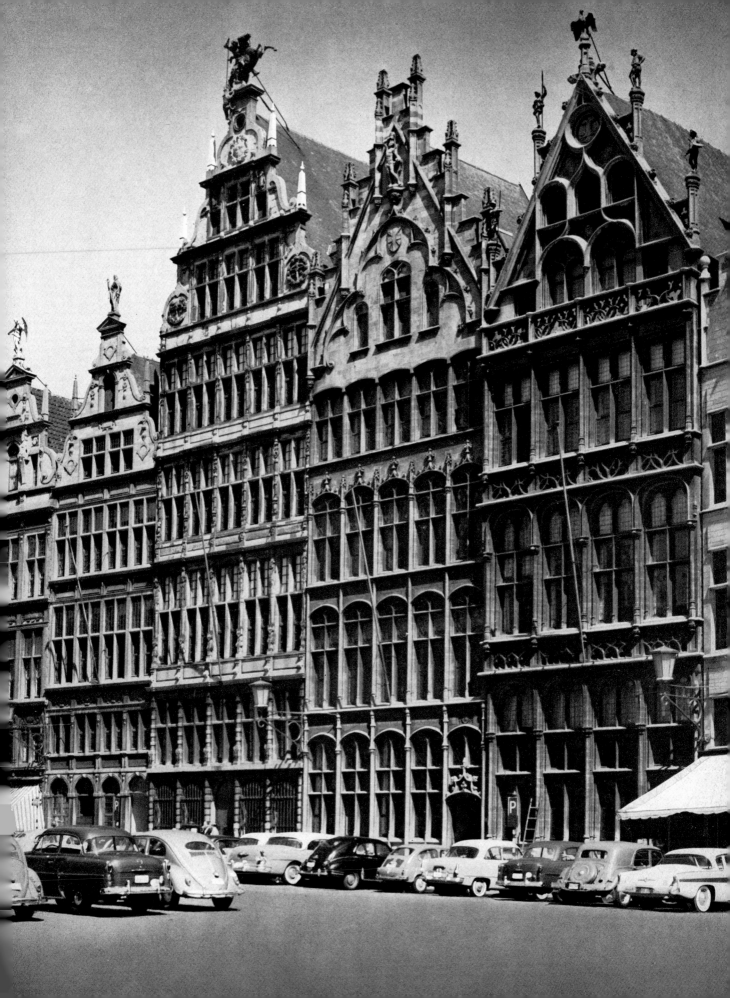

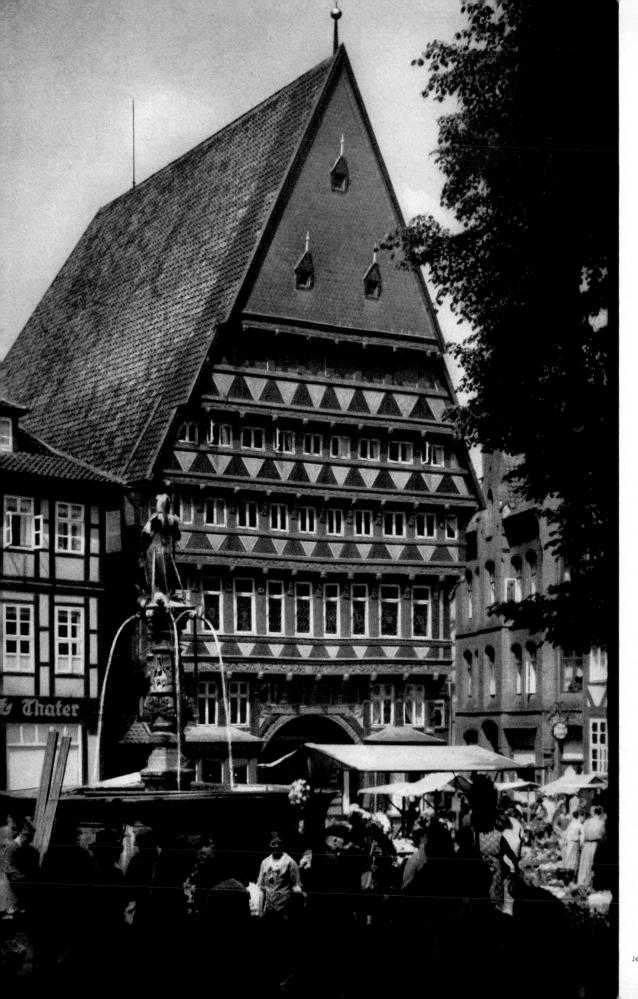

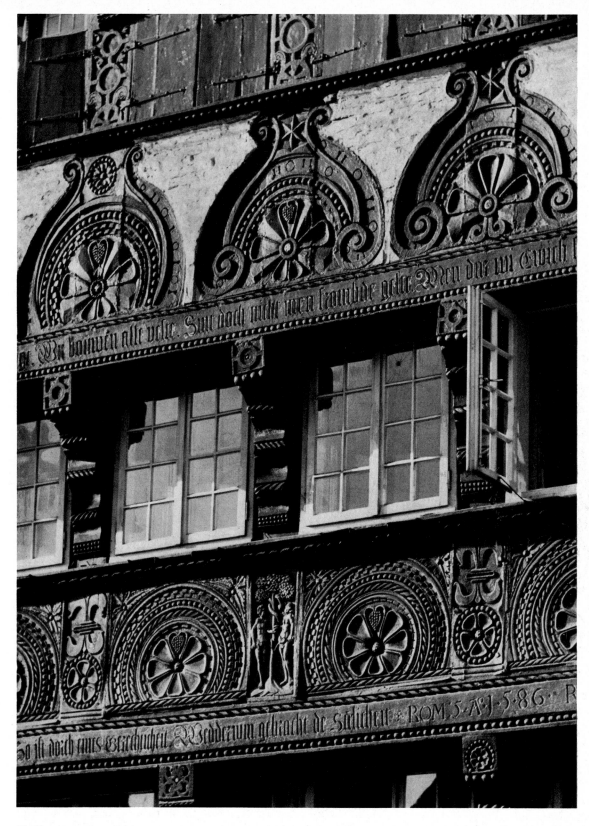

Schneiders

Auch der Holzbau nimmt in allmählichem Übergang Renaissance-Elemente auf. Links: *Hildesheim*. Das Knochenhaueramtshaus (1529, kriegszerstört).
Noch steiler Giebel, schon Betonung der Waagerechten; Renaissanceschmuck am Holzwerk. Oben: *Osnabrück*. Willmannsches Haus, Detail (1586).

Even timber structures gradually take on Renaissance features. Left: *Hildesheim, Lower Saxony*. The Butchers' Guild House (1529, destroyed during the war).
Gable still steep, emphasis already on the horizontal; Renaissance ornamentation on the timbering. Above: *Osnabrück*. Detail of the Willmann House (1586).

Taylor

Archives Photographiques

Coventry, Warwickshire. Ford's Hospital, 1530 erbaut, ist der
Kriegszerstörung im Jahre 1940 weitgehend zum Opfer gefallen.

Coventry. Ford's Hospital, built 1530,
was damaged during World War II (1940).

Angers, Frankreich. Maison d'Adam, Fachwerkhaus des 15. Jh. in der alten Hauptstadt
von Anjou. Rautenförmig sich durchkreuzende Balken als Flächenschmuck.

Angers, France. Maison d'Adam, a 15th century half-timbered house in the old
capital of Anjou with lozenge-shaped inter-crossing beams.

48

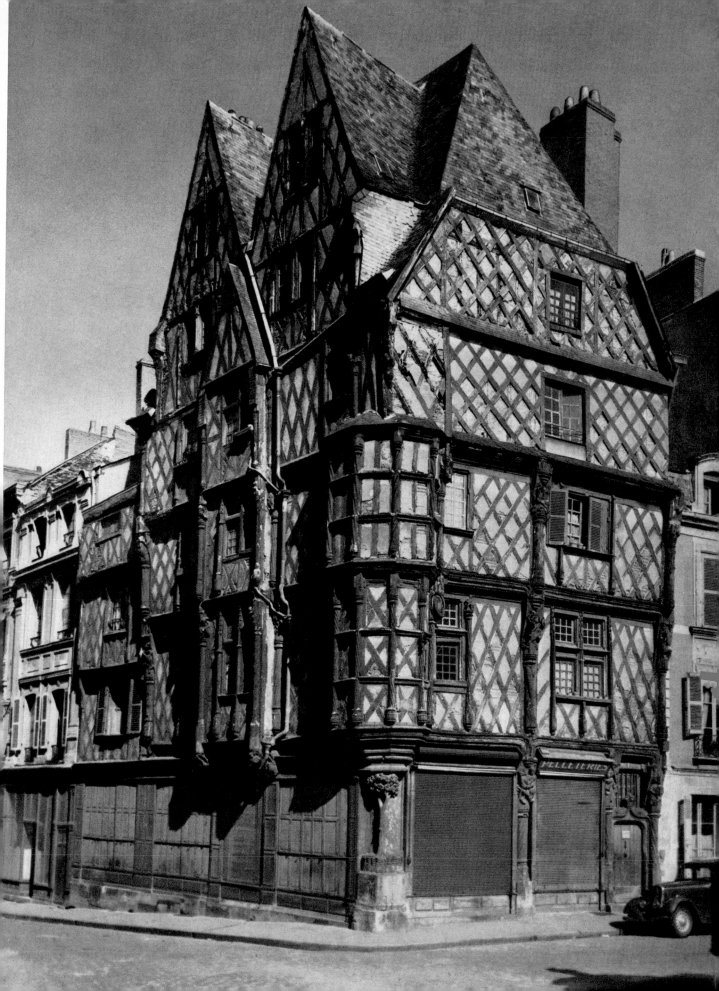

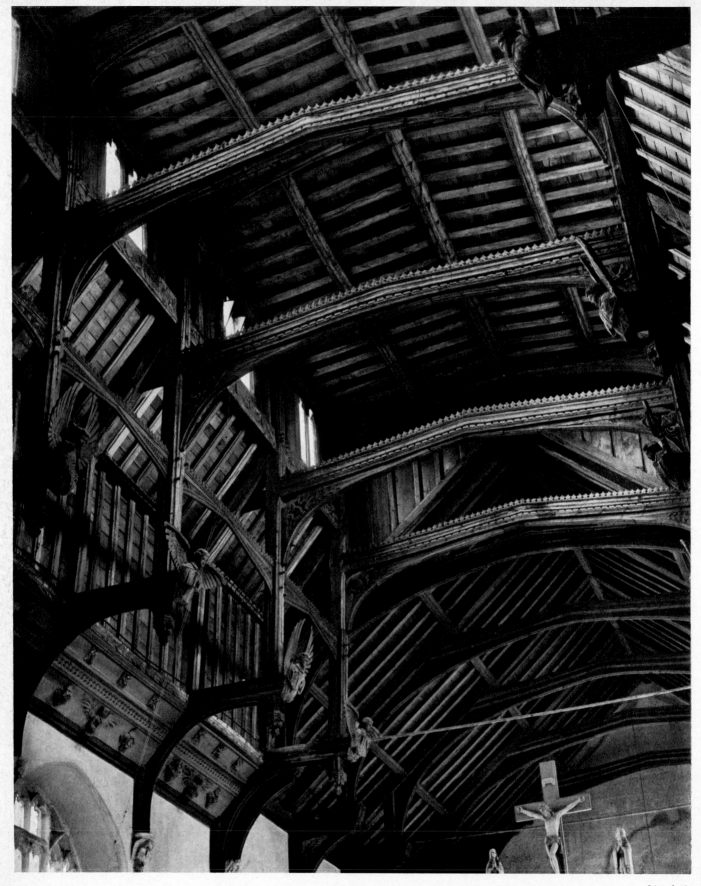

Needham Market, Suffolk. Die kunstvolle Holzdecke (um 1460) des Langhauses der Kirche.
Wie immer, bedeutet die Kirchendecke den Himmel, an dem Engel erscheinen.

Needham Market, Suffolk. The timbered roof (c. 1460) of the nave. As so often, the decoration symbolises heaven peopled by angels.

Little Moreton Hall, Cheshire. Die Füllbalken im Fachwerk (1559 und später), hier nur noch Zierde, zeigen ausgewogen-ruhende Tendenz.
Der Fachwerkbau, reich an regionalen Eigenheiten, bleibt in seinen Grundformen weithin beständig.

Little Moreton Hall, Cheshire. The purely decorative half-timbering (1559 and later) shows tendency towards symmetry.

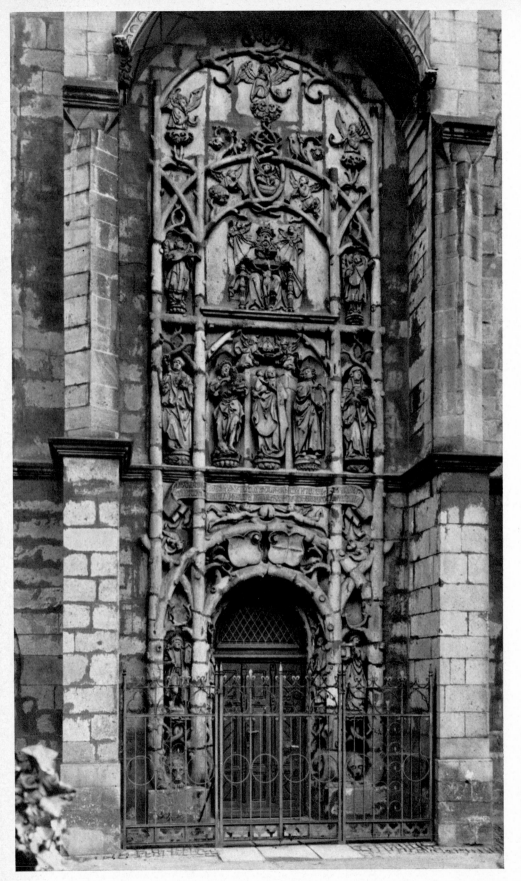

Foto Marburg

Aus den funktionsgebundenen Formen der Gotik erwächst in der Renaissancezeit ein neuer Naturalismus.
Links: *Chemnitz*. Nordtür der Schloßkirche (Hans Witten, 1525). Das Maßwerk ist in ein Gerüst von Stämmen mit Astansätzen umgebildet.
Rechts: *Valladolid, Spanien*.
Fassade der Kapelle San Gregorio (Juan Guas, 1488). Eine unabhängige Entwicklungsparallele: Über dem eingesunkenen „Eselsrücken" des Portalbogens ebenfalls das Baummotiv. Dazu maurische Formen.

MAS

During the Renaissance period a new naturalism grows out of the functional forms of Gothic.
Above: *Chemnitz, Saxony*. North door of the Castle Church (Hans Witten, 1525). The tracery is enclosed in a framework of stems and branches.
Right: *Valladolid, Spain*. Façade of the Chapel of San Gregorio (Juan Guas, 1488). A parallel but entirely independent development: the tree-motif is to be found here too, above the centre ogee-arch along with Moorish decorative forms.

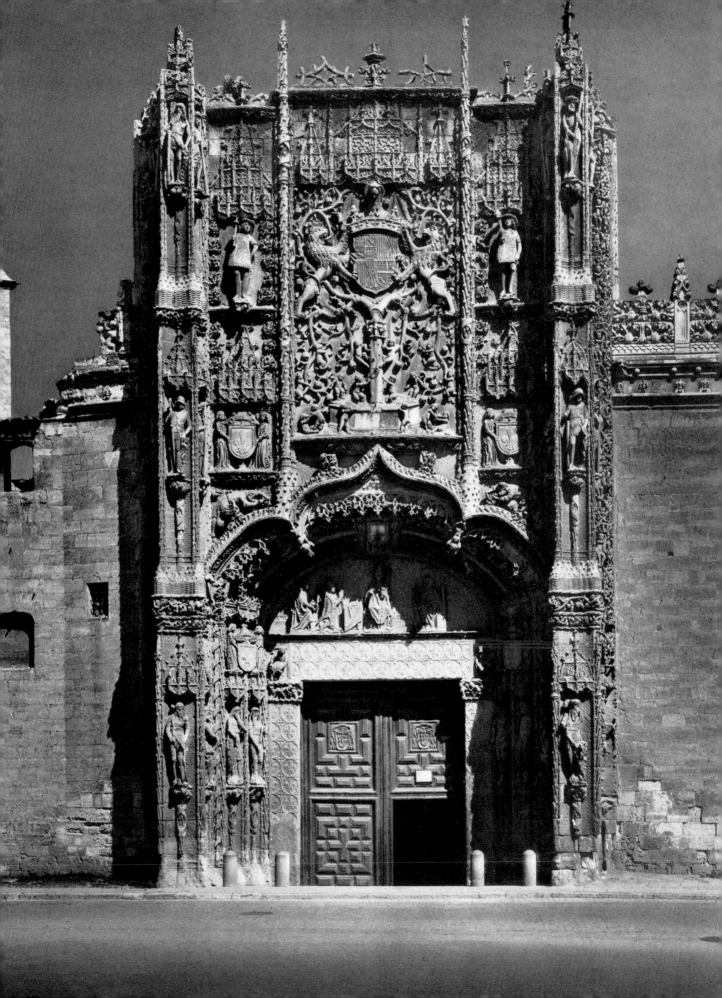

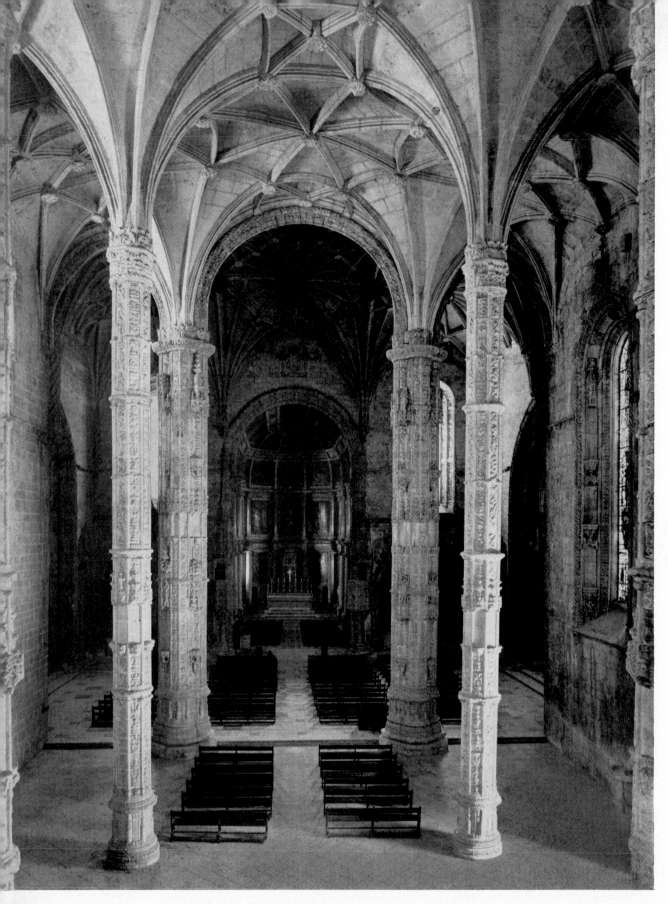

Kloster Belém bei Lissabon. Mittelschiff der Hieronymiten-Klosterkirche (D. Boitaca und J. de Castilho, 1502–19). Achtkantige Pfeiler, mit Renaissance-Grotesken verziert, in einer Hallenkirche mit spätgotischen Sterngewölben.

Belém Monastery near Lisbon. Central aisle of the conventual church of the Hieronymites (D. Boitaca and J. de Castilho, 1502–19). Octagonal shafts adorned with Renaissance grotesques in a "hall church" with Late Gothic star-vaults.

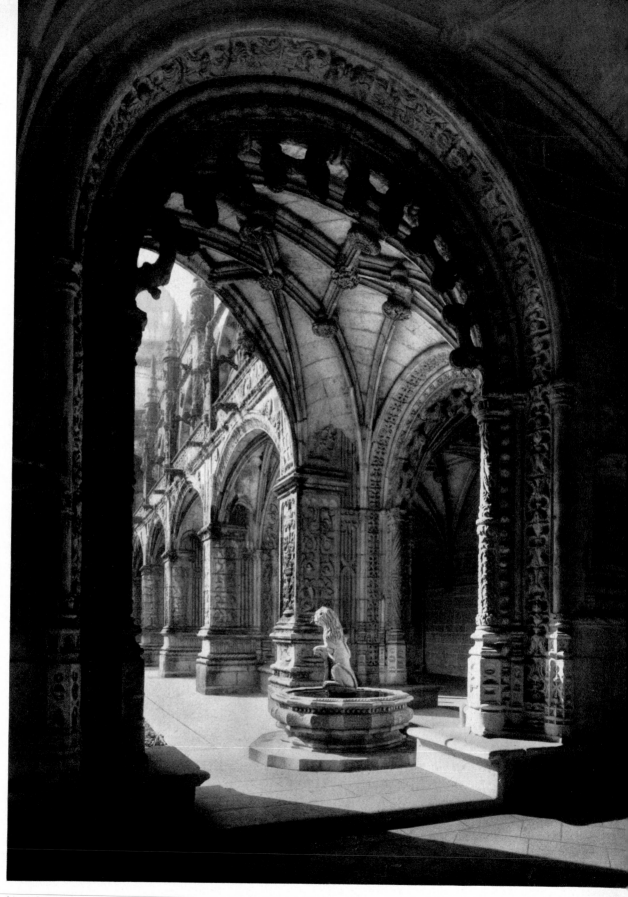

Belém. Kreuzgang des Klosters, um 1520 von Joao de Castilho, dem Schöpfer des „manuelischen" Stils in Portugal. Eine phantastisch blühende Mischung von spanischer Spätgotik und italienischer Renaissance.

Belém. Cloisters (c. 1520), the work of Joao de Castilho, creator of the Manueline style in Portugal. A fantastic mixture of Spanish Late Gothic and Italian Renaissance.

55

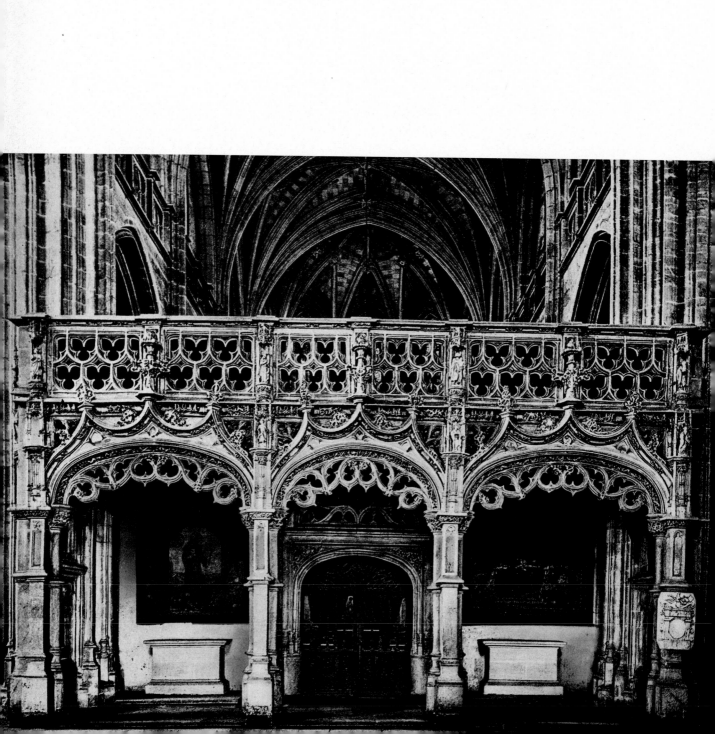

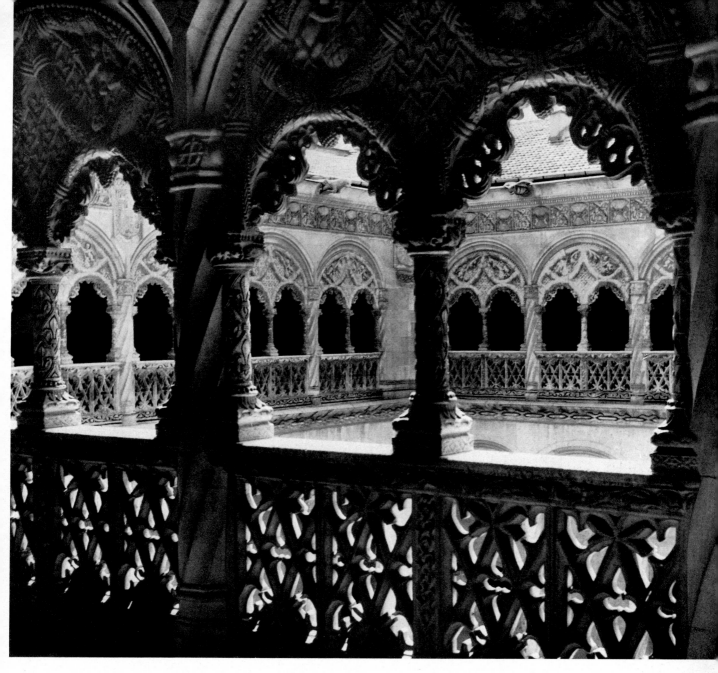

Groth-Schmachtenberger

Bourg-en-Bresse, Ostfrankreich. Lettner der Kirche von Brou,
die Margarete von Österreich 1511–36 errichten ließ.
Die Bautendenz des neuen Zeitalters deutet sich im horizontal gelagerten
und flächigen Charakter des spätgotischen Maßwerks an.

Bourg-en-Bresse, East France. Choir-screen of Brou church,
built 1511–36 at the instigation of Margaret of Austria.
The architectural tendency of the new period
is shown in the horizontal character of the Late Gothic tracery.

Valladolid, Spanien. Der zweite Hof des Colegio de San Gregorio
(Simon von Köln, 1488–96).
Manieristisches Überwuchern des Dekorativen
in der spanischen Spätgotik.

Valladolid, Spain.
The second court of the College of S. Gregorio
(Simon of Cologne, 1488–96).
Mannerist riot of ornament in Spanish Late Gothic.

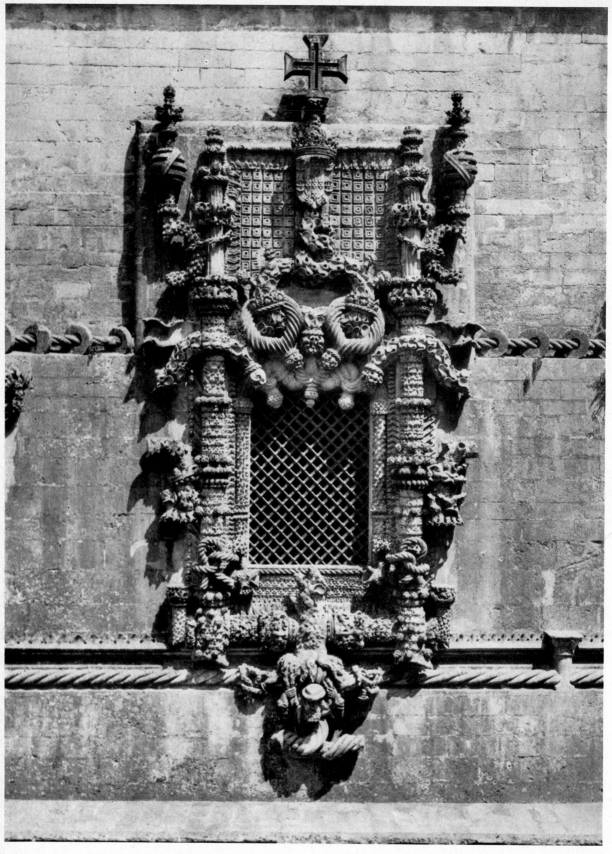

Schmidt-Glassner

YAN

Tomar, Portugal. Fensterumrahmung im Christusritterkloster — ein Beispiel des durch maurische Formen bereicherten „estilo mudéjar", in den die iberische Gotik mündet.

Belém. Der die Tajomündung bewachende Turm (F. de Arruda, 1515–21). Glatte Flächen und Rundbogen als Rückgriff der Renaissance auf die Romanik.

Tomar, Portugal. Window-frame in the chapter-house, an example of the "estilo mudéjar", the end of Iberian Gothic.

Belém. Tower overlooking the Tagus estuary (F. de Arruda, 1515–21). Smooth surfaces and Norman arches, indicative of a return to the Romanesque.

58

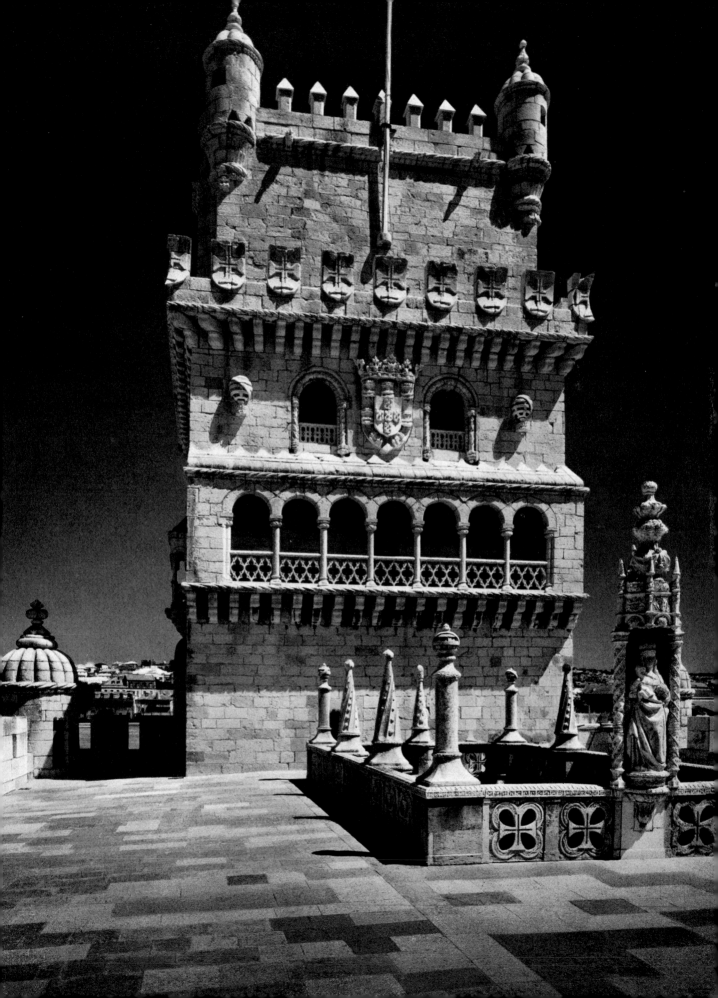

Wolff & Tritschler

Heilbronn. Der Turm von St. Kilian (Hans Schweiner, 1513—29).
Romanische Bestien,
eigenwillig verschmolzen mit Renaissanceformen.

Heilbronn, Wurtemberg. The tower of St. Kilian's (Hans Schweiner, 1513—29).
Romanesque beasts mingle
with Renaissance forms in a highly individual manner.

Augsburg. Grabkapelle (1509—18) der Familie Fugger —
der erste deutsche Bau, der italienische Renaissanceformen aufnimmt.
Noch mit spätgotischem Sterngewölbe. (Vorkriegszustand.)

Augsburg. Mausoleum (1509—18) of the Fugger family,
the first German structure to adopt Renaissance forms
though retaining the star-vault. (Pre-war photograph.)

Eßlingen, Württemberg. Vorplatz im Obergeschoß des Rathauses (Heinrich Schickhardt, 1586).
In gedrungenen Proportionen, mit spätgotischen und Renaissance-Formen durchgeführt.

Esslingen, Wurtemberg. Entrance-hall in the upper storey of the town hall (Heinrich Schickhardt, 1586).
Though its forms are those of Late Gothic and Renaissance, it is a product of the Renaissance in its compact proportions.

Jeiter

S. Thégonnec, Bretagne. Kirche mit Triumphpforte (1587) und Beinhaus (links, 1676). Die Eigenart der Bretagne,
bestimmt durch keltische Schmuckfreude, setzt sich auch im Zeitalter der Spätgotik und Renaissance durch.

S. Thégonnec, Brittany. Church with triumphal door (1587) and charnel-house (left, 1676). The Celtic love of ornamentation
triumphs during the Late Gothic and Renaissance periods.

Kerff

Lüneburg. Von einem Giebel (1548) der Straße Am Sande. Renaissancecharakter auch im Backsteinbau: mit querlaufenden Taustäben, flachen Korbbögen und Medaillons.

Lüneburg. Part of a gable (1548) in the street "Am Sande".

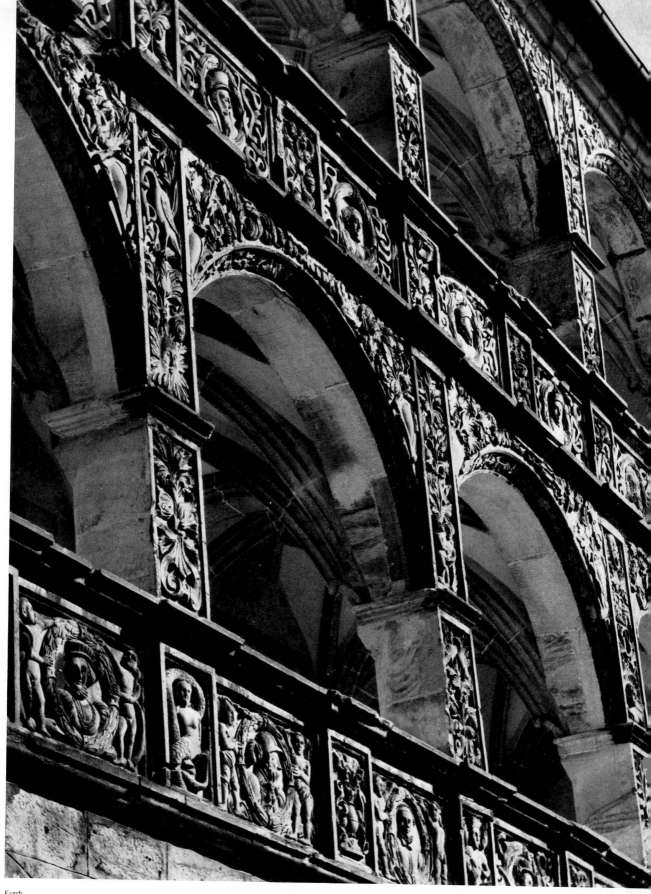

Kusch

Kulmbach, Oberfranken. Arkaden im „Schönen Hof" der Plassenburg (Caspar Vischer, 1551–69).
Flachreliefs nach lombardischen Vorbildern – in Deutschland bevorzugt gegenüber den großflächigen toskanischen.

Kulmbach, Upper Franconia. Arcades in the "Schöner Hof" of the Plassenburg (Caspar Vischer, 1551–69). Bas-reliefs in the Lombard style.

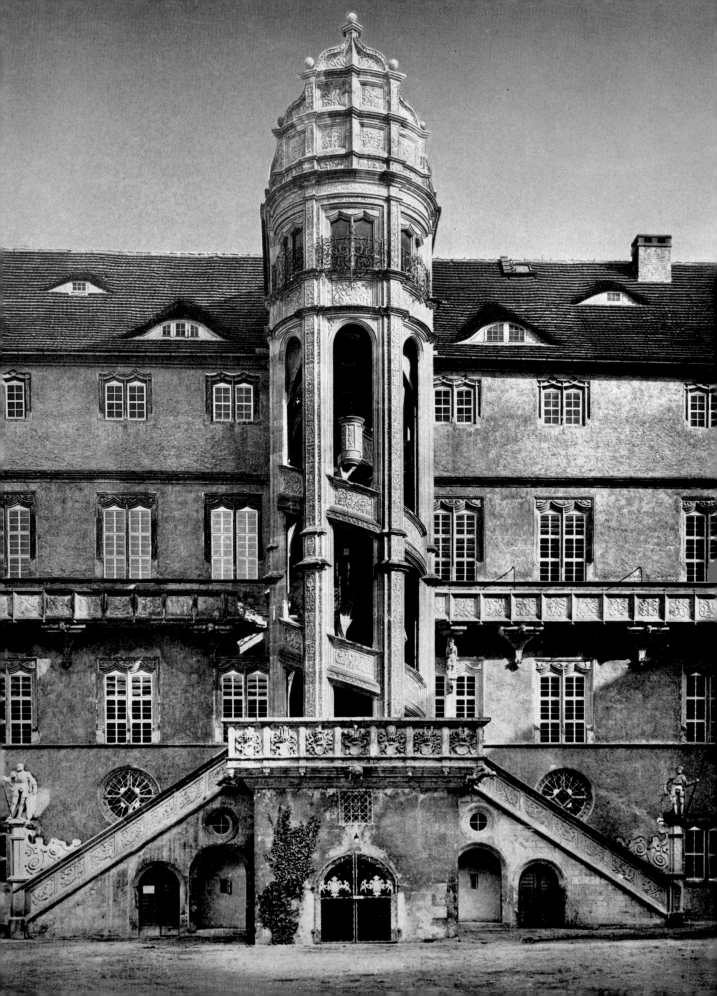

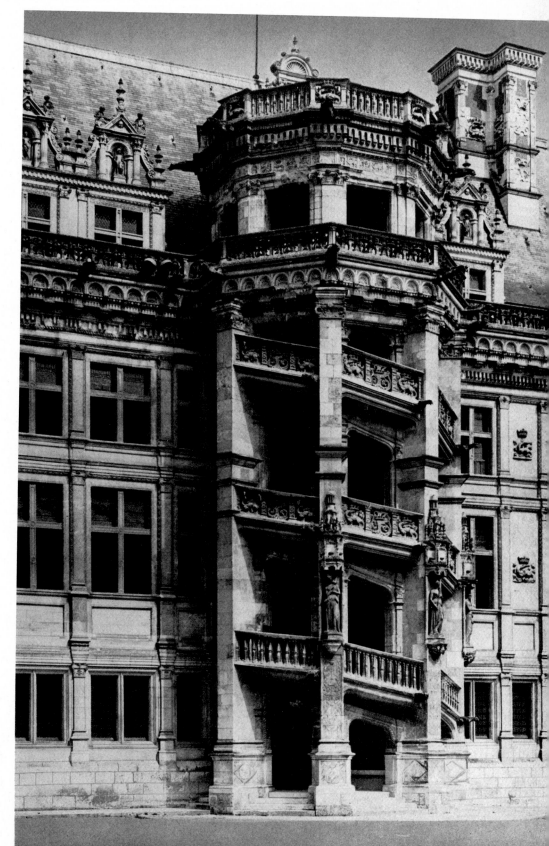

Torgau a. d. Elbe.
Schloß Hartenfels (Konrad Krebs, 1533–35). Über den Fenstern spätgotische Gardinenbögen, an dem Wendelstein aber Pilaster mit antikischen Renaissancegrotesken.

Torgau on the Elbe.
Hartenfels Castle (Konrad Krebs, 1533–35). In front of the staircase pilasters with Renaissance grotesques.

Ehem. Staatl. Bildstelle

Blois a. d. Loire.
Der Turm des von Charles Viart erbauten Schloßflügels (1515–25) ähnelt dem von Torgau, steht aber durch gedrungene Form und waagerechten Abschluß der italienischen Renaissance näher.

Blois - sur - Loire.
The tower of the château wing, built 1515–25 by Charles Viart.

Roubier

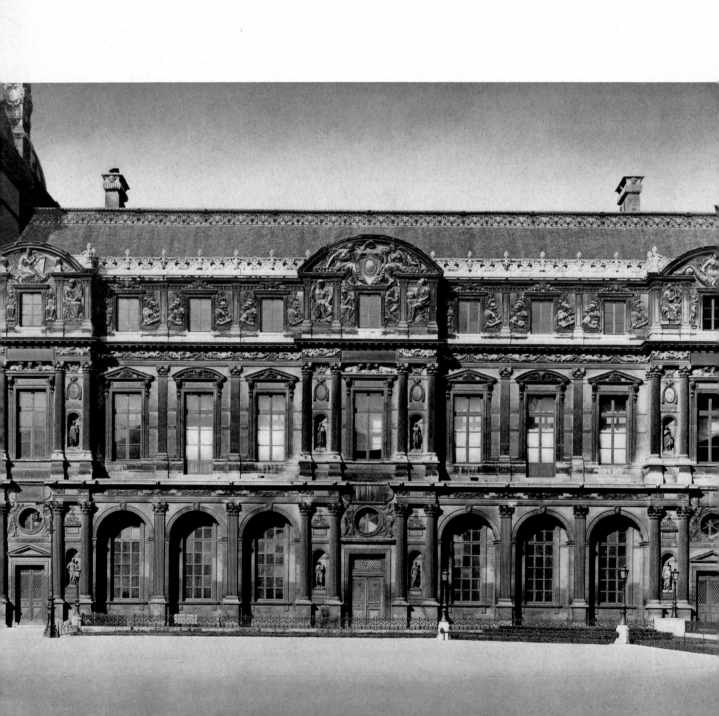

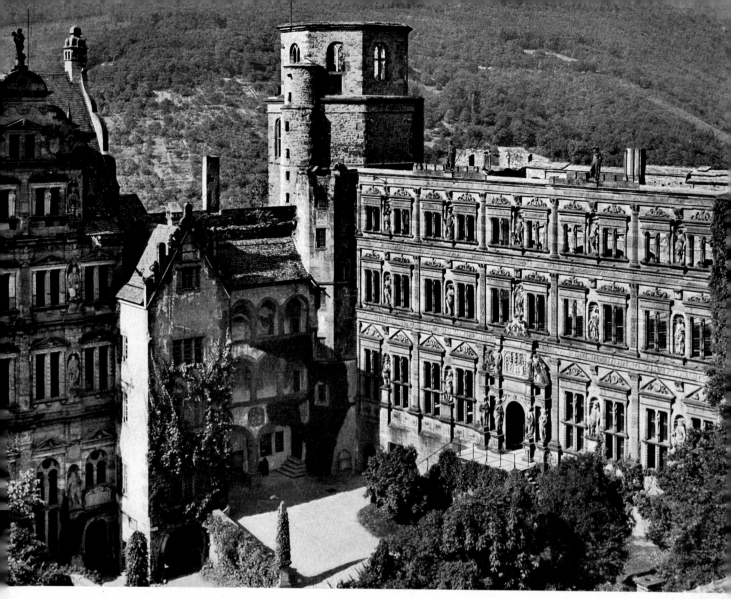

Deutscher Kunstverlag

Foto Marburg

Paris. Louvre. 1546—55 schuf Lescot den ältesten Flügel des Prachtschlosses
der französischen Könige. Eine klassische französische Renaissance,
die noch Jahrhunderte fortwirken sollte, entstand hier aus dem klaren
Begreifen des italienischen Vorbilds.

Paris. Louvre. Lescot designed the oldest wing of the French kings'
Palace between 1546 and 1555.

Heidelberg. Ottheinrichsbau (1556—59) des Schlosses. Die Verwandtschaft
mit dem Louvre zeigt, wie in diesen beiden Bauten auch im Norden
die Renaissance mit ihren „Ordnungen" sich durchsetzt.

Heidelberg. The castle, Ottheinrichsbau (1556—59),
similar in construction to the Louvre. In the north too the Renaissance
"orders" are beginning to make their mark.

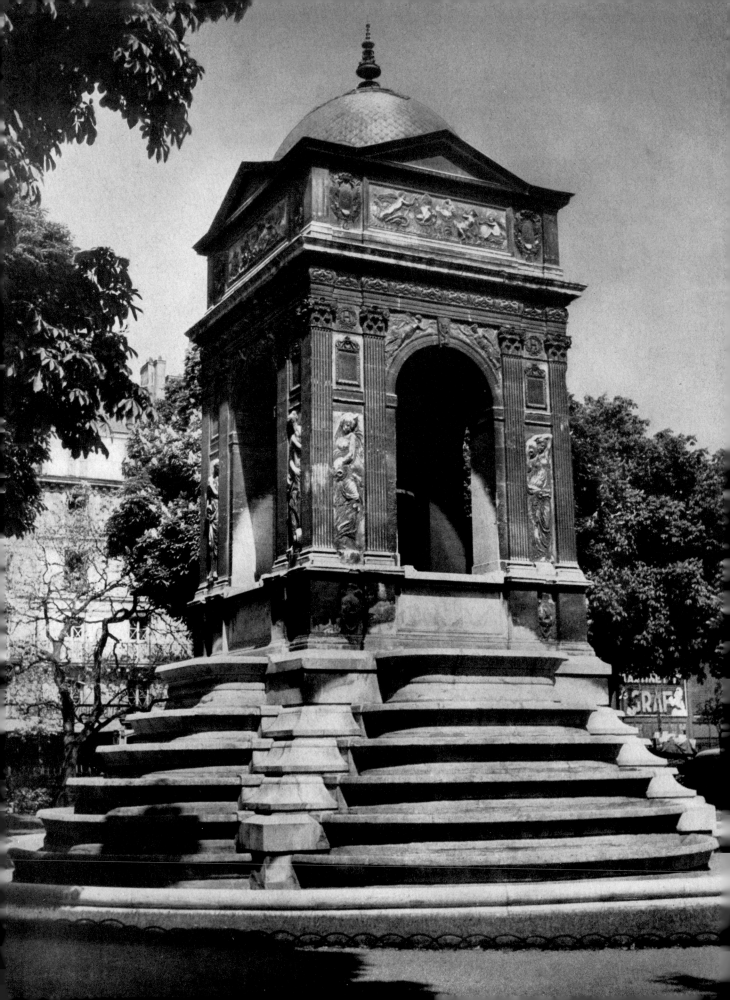

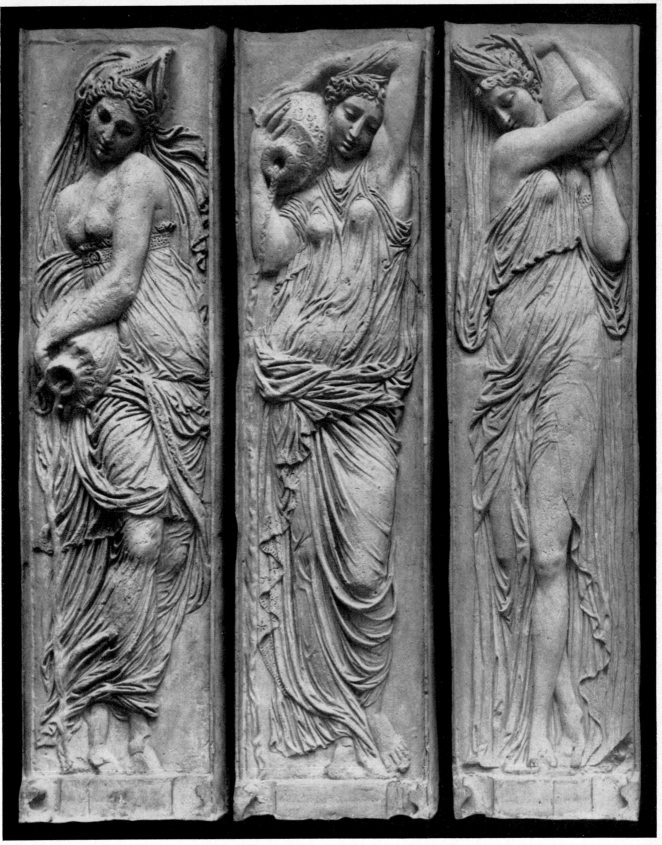

Paris. Die Fontaine des Innocents (1547–49, später umgebaut) ist ein architektonischer Zierbau des Hauptes der französischen Renaissance, Pierre Lescot. Links: Die heutige Gesamtansicht. Oben: Die Quellnymphen des Jean Goujon (Originale im Louvre) sind die edelsten Werke des manieristischen Stils in Frankreich.

Paris. The Fontaine des Innocents (1547–49, with later alterations) is a purely decorative structure by the head of French Renaissance, Pierre Lescot. Left: general view. Above: the Nymphs at the Spring by Jean Goujon (originals in the Louvre).

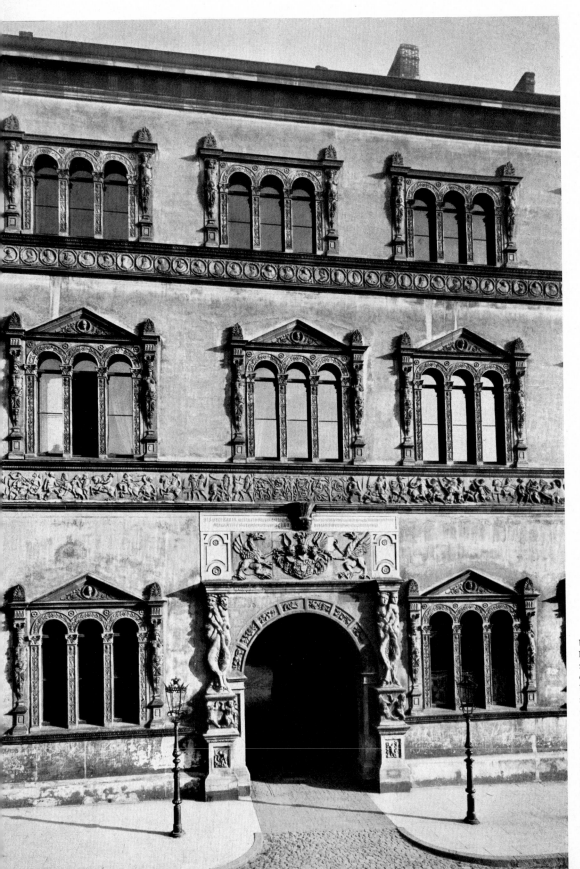

Azay-le-Rideau a. Indre.
Der Schloßhof (1518—27) mit
dem rechtwinklig gebrochenen
Treppenhaus unter dem
Hauptgiebel. Die schlanken
Säulen des mittleren Erkers
und die vier steilen Giebel
mit ihren Obelisken sind erste
Zeugen des manieristischen
Stils.

Azay-le-Rideau - sur - Indre.
Courtyard of the château
(1518—27) with the rectangular
cage of the staircase under the
main gable.

<div align="right">Jeiter</div>

Wismar, Mecklenburg.
Der Fürstenhof (Ziegelbau,
1550—55), nach einem von
oberitalienischen Palazzi
bestimmten Plan von
niederländischen Baumeistern
errichtet. Die Gesimse mit
Reliefs lombardischer Art
in Kalkstein und Terrakotta
gefüllt.

Wismar, Mecklenburg.
The Fürstenhof (brick building,
1550—55) constructed by
Dutch architects following the
plan of the Italian Palazzi.

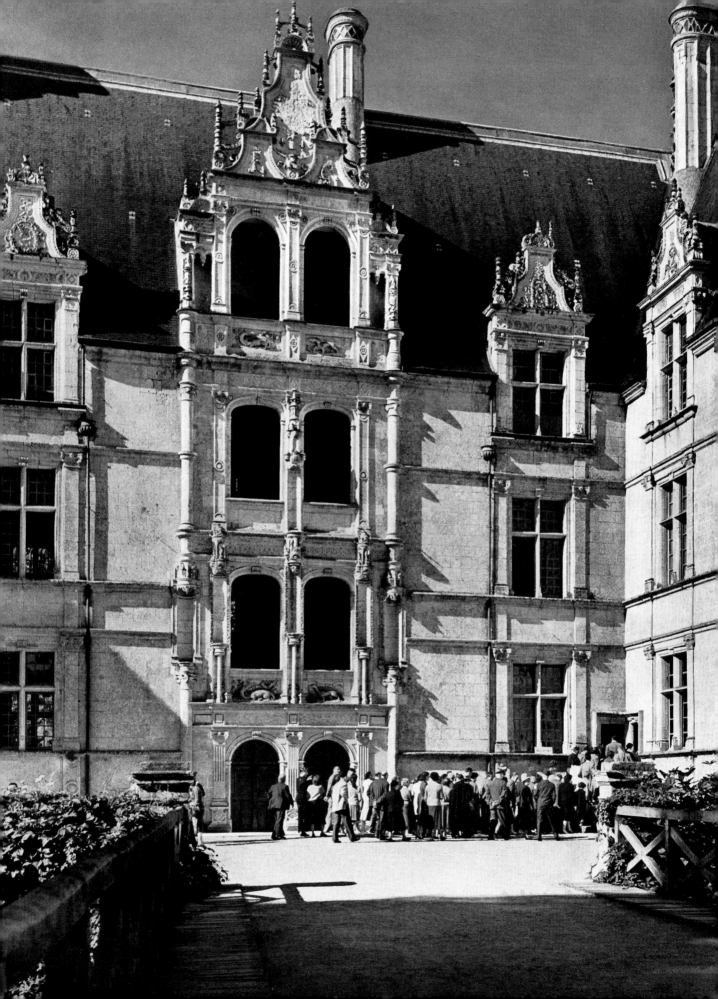

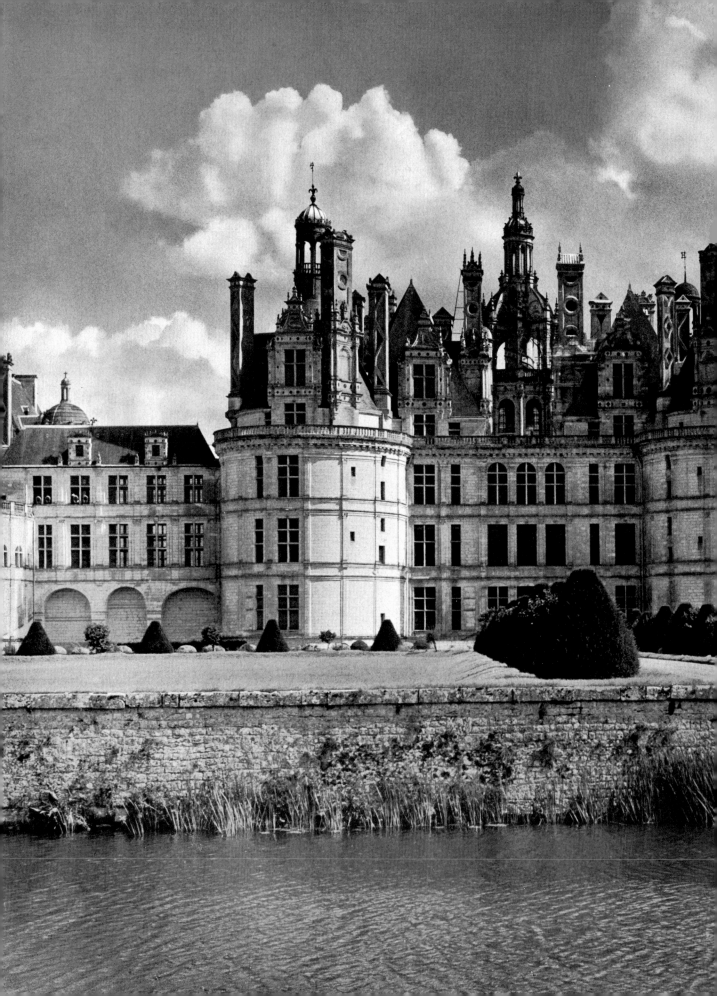

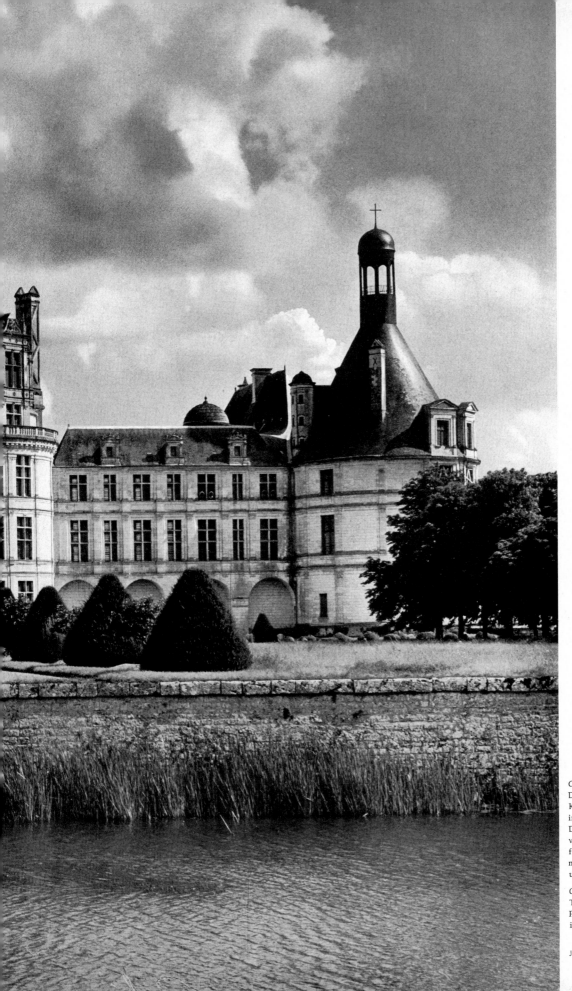

Chambord a. d. Loire.
Das riesige Wasserschloß
König Franz I., 1519 begonnen,
im 17. Jh. vollendet.
Der Mittelbau gipfelt in
vertikalen Formen des
französischen Manierismus,
mit einem Heer von Dacherkern
und Schornsteinen.

Chambord - sur - Loire.
The huge château begun by
Francis I in 1519 and completed
in the 17th century.

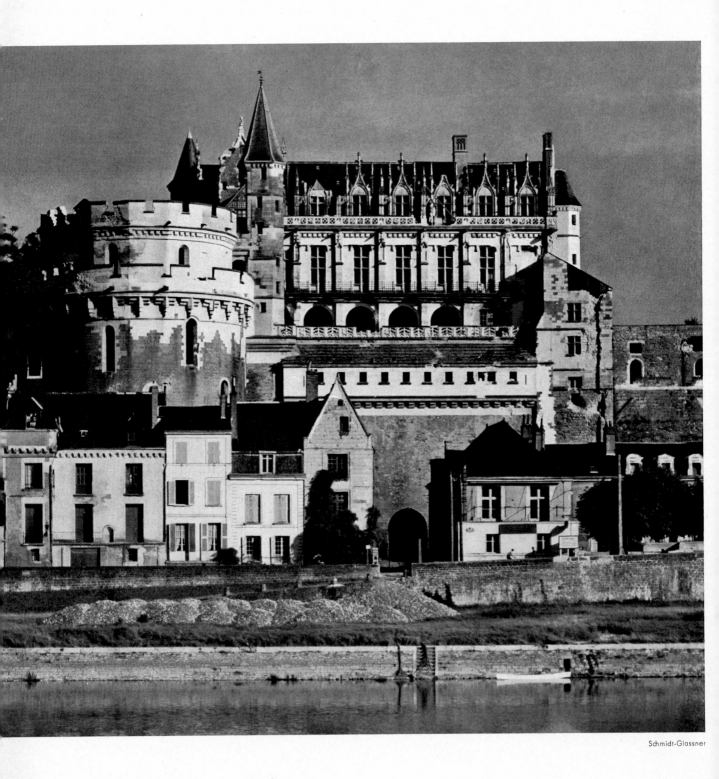

Schmidt-Glassner

Jeiter

Amboise a. d. Loire. Das Schloß wurde 1490 von König Karl VIII. begonnen, der eine italienische Künstlerkolonie hierher berief. Gesims und Balustrade betonen die Horizontale. Mit den Dachfenstern, die Kielbogen aus sich wachsen lassen, bricht im 16. Jh., im Manierismus, die Vertikale wieder durch.

Amboise - sur - Loire. The château was begun in 1490 by Charles VIII who summoned there a colony of Italian artists.

Rigny-Ussé a. d. Loire. Schloß mit Donjon (Wohnturm) des 15. Jh. und einer Fülle manieristischer Türmchen und Schornsteine aus dem 16. Jh., die eine französisch-gotische Tradition weiterführen. Von Vauban im 17. Jh. vergrößert.

Rigny-Ussé - sur - Loire. Château (15th century) with donjon and an abundance of turrets and chimneys from the 16th century. Extensions by Vauban in the 17th century.

76

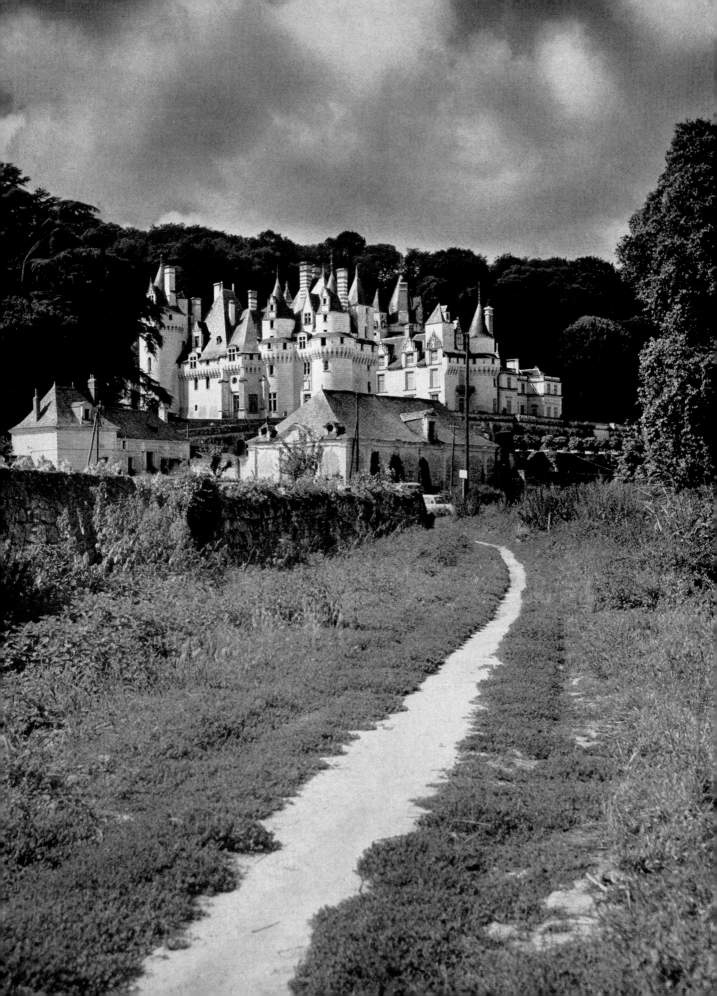

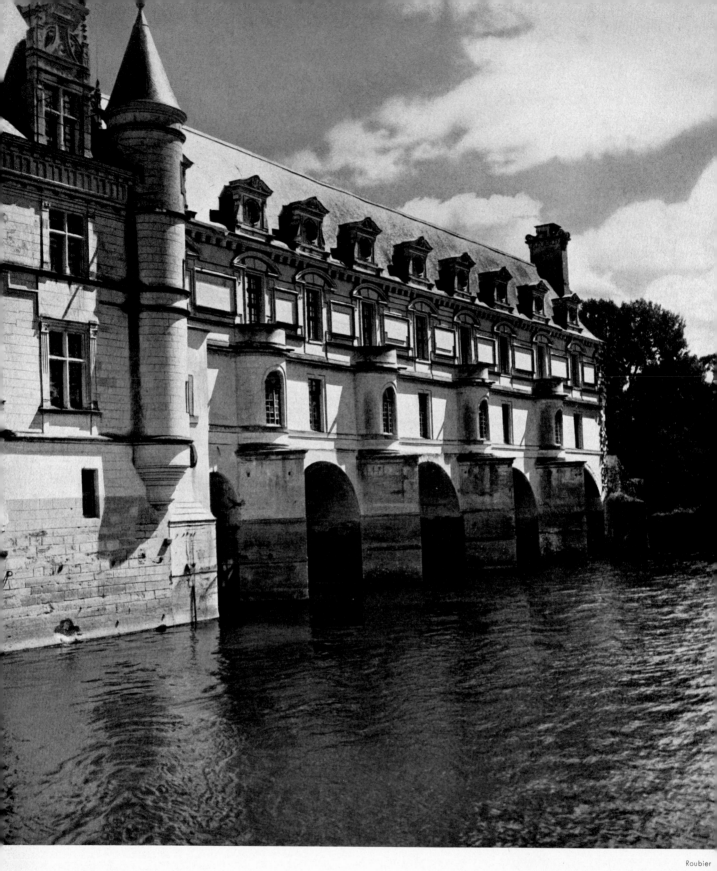

Chenonceaux. Das Schloß wurde nach 1515 mitten im Cher,
einem Nebenfluß der Loire,
für einen reichen Bürger errichtet.
Waagerechtes, um die halbrunden Vorsprünge verkröpftes Gesimsband;
Renaissance-Dachfenster.

Chenonceaux. The château (post 1515) was built astride the Cher,
a tributary of the Loire.

Verschiedene Stufen in der Aneignung des italienischen Baukanons
der Renaissance. Rechts oben: *Fontaine-Henry, Normandie* (1533–44).
Über dem Renaissancebau gotisch-steile Dächer und Schornsteine. Rechts unten:
Azay-le-Rideau, Wasserfront. Regelmäßige Anlage, schweres, durchgehendes Dach.

Right, above: *Fontaine-Henry, Normandy* (1533–44). French sloping roofs
and chimneys in the Gothic tradition above a Renaissance structure.
Right, below: *Azay-le-Rideau*. Façade overlooking the Indre.

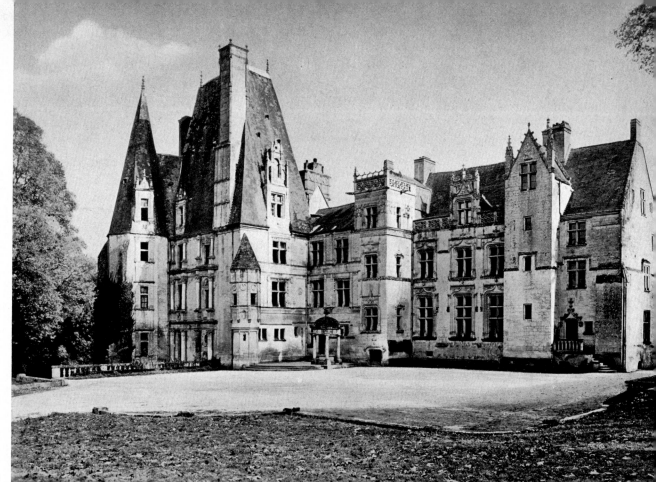

Foto Marburg

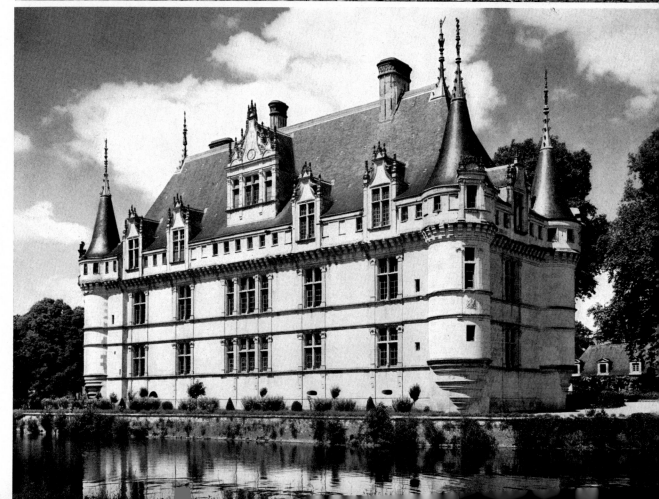

Foto Marburg

Ein Streben der Renaissancezeit: das Aufspüren von Harmonieregeln und ihre Verwirklichung im Großen wie im Detail.
Links: *Palmanova, Venetien.* Eine der frühesten planmäßig angelegten Städte (Scamozzi, 1593). Oben: *Burgos, Spanien.*
Stern im Vierungsgewölbe (1539—68) der Kathedrale, aus dem spätgotischen Sterngewölbe entwickelt und mit einem schimmernden Grunde hinterfangen.

Left: *Palmanova, Venetia,* one of the earliest examples of town-planning (Scamozzi, 1593). Above: *Burgos, Spain.*
Star in the vault (1539—68) over the crossing of the cathedral — a development of Late Gothic stellar vaulting.

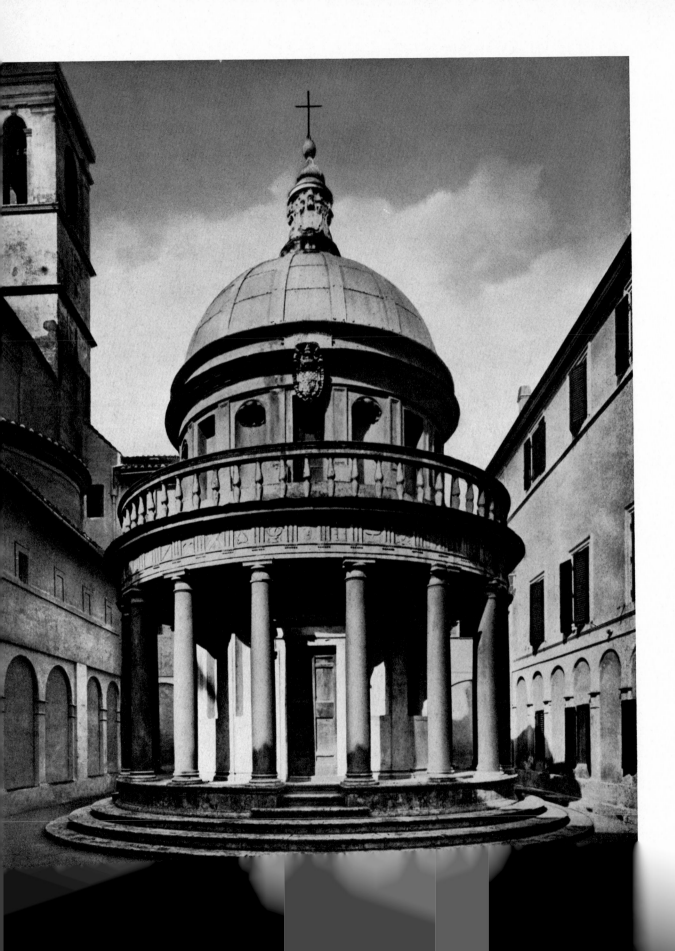

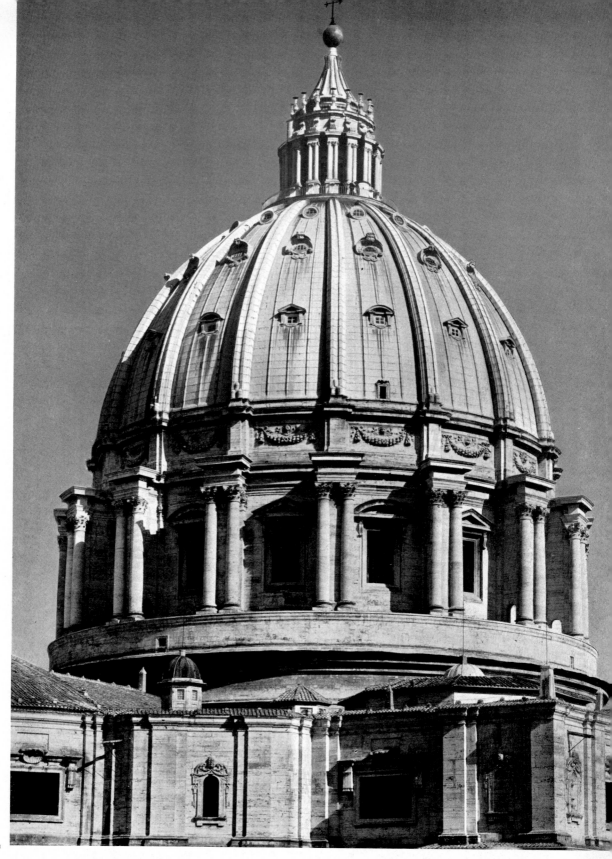

Rom. Der Idealbau der Hochrenaissance – die nur einen kurzen Moment
in der Menschheitsgeschichte ausmacht – ist Bramantes Tempietto (1500–c2)
von San Pietro in Montorio. Vollkommene, in sich geschlossene Harmonie.

Rome. S. Pietro in Montorio. The ideal structure of the High Renaissance –
which lasted for only a brief moment in the history of mankind –
is represented by Bramante's Tempietto (1500–02).
Complete, self-contained harmony.

Rom. Kuppel von St. Peter, 1557 von Michelangelo entworfen.
Auf dem Wege zu Manierismus und Barock: Aus den gedoppelten Säulen
steigen Kraftströme durch die Rippen bis in die Laterne.

Rome. Dome of St. Peter's designed in 1557 by Michelangelo,
already suggestive of Mannerism and Baroque.
Waves of strength rise from the double pillars, through the ribs,
right up to the lantern.

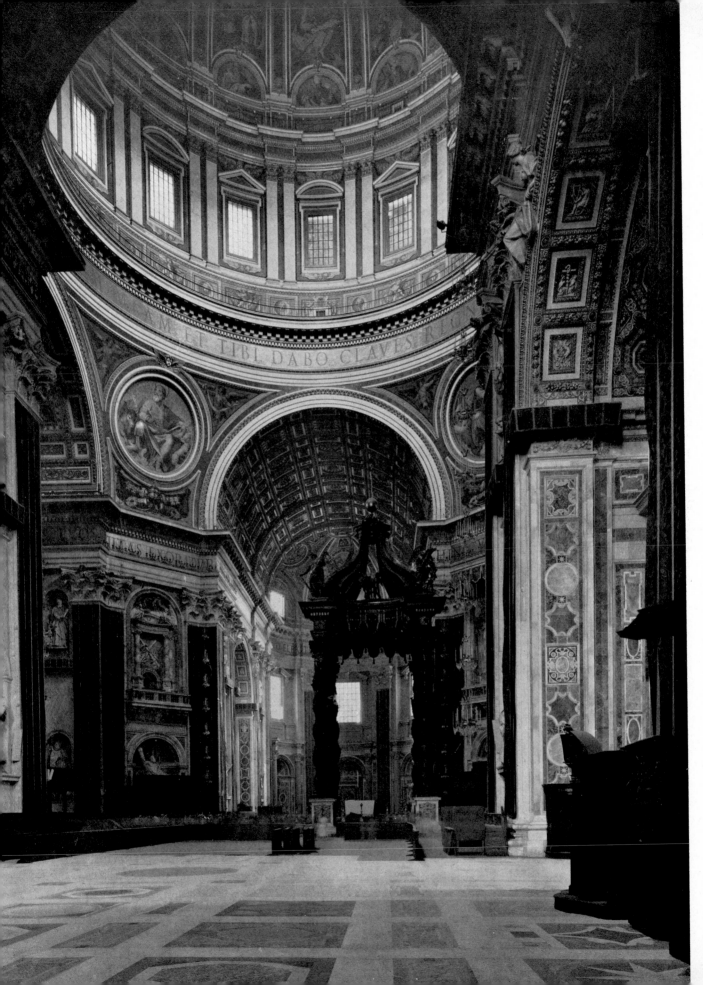

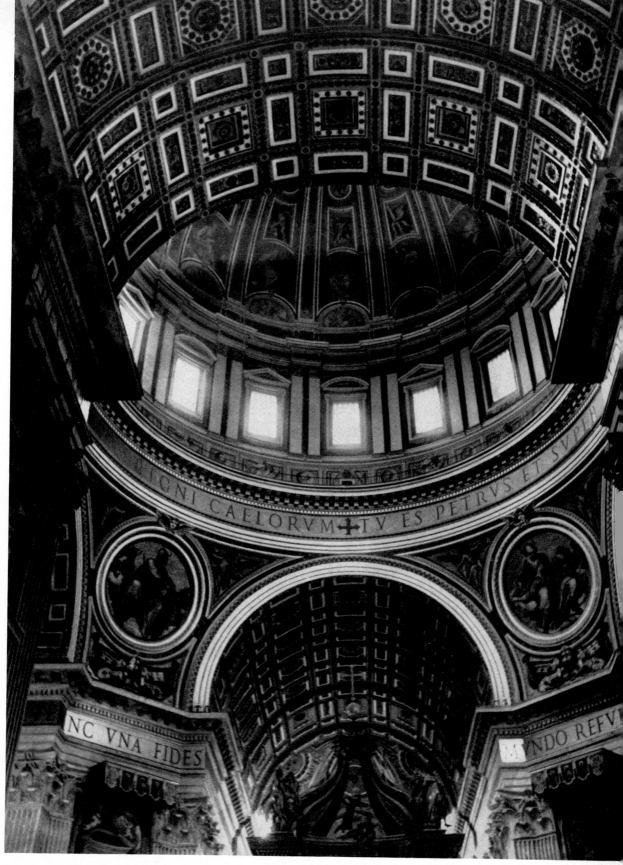

Degenhardt

Rom. St. Peter. 1506 von Bramante begonnen, das frühe Sichtbare seit 1547 von Michelangelo. Dieser Raum mit seinen ungeheuren schwebenden Massen bedeutet den Gipfel für den Kirchenbau der Hochrenaissance. Links: Blick ins Querschiff. Oben: Die Kuppel.

Rome. St. Peter's, begun by Bramante in 1506. The earliest visible part (after 1547) is the work of Michelangelo. It is the supreme masterpiece of High Renaissance ecclesiastical architecture. Left: transept. Above: cupola.

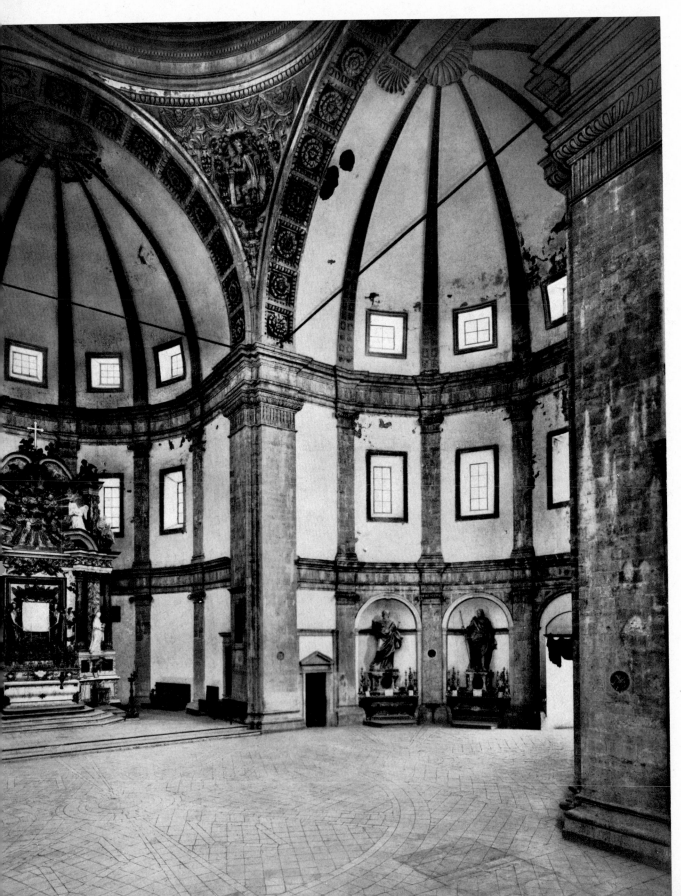

86

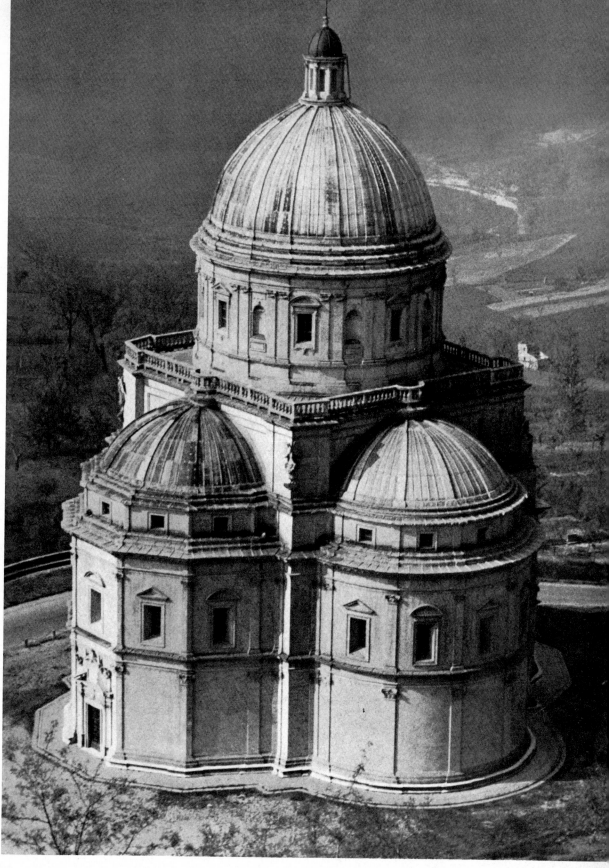

Stefani

Todi, Umbrien. S. Maria della Consolazione, um 1520 von zwei Schülern Bramantes erbaut. Der folgerichtigste Zentralbau der Hochrenaissance, der den in der Mitte still Stehenden allseitig umschließt (links). Oben: An vier Seiten des überkuppelten Quadrats halbrunde Apsiden.

Todi, Umbria. S. Maria della Consolazione built c. 1520 by two of Bramante's pupils. The most logically consistent centrally planned church of the High Renaissance, completely encircling the viewer standing in the centre (left). Above: semicircular apses on four sides of the dome-capped square.

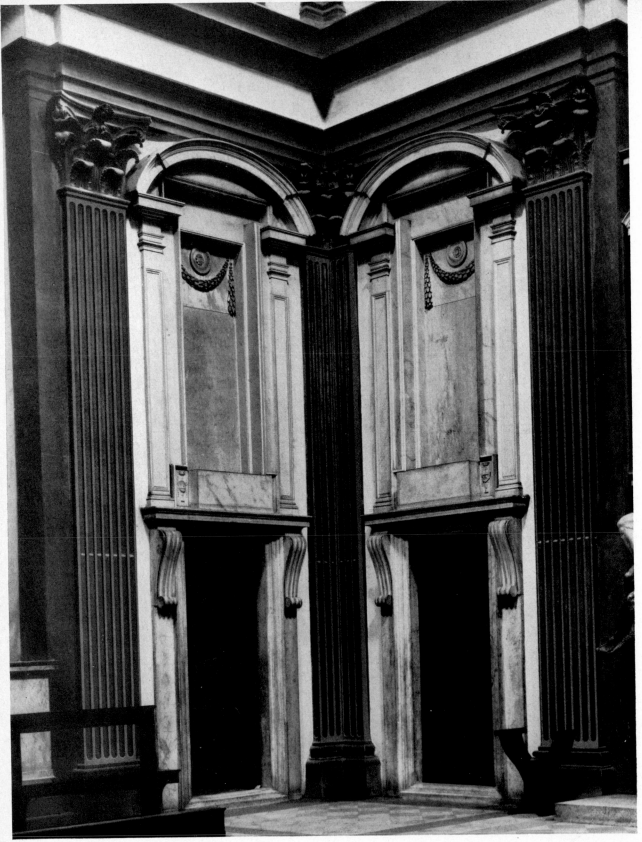

Florenz, S. Lorenzo. Die Neue Sakristei (1520–24), Grabkapelle der Medici, zeigt Michelangelo auf der Wende von der Hochrenaissance zum Manierismus: Mächtige Pilaster beengen bereits die Nischen (oben). Rechts: Sarkophag des Lorenzo de'Medici mit den Allegorien von Morgen und Abend.

Florence. The Medici Mausoleum (1520–24) in the New Sacristy of S. Lorenzo reveals Michelangelo at the turning point between High Renaissance and Mannerism. The niches (above) are confined by mighty flanking pilasters.
Right: sarcophagus of Lorenzo de'Medici showing the allegories of Dawn and Evening.

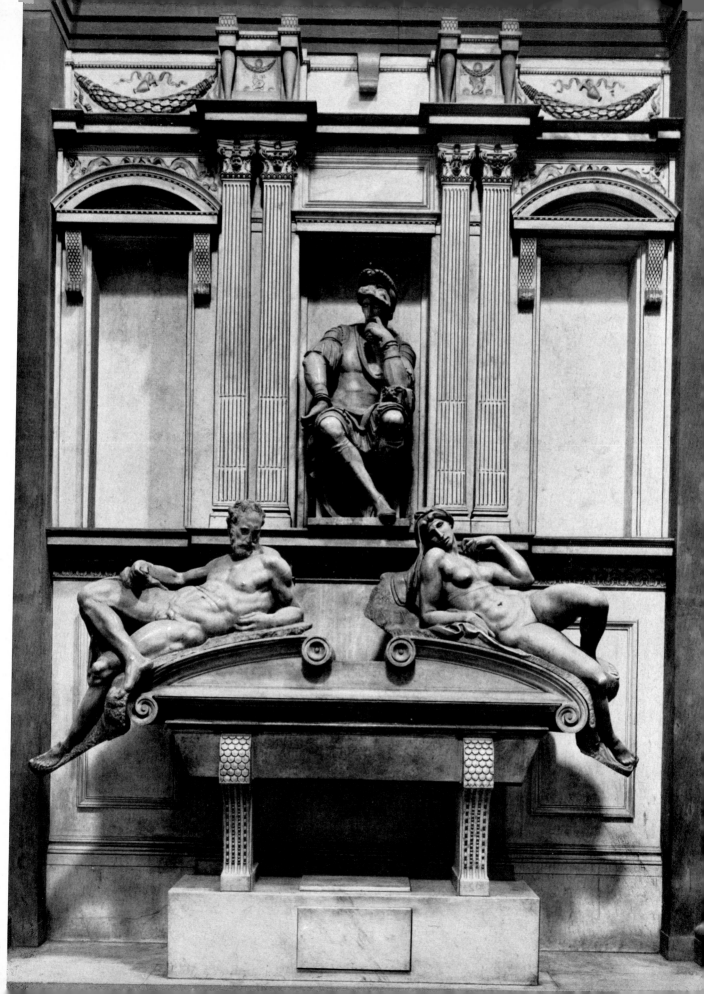

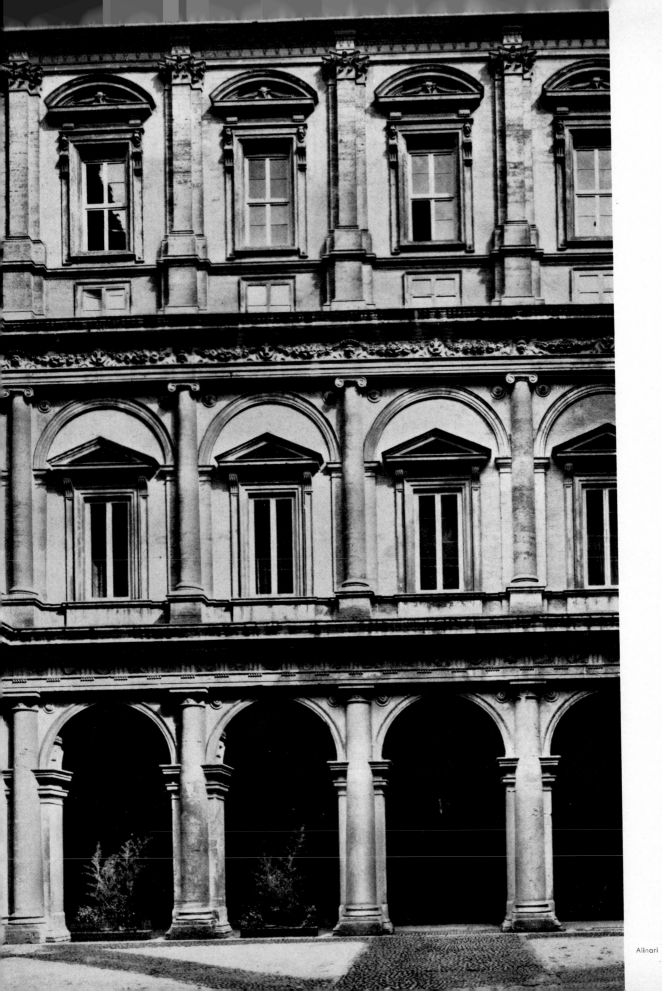

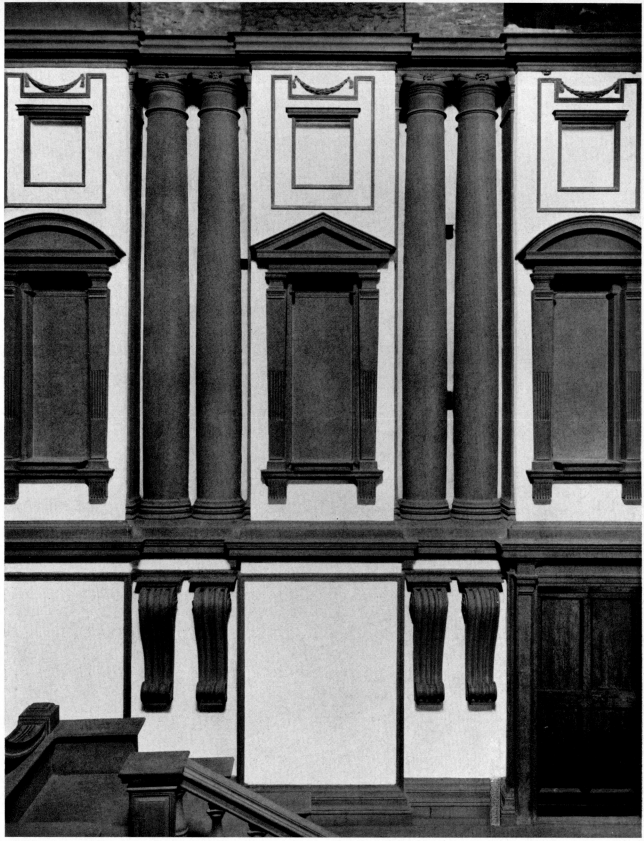

Rom. Im Palazzo Farnese (Antonio da San Gallo, 1514–86) findet sich
der am reichsten im Sinn der Hochrenaissance gegliederte Palazzo-Hof.
Oberstes Geschoß von Michelangelo.

Rome. Palazzo Farnese (Antonio da San Gallo, 1514–86)
with the most superbly articulated High Renaissance cortile.
Top storey by Michelangelo.

Florenz. Biblioteca Laurenziana,
Wandgliederung im Treppenhaus (1526 von Michelangelo entworfen).
Die Ausgewogenheit der Hochrenaissance ist abgelöst
durch eine unausgeglichene Gedrängtheit dekorativer Effekte: Manierismus.

Florence. Biblioteca Laurenziana.
The flanking wall of the staircase (designed by Michelangelo in 1526).

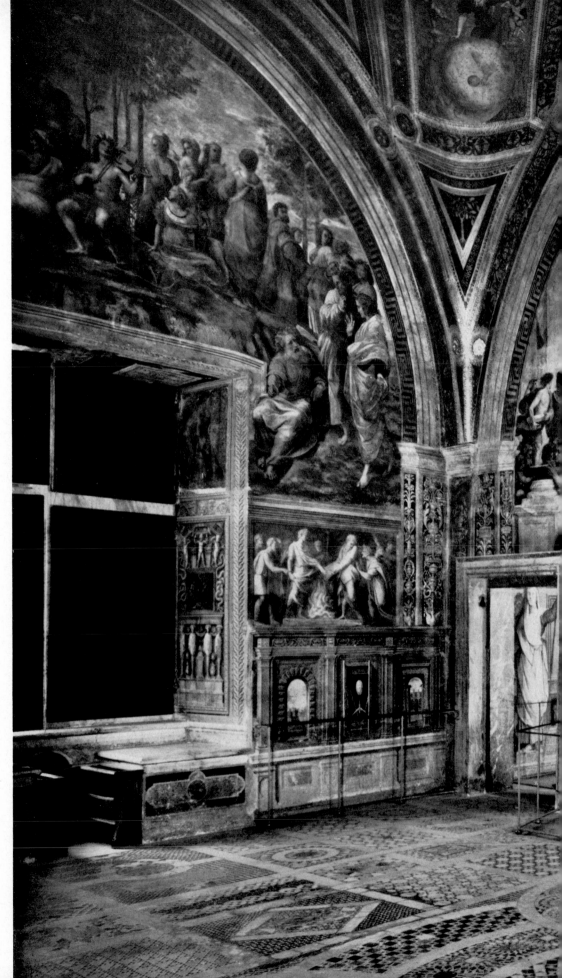

Rom. Durchdringung
von Malerei und Architektur:
Raffaels Fresken
in der Stanza della Segnatura
im Vatikan (1508—10) —
Gipfel der Renaissancemalerei.
Der Parnaß links
bedeutet die Poesie —
die „Schule von Athen"
rechts die Philosophie.

Rome. Marriage of painting
and architecture:
Raphael's frescoes in the Stanza
della Segnatura in the Vatican
(1508—10) — the crowning glory
of Renaissance painting.
The Parnassus on the left
indicates Poetry —;
the "School of Athens"
on the right Philosophy.

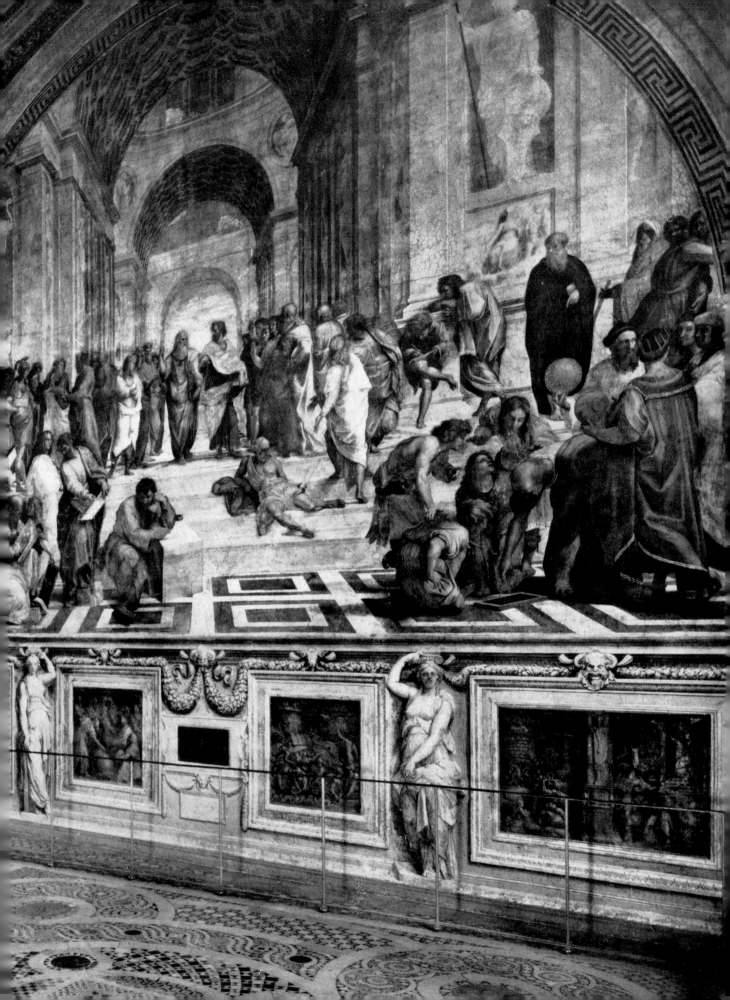

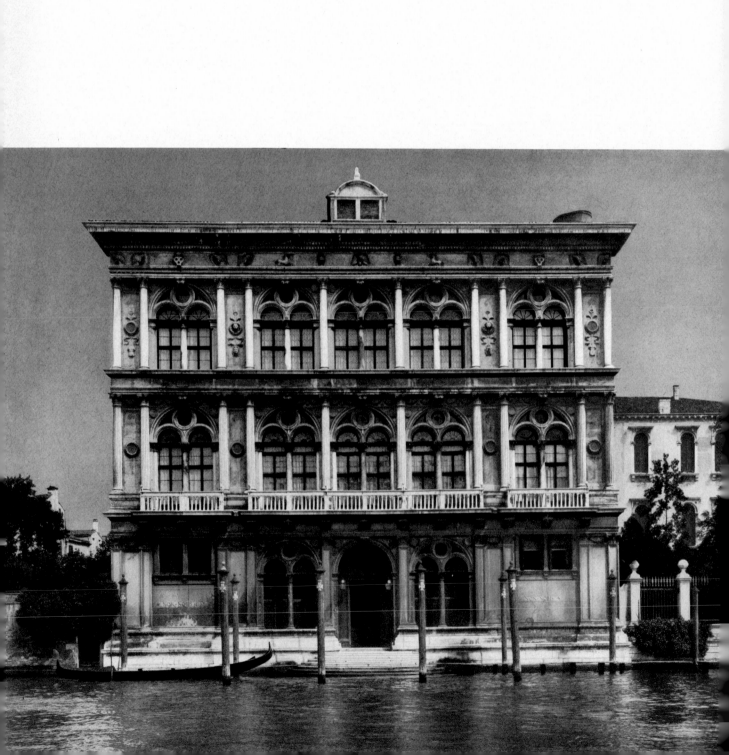

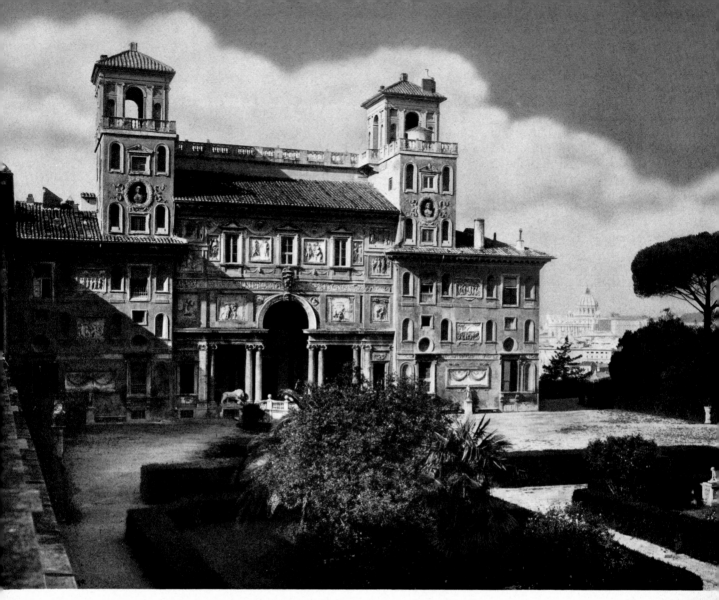

Venedig. Der Palazzo Vendramin-Calergi (Pietro Lombardo, 1481).
Hauptbeispiel der venezianischen Frührenaissance, die reicher dekoriert ist
als die toskanische. Gegliedert durch korinthische Pilaster und Säulen.

Venice. The Palazzo Vendramin-Calergi (Pietro Lombardo, 1481).
Principal example of the Venetian Early Renaissance,
richer in ornamentation than the Tuscan.

Rom. Die Gartenfront der Villa Medici (A. Lippi, 1544),
geschmückt mit Stukkaturen
und Bruchstücken antiker Statuen.

Rome. Façade of the Villa Medici
overlooking the garden (A. Lippi, 1544),
decorated with stucco-work and fragments of classical statuary.

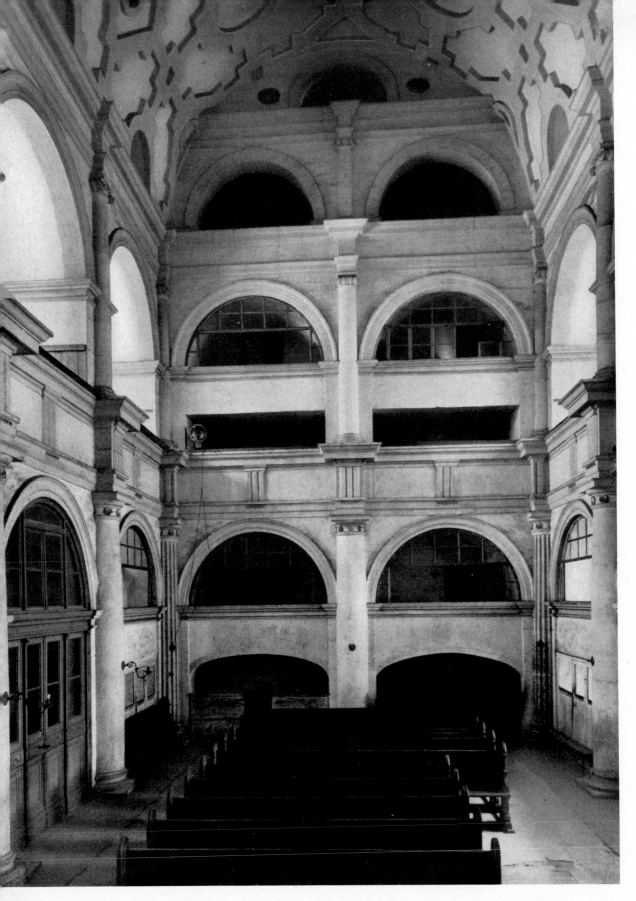

Augustusburg, Sachsen. Das Innere der Schloßkirche (wohl von E. van der Meer, 1568—79)
mit Emporen und quadrierten Tonnengewölben in strengen, niederländischen Renaissanceformen.

Augustusburg, Saxony. Interior of the castle church (probably the work of E. van der Meer, 1568—79),
with tribune and intersecting barrel-vaults in the severe forms of the Dutch Renaissance.

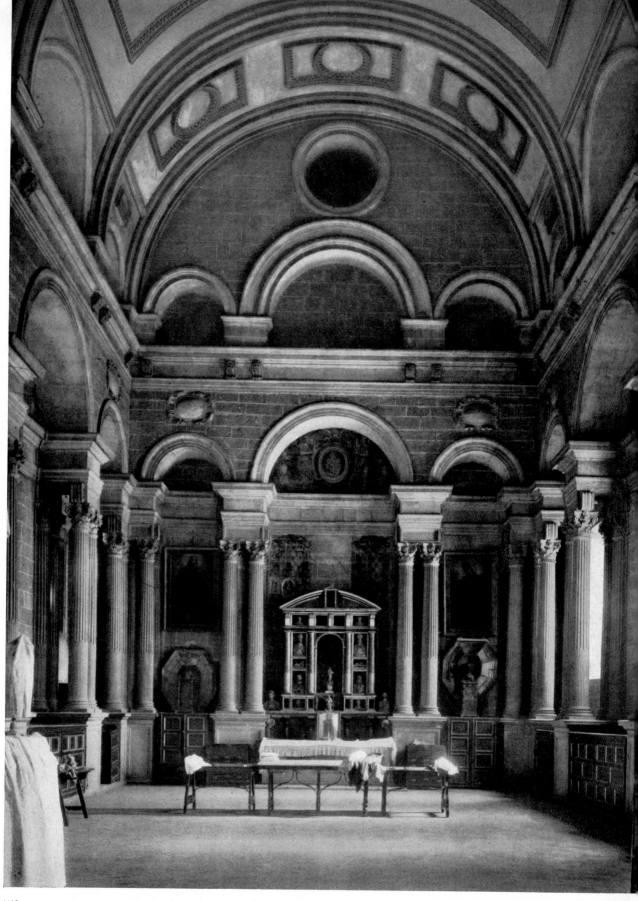

MAS

Jaén, Spanien. Die Sakristei der Kathedrale (Pedro de Valdelvira, nach 1532) in den zu jener Zeit international gewordenen Renaissanceformen.

Jaén, Spain. Cathedral sacristy (Pedro de Valdelvira, post 1532) in the Renaissance forms which by then had become international.

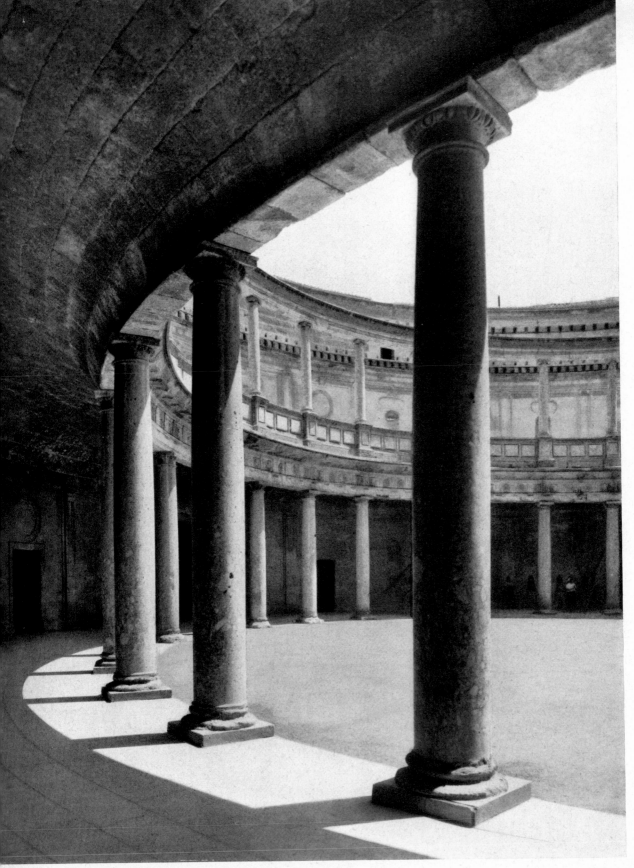

Stursberg

Alinari

Granada. Der Hof im Palast Kaiser Karls V.
auf der Alhambra (beg. 1526 durch Pedro Machuca).
Der der italienischen Hochrenaissance am nächsten kommende Bau Spaniens.

Granada. Courtyard in the palace of the Emperor Charles V
in the Alhambra (begun by Pedro Machuca in 1526).

Rom. Der Hof des Palazzo Massimo alle Colonne,
seit 1532 von Baldassare Peruzzi in den strengen Maßverhältnissen
der Hochrenaissance erbaut.

Rome. Courtyard of the Palazzo Massimo alle Colonne,
built by Baldassare Peruzzi after 1532.

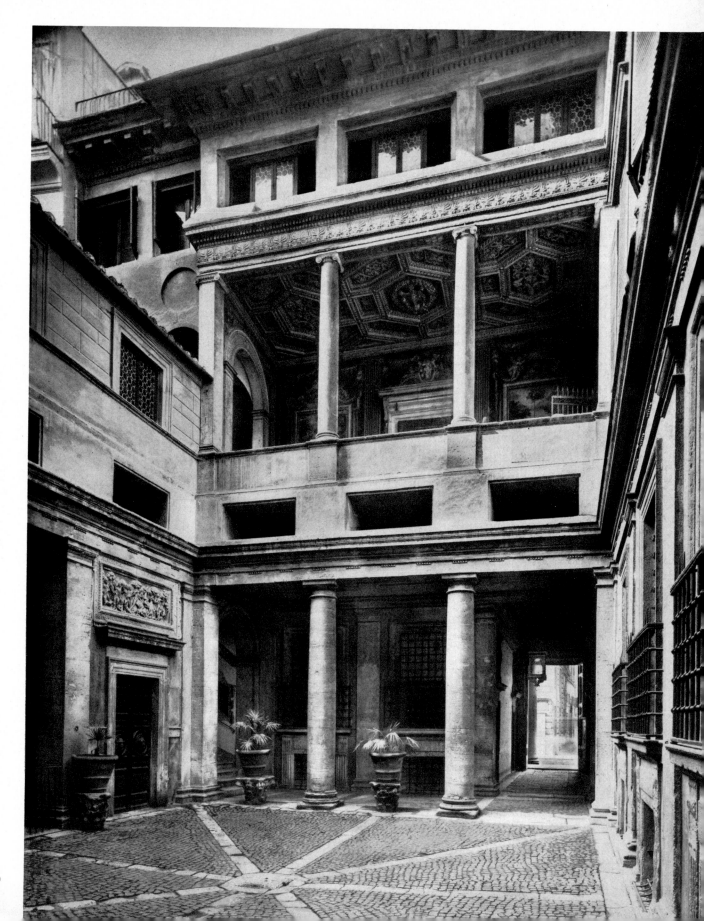

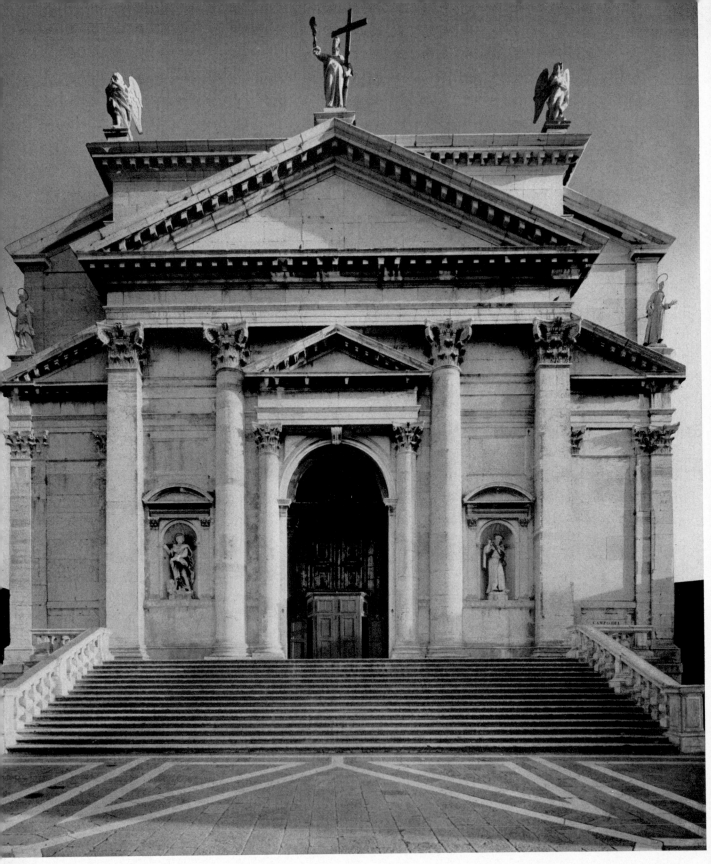

Venedig. Fassade von Il Redentore, d. h. Erlöserkirche,
1577—92 von Palladio als viersäulige Tempelfront errichtet,
mit einer kontrastierenden kleineren Front um den Eingang.

Venice. Four-columned, temple-like façade of Il Redentore
(Church of the Redemption), built by Palladio 1577—92
with a contrasting pillared portico.

Venedig. S. Giorgio Maggiore, 1565 von Palladio begonnen,
mit tonnengewölbtem Langhaus und Kuppel in dem großflächigen,
wesentlich durch die Proportionen wirkenden Stil der Spätrenaissance.

Venice. S. Giorgio Maggiore, begun by Palladio in 1565,
with the barrel-vaulted nave and cupola
in the harmoniously proportioned style of the Late Renaissance.

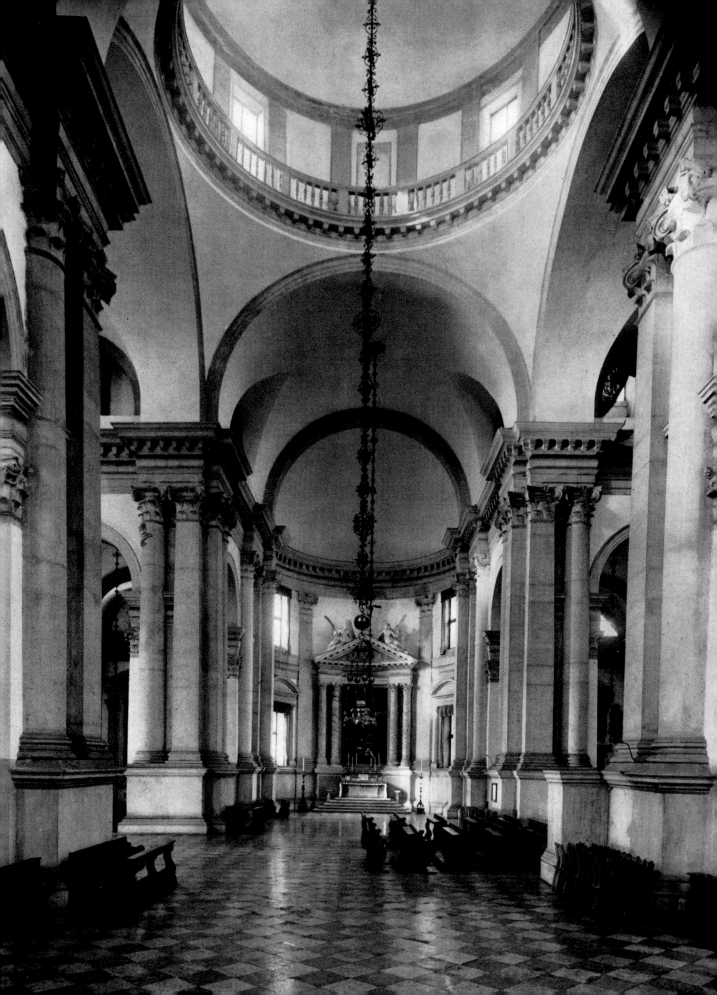

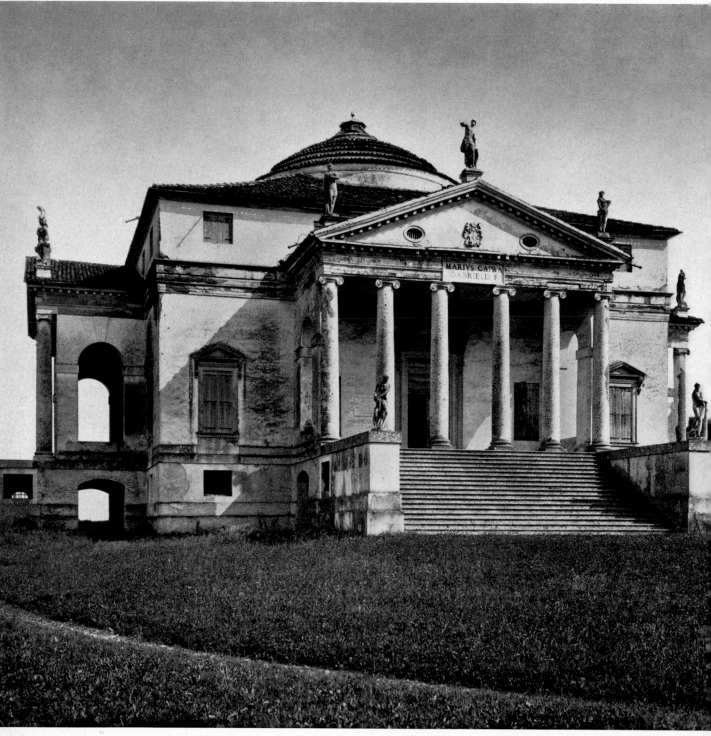

Alinari

Vicenza, Oberitalien. Die Villa Rotonda (1552), ein Hauptwerk Palladios,
des Begründers eines regelhaft-akademischen Stils.
Jeder Quadratseite ist eine Tempelfront vorgelegt.
Goethe bewunderte dieses Gebäude besonders,
weil es den allseitig
harmonisch entwickelten Menschen spiegelt.

Vicenza, N. Italy. The Villa Rotonda (1552),
a major work of Palladio.
It forms a square with a pillared portico to each face.

Vicenza. Zwei weitere Hauptwerke Palladios (rechte Seite)
Oben: Palazzo della Ragione (seit 1549 zur Basilika umgestaltet)
Über einer dorischen eine jonische Bogenhalle. Unten: Palazzo Chieregati (1566)
Charakteristisch für die Spätrenaissance: Auflockerung der Blockform durch Säulenhallen

Vicenza. Another two of Palladio's major works (right-hand page)
Above: Palazzo della Ragione (converted into a Basilica in 1549)
Arcades consist of superimposed Doric and Ionic orders. Below: Palazzo Chieregati (1566)
An effect of lightness is achieved by the addition of an orde
to the rusticated lower storey, a typical Late Renaissance feature

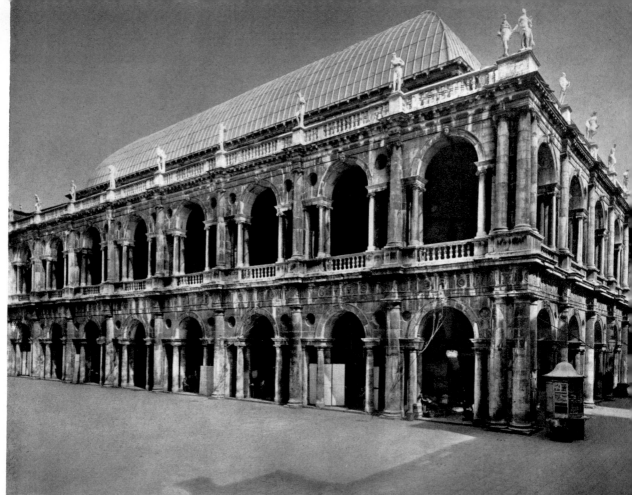

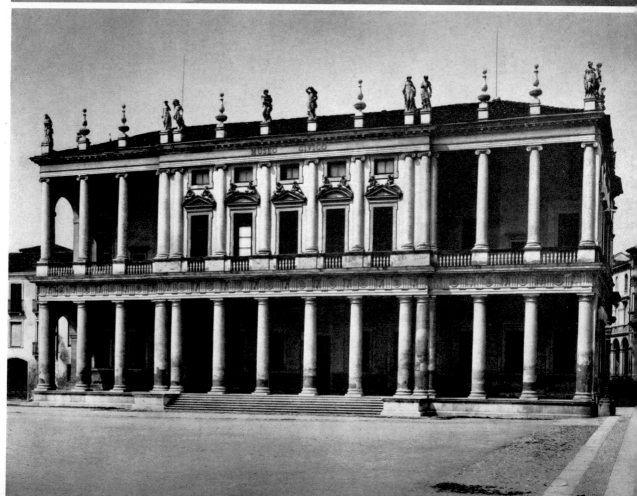

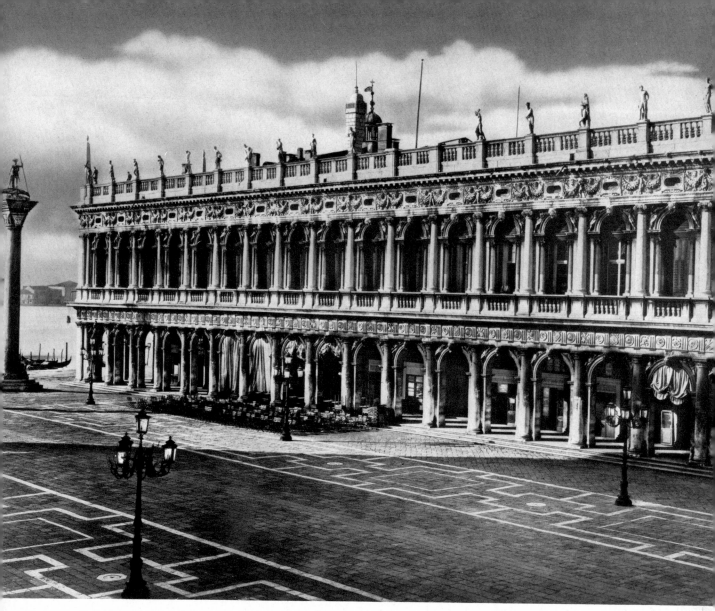

Florenz. Hof der Uffizien (Vasari, 1560—74).
Hauptbeispiel für die beengende „Raumschlucht" des Manierismus,
jenes Stils, der die Hochrenaissance ablöst.

Florence. Courtyard of the Uffizi Palace (Vasari, 1560—74),
showing the narrow effects achieved by Mannerism —
the style which follows High Renaissance.

Venedig. Die Alte Bibliothek (J. Sansovino, 1536—53),
prachtreichster Bau der italienischen Spätrenaissance.
Doppelhalle von Bogenpfeilern zwischen Halbsäulen,
das untere Gesims dorisch, das obere mit Festons (Fruchtgehängen) geschmückt.

Venice. The Library of St. Mark (J. Sansovino, 1536—53),
the most lavish structure of the Italian Late Renaissance.

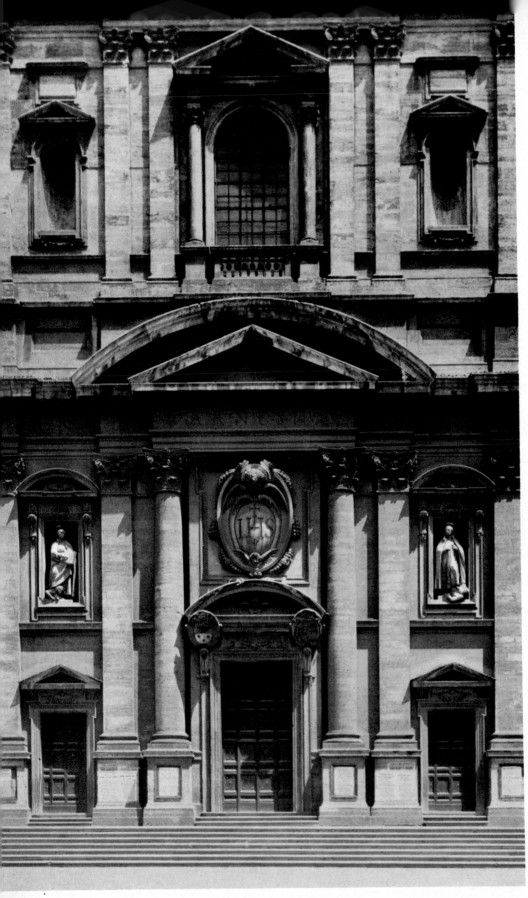

Rom. Die Jesuitenkirche Il Gesù. Fassade von Giacomo della Porta, 1573 entworfen.
Zweigeschossig, durch Pilaster, Dreiecks- und Segmentgiebel gegliedert.

Rome. The Jesuit church of Il Gesù. Façade Giacomo della Porta, designed 1573.

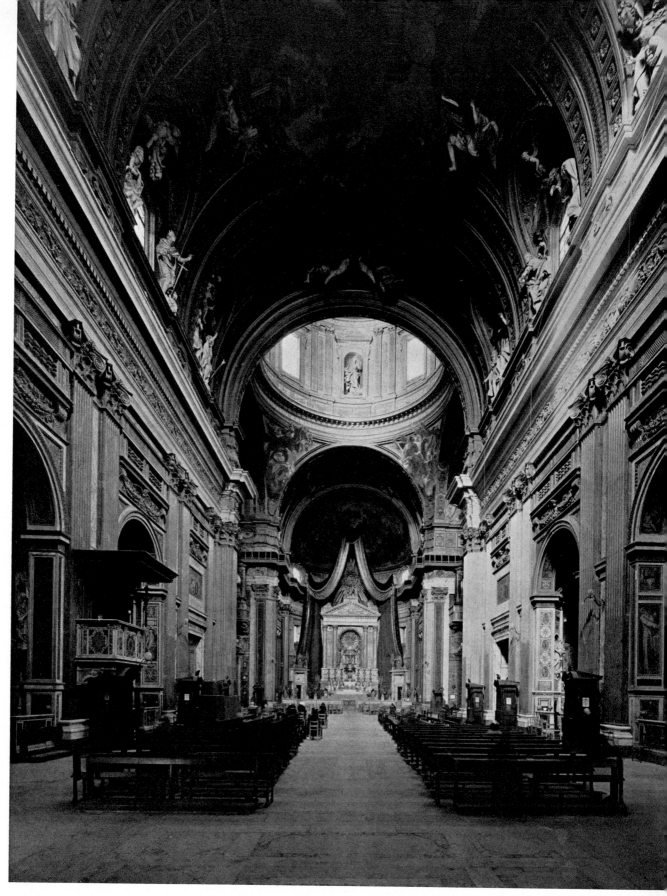

Rom. Il Gesù, Innenraum von Vignola (1568–76). Ein tonnenüberwölbtes Langhaus
führt zu einem lichtdurchfluteten Kuppelraum. Vorbild für die meisten Barockkirchen.

Rome. Il Gesù, interior by Vignola (1568–76). A barrel-vaulted nave leads to the crossing
with its mighty cupola. This interior became a model for most Baroque churches.

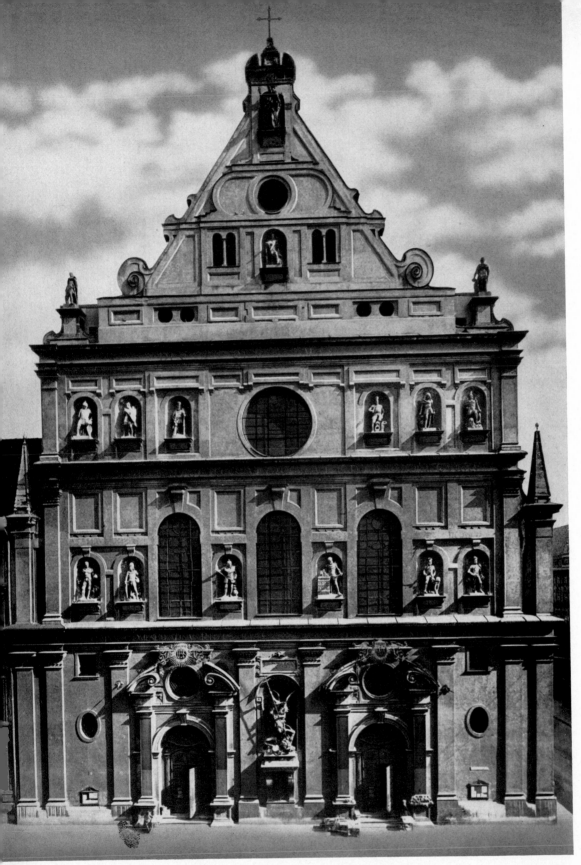

München. Die Jesuitenkirche St. Michael (W. Miller und F. Sustris, 1582–97) zeigt an der Fassade (oben) italienische Formen,
verschmolzen mit einem deutschen Giebelbau. Rechts: In die gewaltige Tonne des Langhauses schneiden die Quertonnen der Seitenkapellen ein.
(Nach Kriegsschäden wiederhergestellt.)

Munich. The Jesuit church of St. Michael (W. Miller and F. Sustris, 1582–97). Italian forms are to be seen on the façade (above)
of this German gabled structure. Right: Interior (restored after suffering bomb-damage.)

108

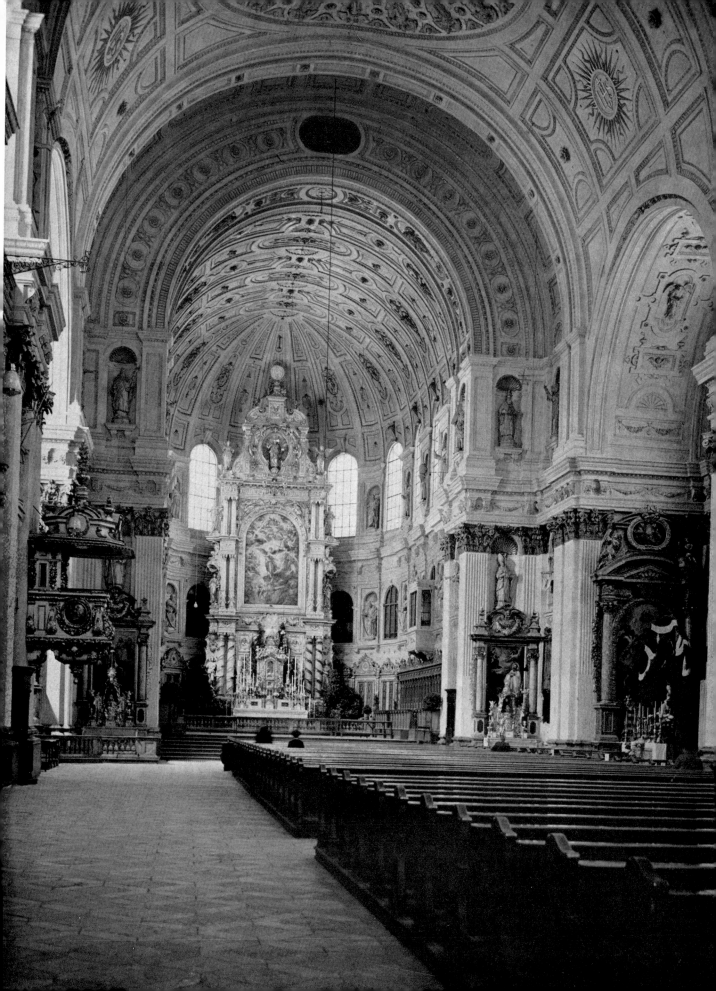

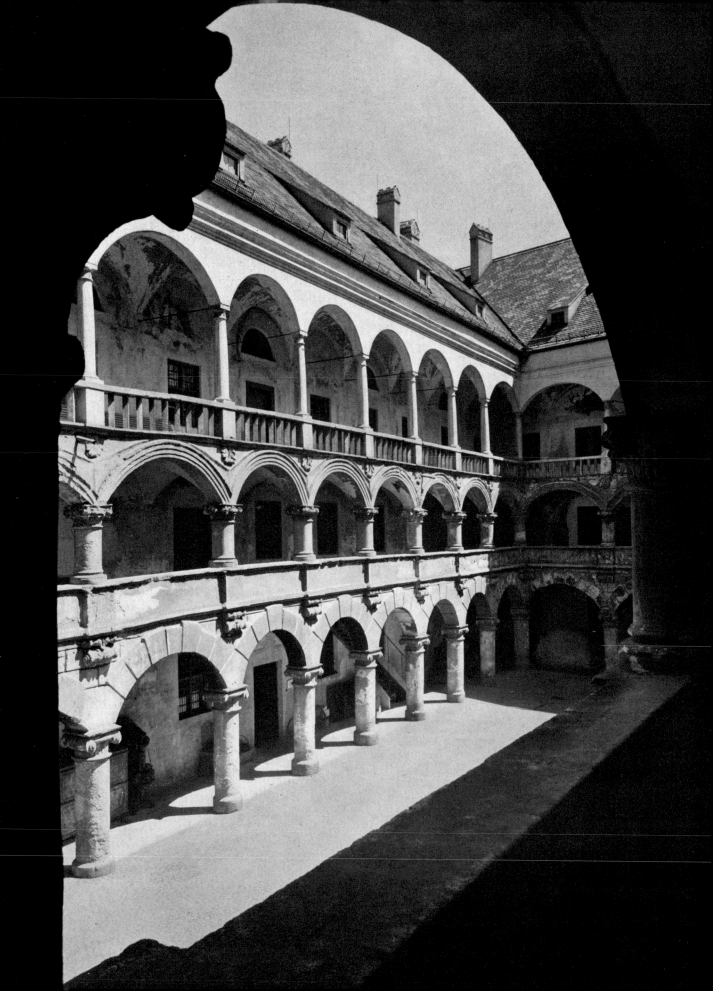

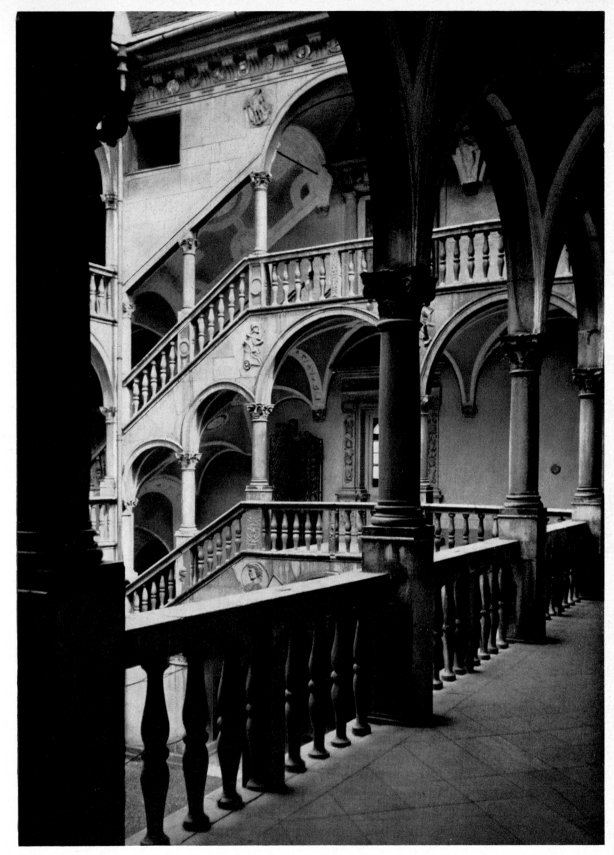

Busch

München. Turnierhof des alten Marstalls, später Münze, seit 1563 von Eckl als dreigeschossige Laube in schweren Proportionen errichtet.

Munich. Exercise yard at the old Royal Stables, later the Mint, built after 1563 by Eckl.

Spittal, Kärnten. Der Arkadenhof des Schlosses Porcia, dessen Bau 1527 von dem italienischen Architekten V. Scarmazzi begonnen wurde.

Spittal, Carinthia. The cortile of the castle of Porcia, begun by the Italian architect V. Scarmazzi in 1527.

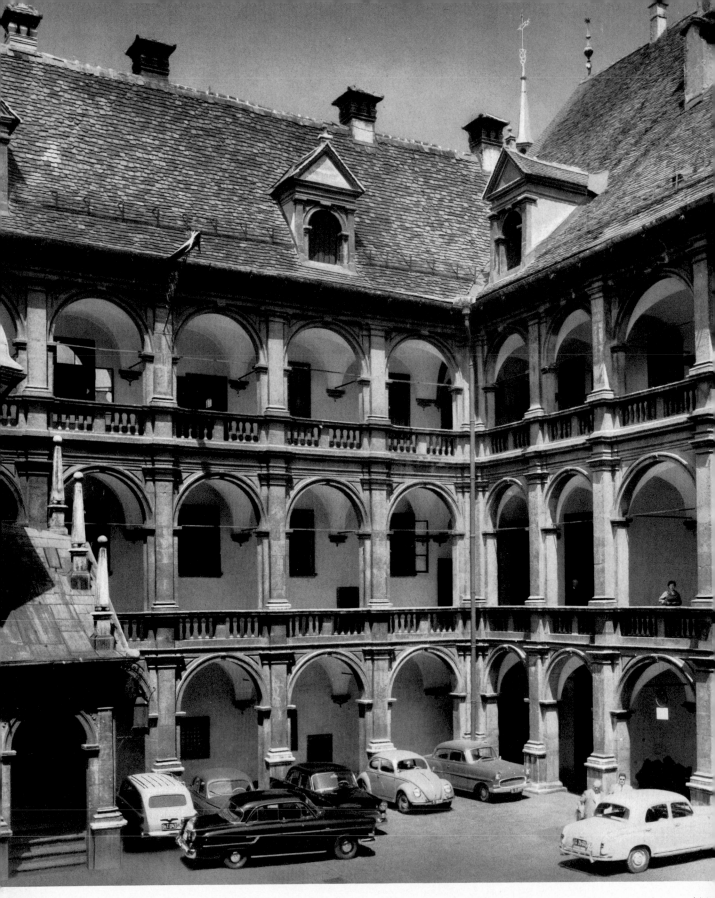

Jeiter

Graz, Steiermark. Der Arkadenhof des Landhauses, 1557–65 von Domenico de Lalio aus Lugano errichtet, zeigt drei Laubengeschosse mit toskanischen Pilastern.

Graz, Styria. Cortile of the provincial diet built 1557–65 by Domenico de Lalio of Lugano.

Basel. Die Front des Spießhofes (um 1580), sparsam und großflächig mit Säulen gegliedert.

Basle. Façade of the Spiesshof (c. 1580), articulated by columns set wide apart.

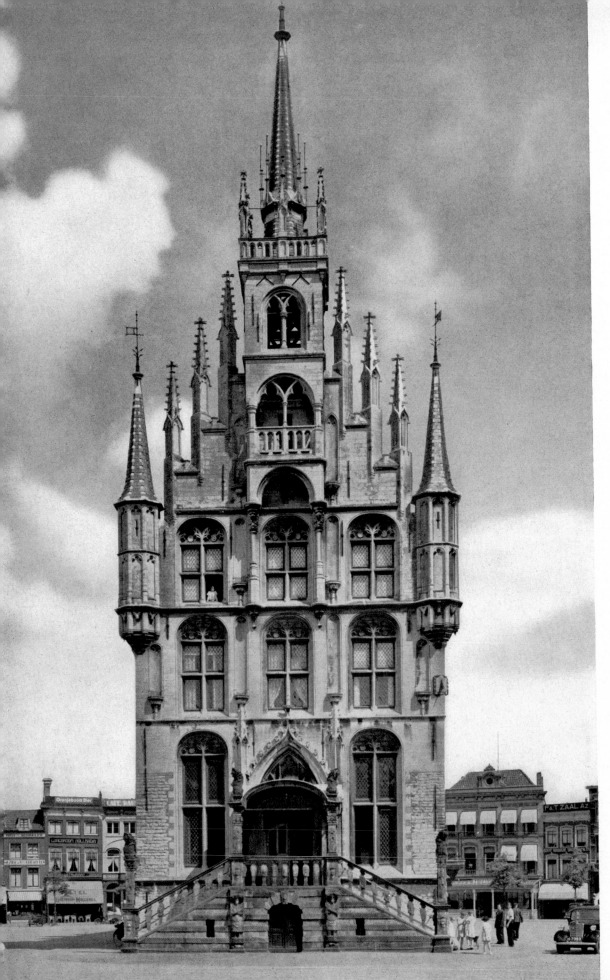

Im nördlichen Europa
wachsen in allmählichem
Übergang die Formen
der Spätgotik denen der
Renaissance entgegen,
zumal im Profanbau.

Gouda, Holland.
Front des Stadthauses
(1449—59).

In N. Europe
by a gradual
transition process
the forms of Late
Gothic merged into
those of Renaissance.

Gouda, Holland.
Front of the city hall
(1449—59).

Foto Marburg **114**

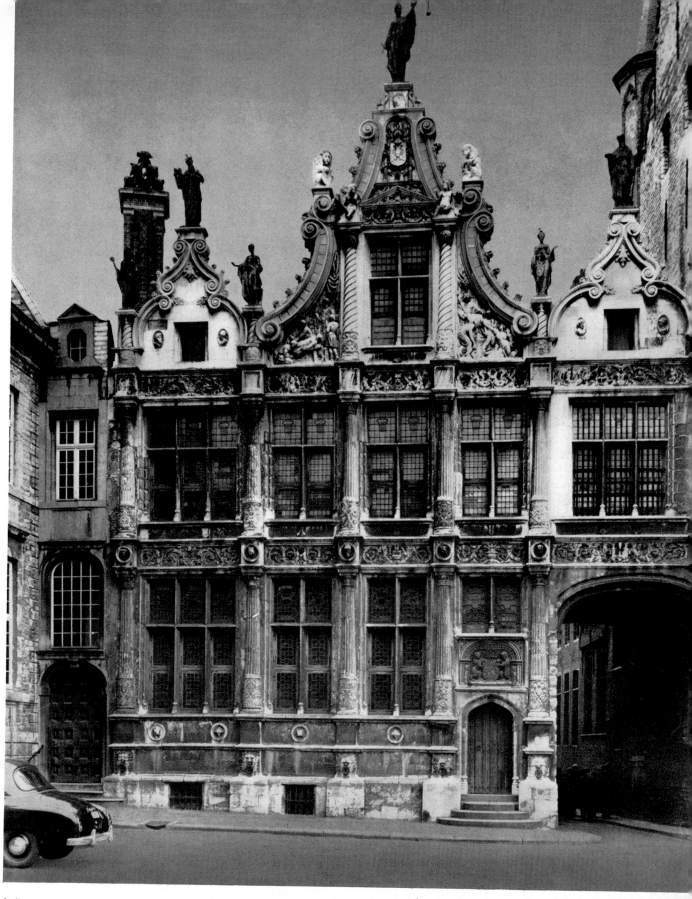

Roubier

Brügge, Belgien. Kanzleigebäude, „Ancienne Greffe" (1535—37).
Über der Renaissancegliederung der Geschosse zwischen Schwüngen ein manieristischer Giebel.

Bruges, Belgium. The "Ancienne Greffe" (1535—37), now part of the Palais de Justice.

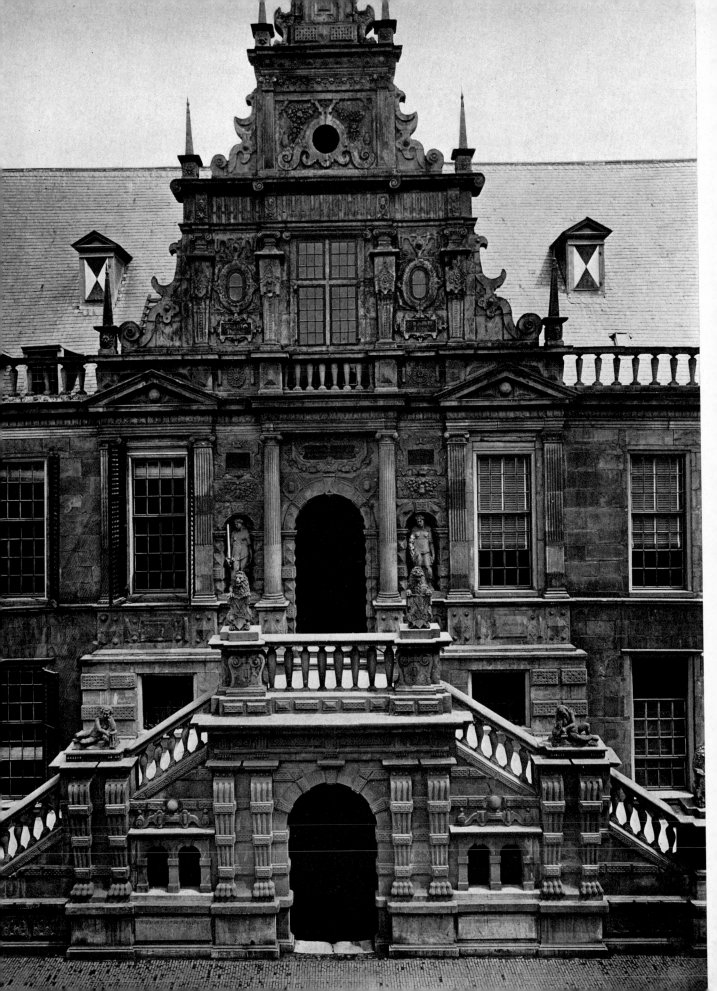

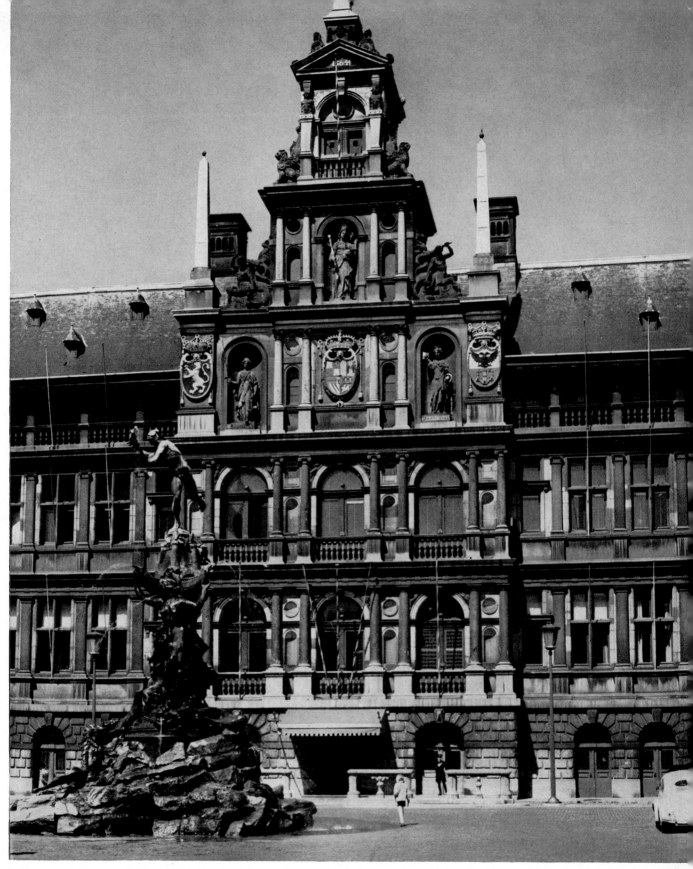

Roubier

Monumentenzorg

Leiden, Holland. Rathaus (L. de Key, 1597–1603). Übernahme klassischer Formen
für eine nordische Fassade, die ihre besondere Wirkung
durch ein Wechselspiel von Haustein und Ziegelwerk gewinnt.

Leyden, Holland. Town hall (L. de Key, 1597–1603).

Antwerpen. Rathaus (C. Floris, 1561–65). Das Hauptwerk des flämischen
Manierismus — zugleich das zuchtvollste, da nicht überladen.

Antwerp. Town hall (C. Floris, 1561–65).
The chief monument of Flemish Mannerism.

Felton

Glastonbury, Somerset. Der Pilgergasthof „George and Pilgrims" (1470–75).
Besonders in England setzen sich schon in der Spätgotik rechtwinklige Gliederung und horizontale Lagerung durch.

Glastonbury, Somerset. The George Inn (1470–75), frequented by pilgrims.
At an early date during the Late Gothic period rectangular articulation, with the emphasis on horizontality, came into its own in England especially.

Burghley House
(1585, bei Stamford)
vermischt im Hauptpavillon
des Hofes unbefangen
das französische
Triumphbogenmotiv mit einem
englischen Erkerfenster
und flämischem Schnörkelwerk
zu einem manieristischen Effekt.

Burghley House (1585)
near Stamford.
In the main block
of the central court
a number of features contribute
to the Mannerist effect —
he French triumphal arch motif,
together with an English
oriel-window and Flemish
scroll-work.

Kersting

Edwin Smith

Hengrave Hall in Suffolk, ein englischer Landsitz, zwischen 1525 und 1538
von dem neu geadelten Tuchhändler John Kytson erbaut.
Der mit Wappen und Putten geschmückte Erker über dem Portal
kontrastiert mit der sonst glatten Wand.

Hengrave Hall in Suffolk, a country house built between 1525 and 1538
by John Kytson, a draper recently raised to the nobility.

Hengrave Hall. Der von John Sparke geschaffene Erker
springt auf konzentrischen Ringen dreiteilig vor die Front vor;
die trennenden Pilaster stehen auf Gebilden,
die den Schlußsteinen spätgotischer Gewölbe ähneln.

Hengrave Hall. The balcony, the work of John Sparke,
juts out from the front in three parts based on concentric circles.

121

Paris. Die Kirche
S. Etienne-du-Mont
(1517–1618).
Links: Über einem
Dreiecks- und einem
Segmentgiebel ein
manieristisch steiler
Giebel, die Rose mit
spätgotischem Maßwerk
gefüllt. Rechts: Lettner
(Biard, 1600–05).
Pfeiler und Gewölbe
gotisch, Türrahmen
zum Seitenschiff
Renaissance,
Spiraltreppe manieristisch.

Paris. Church of S. Etienne
du Mont (1517–1618).
Left: above a triangular
and a segmental gable
towers a Mannerist
steep-pitched gable.
Rose window with
Late Gothic tracery.
Right: rood-screen
(Biard, 1600–05).

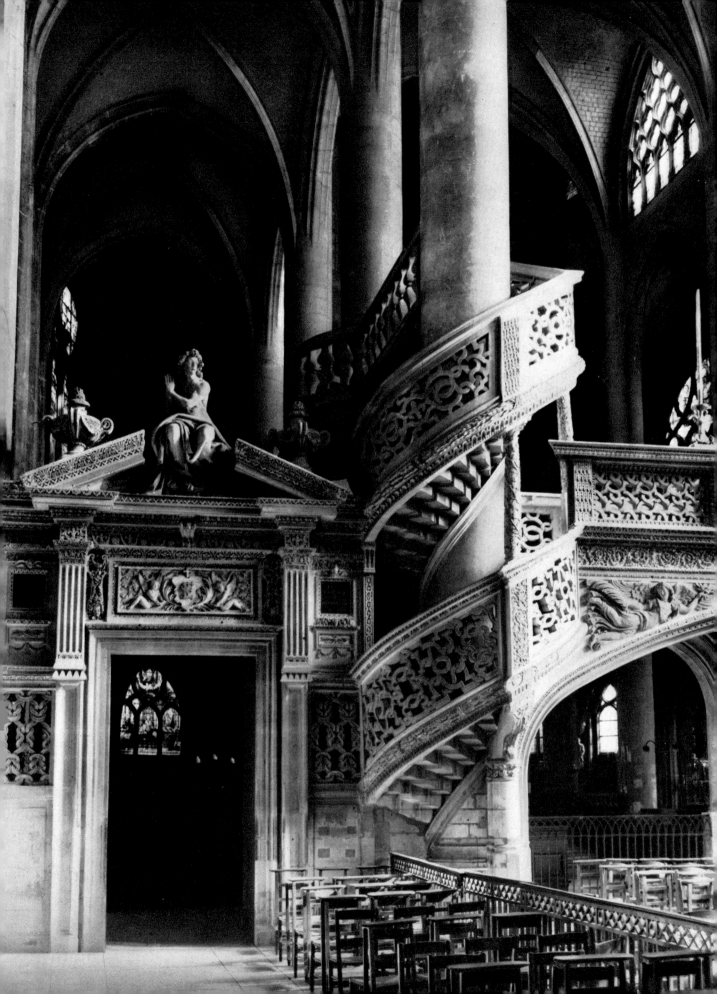

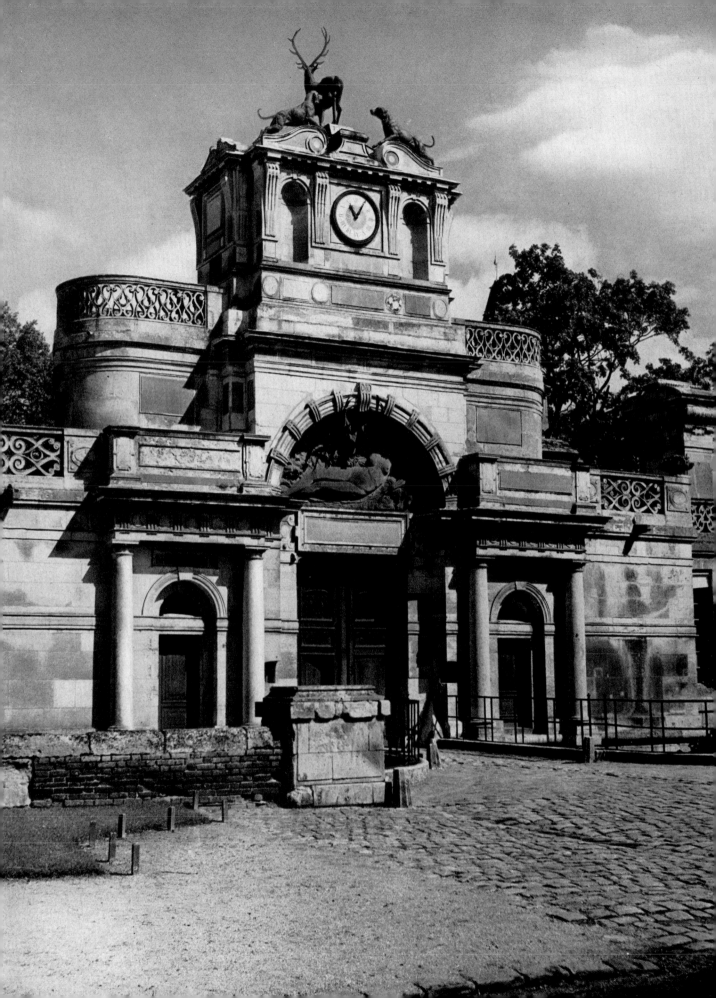

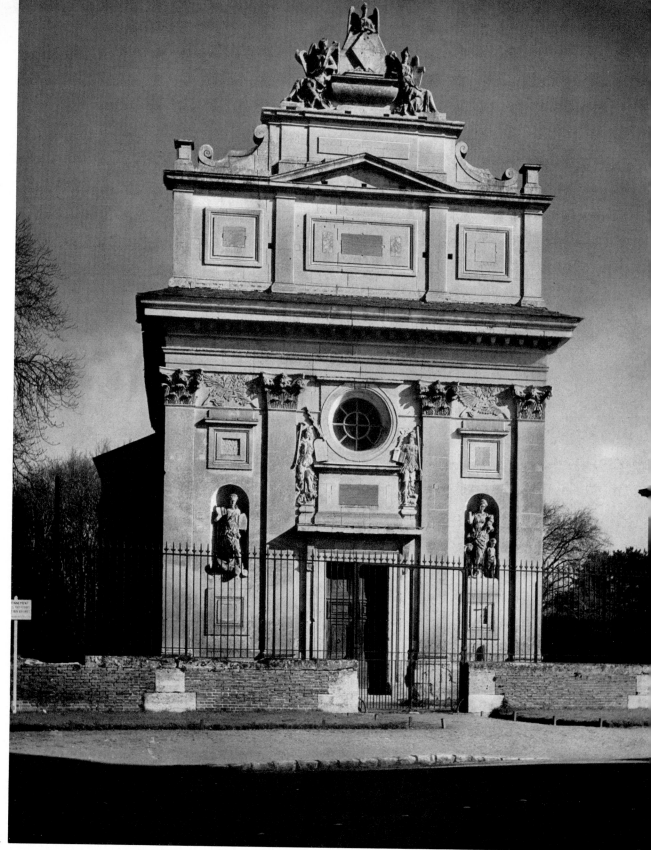

Jeiter

Roubier

Anet, Frankreich. Haupttor des Schlosses,
1548–1552 von Philibert Delorme. Die gerundete Attika und die Balustraden
wandeln die italienischen Anregungen eigenwillig ab.

Anet, France. Main gate of the castle,
designed 1548–52 by Philibert Delorme.

Anet. Die Fassade der Kapelle (vor 1500), die sich Diana von Poitiers,
Favoritin des Königs, als Grabstätte im Schloß baute. Charakteristisch die
französisch flachen Reliefs mit Pilastern, welche Nischenfiguren einschließen.

Anet. Façade of the chapel (pre 1500) which Diane de Poitiers,
the king's mistress, had built in the castle as a last resting place.

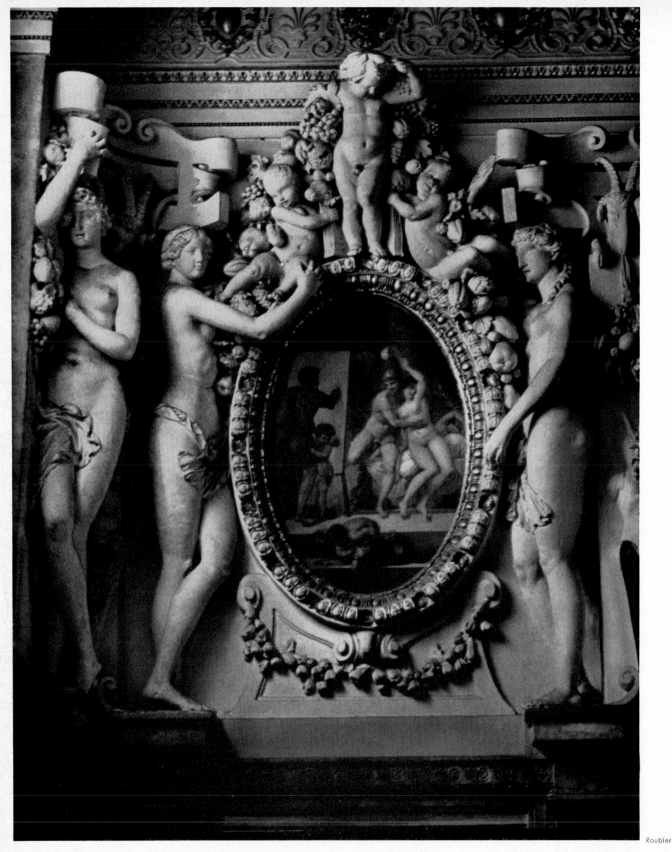

Plastik und Malerei des Manierismus, mit ihrer Vorliebe für Allegorien, leisten ihr Bestes als Dekoration im Dienste der Architektur.
Oben: *Fontainebleau*. Schloß. Wandschmuck von R. Rossi (um 1535). Rechts: *Paris*. S. Denis. Grabmal (1517–31) für Ludwig XII.
und Anne de Bretagne – einmal als Leichname dargestellt, darüber als Lebende im Gebet.

Mannerist sculpture and painting are at their best as decoration in the service of architecture. Above: *Fontainebleau*. Château.
Mural decoration by R. Rossi (c. 1535). Right: *Paris*. S. Denis. Tomb (1517–1531) of Louis XII
and Anne of Brittany – portrayed once as corpses and above alive, kneeling in prayer.

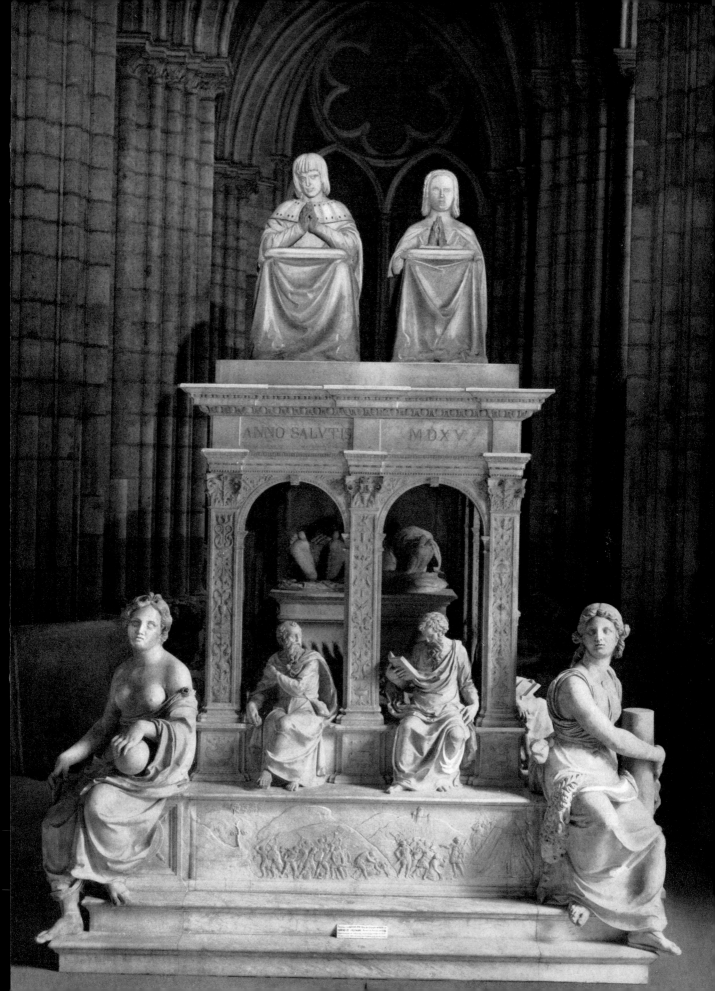

Roubier

Schneiders

Fontainebleau. Schloß. Decke aus sechsseitigen Kassetten, die von römischen Vorbildern abstammen.

Fontainebleau. Château. Ceiling of hexagonal wood-panelling, a replica of Roman models.

Schloß Heiligenberg, unweit des Bodensees. Der Rittersaal, dessen kunstvoll komponierte Lindenholzdecke mit Grotesken und Akanthus gefüllte Felder aufweist. (Vollendet 1584)

Heiligenberg Castle not far from Lake Constance. The Knights' Hall withs its artistically composed lime-wood ceiling, a riot of grotesques and acanthus. Completed 1584.

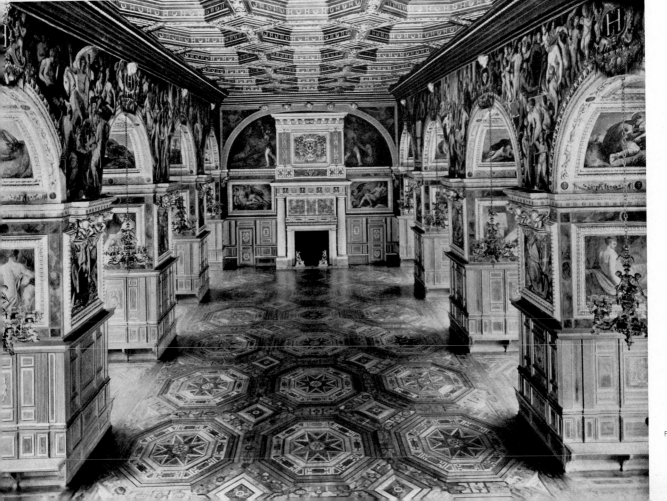

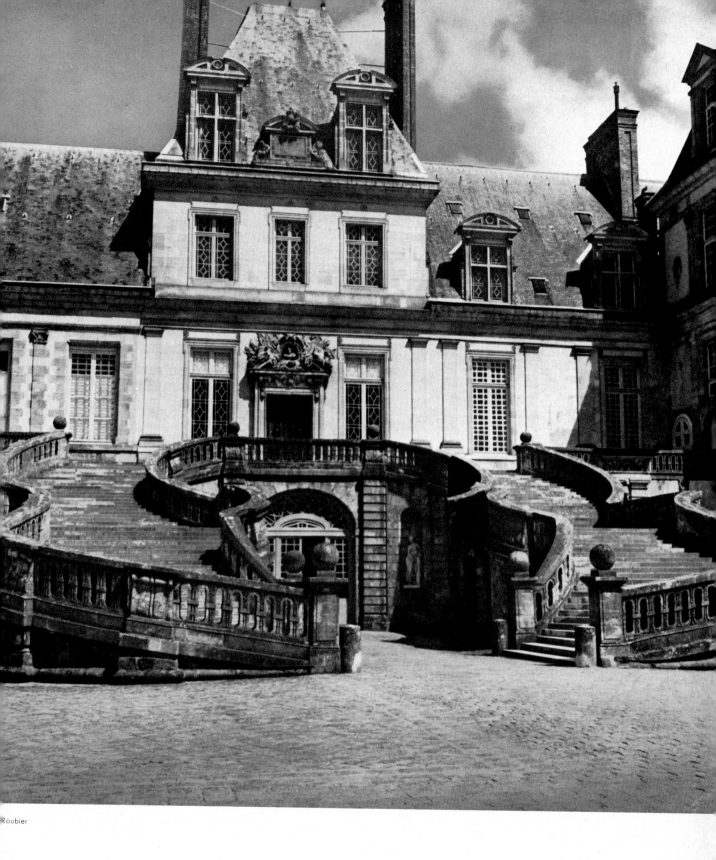

Roubier

Fontainebleau. Oben: Der Hof des Schlosses, das Gilles le Breton für König Franz I. begann. Die geschwungene Ehrentreppe 1634 von J. Lemercier.
Linke Seite: Die Ausstattung des Inneren. Oben: Stuckarbeiten in der Galerie Franz I. Hier etablierte nach 1530
eine italienische Künsterkolonie unter Rossi und Primaticcio die „Schule von Fontainebleau", Quelle des französischen Manierismus.
Unten: Der Saal Heinrichs II., 1553 durch italienische Maler und Ph. Delorme gestaltet.

Fontainebleau. Above: Courtyard of the château begun for Francis I by Gilles le Breton. The bold sweeping staircase by J. Lemercier 1634.
Left page: interior decoration. Above: stucco work in the Gallery of Francis I. A colony of Italian artists was responsible for the decorative trends
of French Mannerism after 1530. Below: Hall of Henry II, the work of Italian painters and Ph. Delorme. 1553.

Busch

Foto Marburg

Blois a. d. Loire. Kamin in dem von König Franz I. (1515—47) erbauten Flügel des Schlosses, mit zartem italienischem Renaissanceornament. Der Kamin ist im Profanbau der Hauptträger des Schmuckes, wie es in der Kirche der Altar war.

Blois - sur - Loire. Fireplace with the delicate ornamentation of the Italian Renaissance in the wing built by Francis I (1515—47). The fireplace is to secular buildings what the altar is to a church — the focus of attention and therefore more lavishly decorated than any other part.

Jever, Oldenburg. Die überreich geschnitzten Kassetten an der Decke des Audienzsaales im Schloß der Maria von Jever, 1566 von Meister P. H.

Jever, Oldenburg. The lavishly carved panelling on the ceiling in the Audience Chamber of Maria von Jever's castle, executed by Master P. H. in 1566.

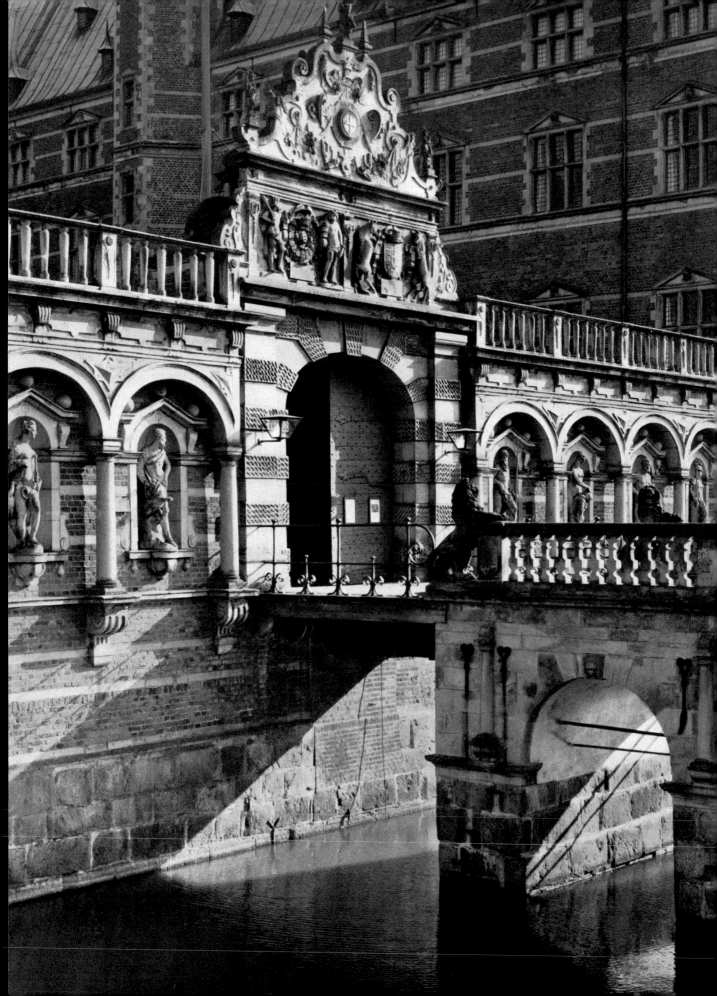

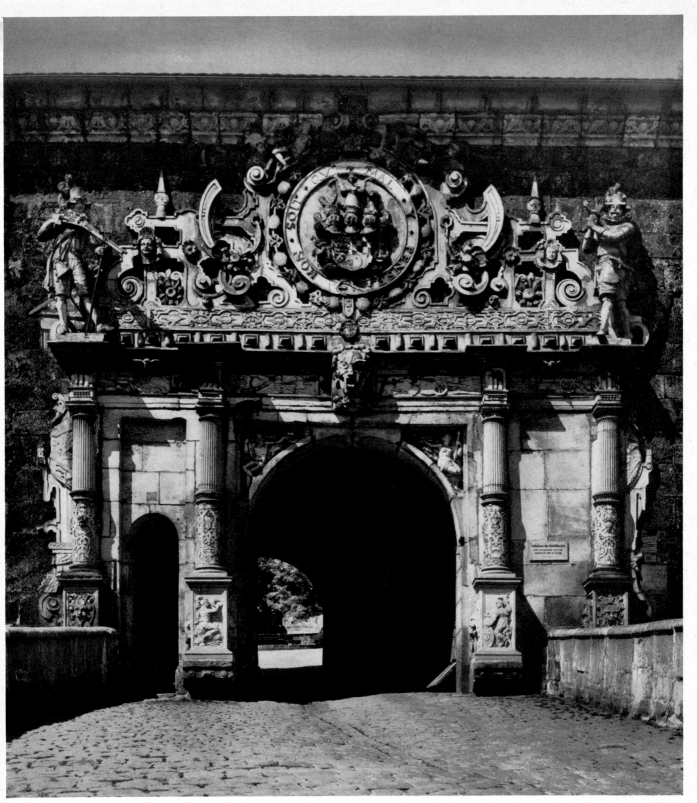

Eschen

ederiksborg, Dänemark. Das vor 1620 erbaute Portal des Schlosses
(ehe Abb. 137) in dem mit Figurennischen italienischer Art
gliederten Abschlußtrakt. Die „welsche Mode" hat sich nun auch im Norden
r bodenständigen Baugesinnung eingeschmolzen.

ederiksborg, Denmark. The castle portal (built before 1620,
illustration 137) with Italianate niche statuettes. The "foreign fashion"
s adapted itself to native architectural forms.

Tübingen. Das dreiteilige Portal des Schlosses.
Die Säulen stehen auf hohen Postamenten; eine Wappenkartusche,
durch Schweifwerk mit Voluten und Soldatenfiguren gerahmt, krönt das Tor.

Tübingen, Wurtemberg. The portal of the castle.
The pillars rest on high pedestals.
Often the north adopts Renaissance forms only
for isolated parts of the structure.

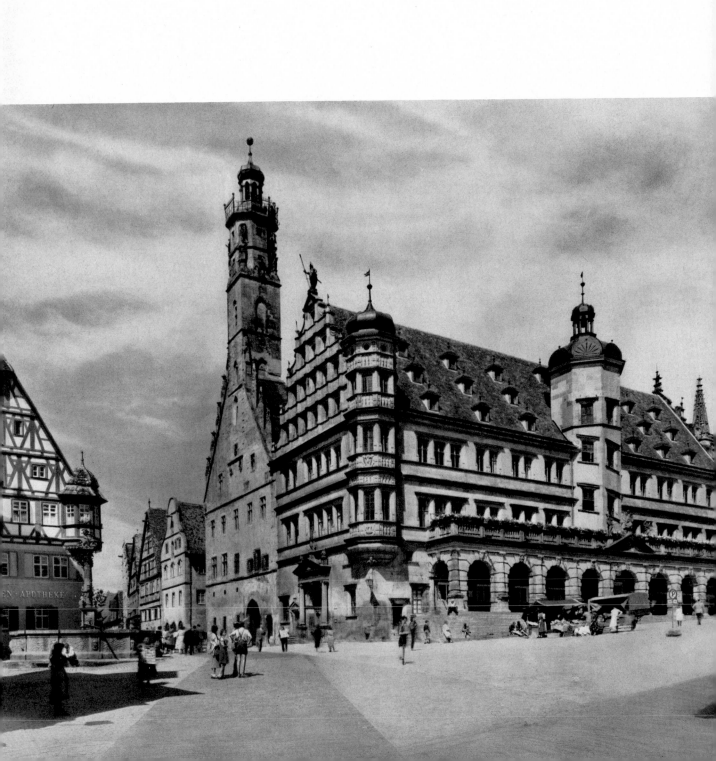

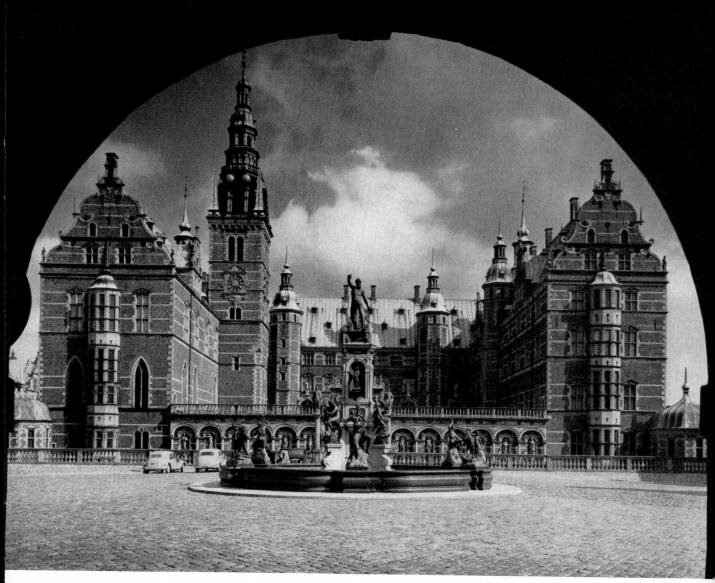

othenburg ob der Tauber. Das Rathaus, dessen repräsentativer
enaissancetrakt 1572–78 mit einem Erker und einem Treppenturm
ewußt unsymmetrisch dem gotischen Teil vorgelegt wurde.

othenburg. Town hall. The impressive Renaissance wing (1572–78)
ith balcony and staircase-turret was added to the Gothic part,
eating an effect of studied asymmetry.

7

Frederiksborg, Dänemark. Das Schloß (1602–20),
ein frühes Beispiel der um einen Ehrenhof
angelegten Dreiflügelbauten.

Frederiksborg, Denmark. The castle (1602–20),
an early example of a three-winged
structure grouped round a grand courtyard.

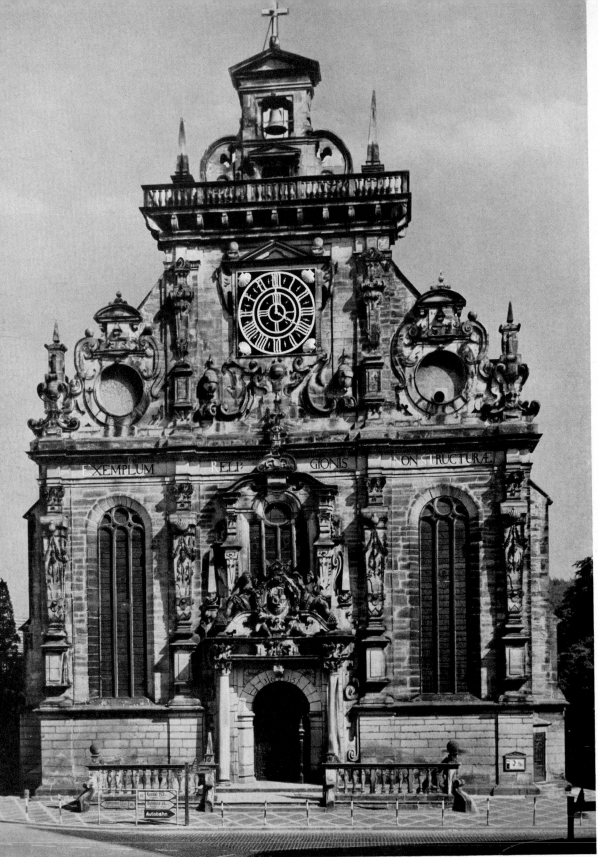

Bückeburg, Stadtkirche. Mehr als das Innere
vertritt die turmlose Giebelfront (erbaut von Hans Wolf)
mit stark sprechenden Gesimsen und dekorativ krausem Schmuck
die neue Bauepoche des Manierismus.

Bückeburg, Lower Saxony. Stadtkirche.
The towerless gable front designed by Hans Wolf,
representative of the new age of Mannerism.

Bückeburg. Inneres der Stadtkirche (1611–15
einer gotisch konstruierten Hallenkirch
die sich durch antike Säulen und Kapite
der Renaissance angleich

Bückeburg. Interior of the Stadtkirche (1611–15
a hall-church constructed in the Gothic sty
with Renaissance touches — classical columns and capital

1

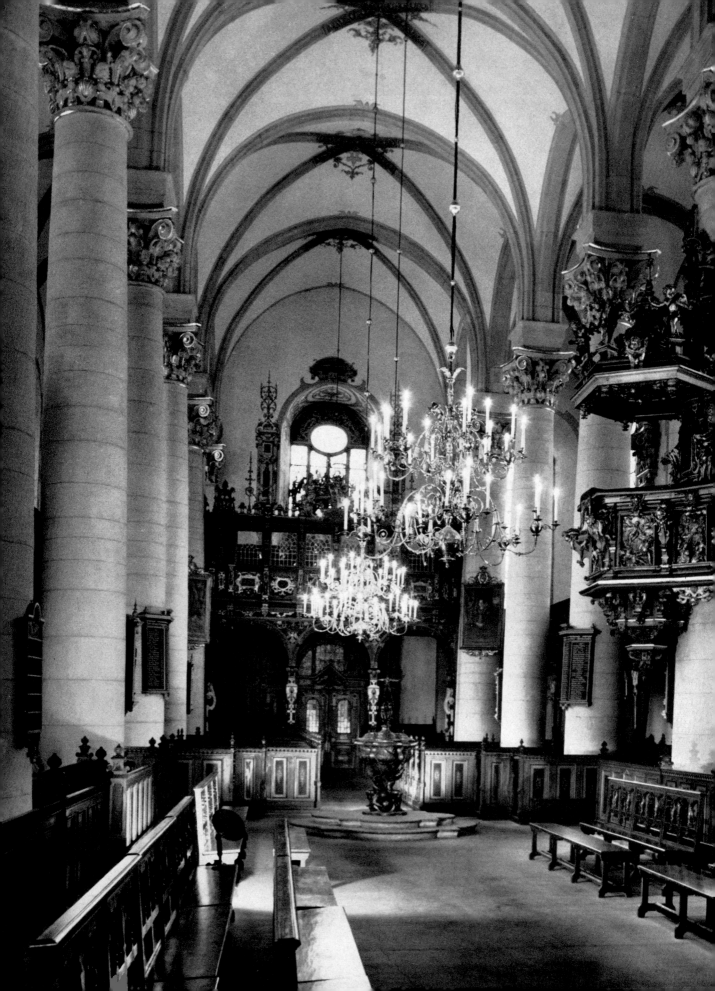

Evers

Hannoversch-Münden. Das Portal des Rathauses — Beispiel für viele ähnliche im Norden —
bereichert den Bogen und das Gesims mit seinen Obelisken sowie mit dem Beschlag- und Schweifwerk des Manierismus.

Hannoversch-Münden. The town hall portal, a model for many such in the north.

Lüneburg. Die Ratsstube (Albert von Soest, 1684). Die zurückhaltende Pilastergliederung der Tür kontrastiert mit den überladenen, tief durchbrochenen Seitengebilden, in denen das Erbe spätgotischer Sakramentshäuser fortlebt.

Lüneburg. The council chamber of the town hall (Albert of Soest, 1684).

Deutscher
Kunstverlag

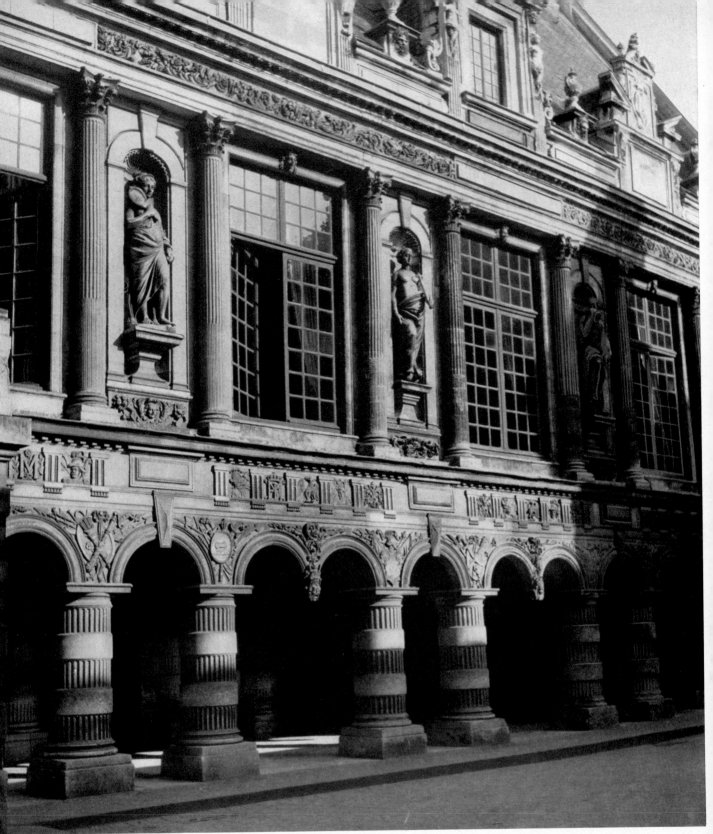

La Rochelle. Hof des Rathauses (1595–1607). Stämmige Säulen tragen Bogen, die zum Teil frei hängen. Über ihnen ein dorisches Gesims, Nischenfiguren und ein jonisches Gesims.

La Rochelle. Town hall courtyard (1595–1607). Sturdy pillars support arches standing partly on their own. Above them are to be seen a Doric entablature, niche-statuettes and an Ionic entablature.

Lüttich. Hofseite des Bischofspalastes (1525–32 Ein manieristischer Effekt läßt schwache Säulen stärkere Kelch und diese wiederum Kapitelle mit dekorativen Köpfen trager

Liège. Episcopal Palace (1525–32) seen from the courtyar The effect of Mannerism is produced by the slender column carrying sturdier cusped capitals carved with decorative head

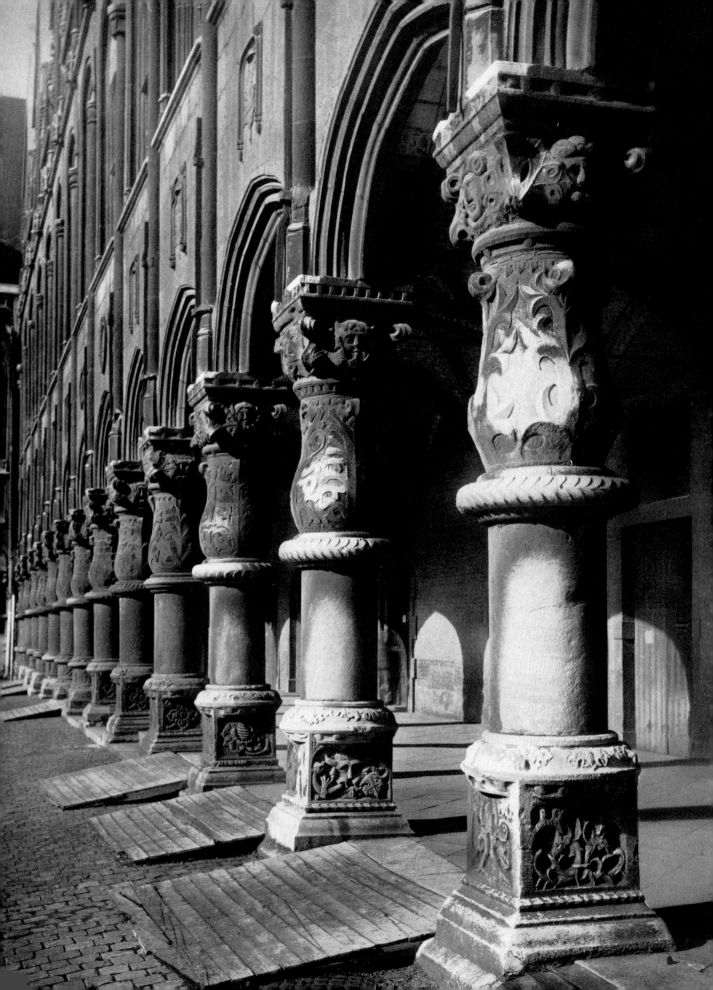

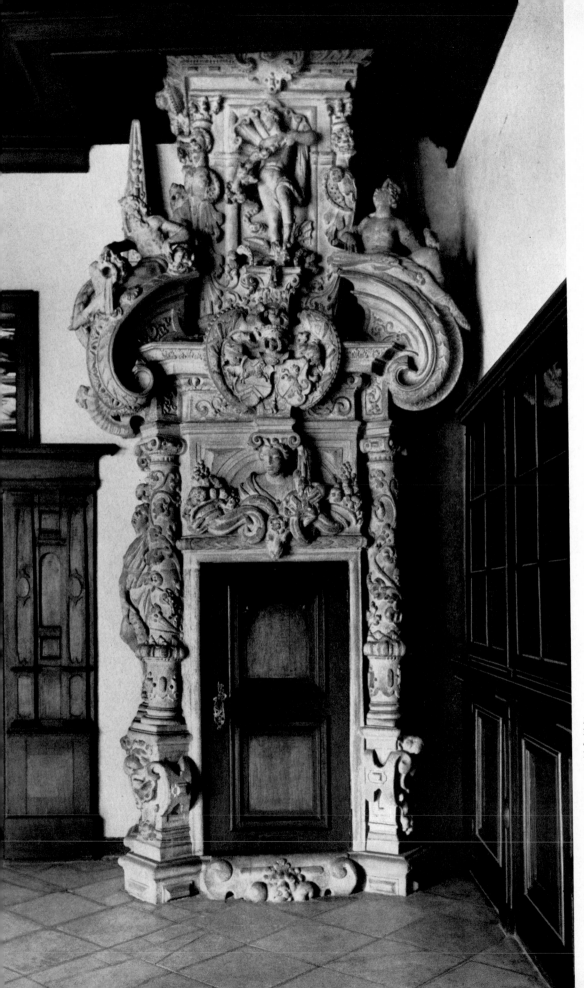

Nürnberg. Der ehemalige
Kamin im Pellerhaus läßt,
charakteristisch für den
Manierismus, schwache
Säulen eine schwere Volute
tragen, die in der Mitte
gesprengt ist, um ein
Wappen erscheinen
zu lassen.

Nuremberg. A typical
feature of Mannerism
is to be seen in the
former fireplace of the
Pellerhaus. Slender
columns support a heavy
volute opening in the centre
to reveal an
escutcheon.

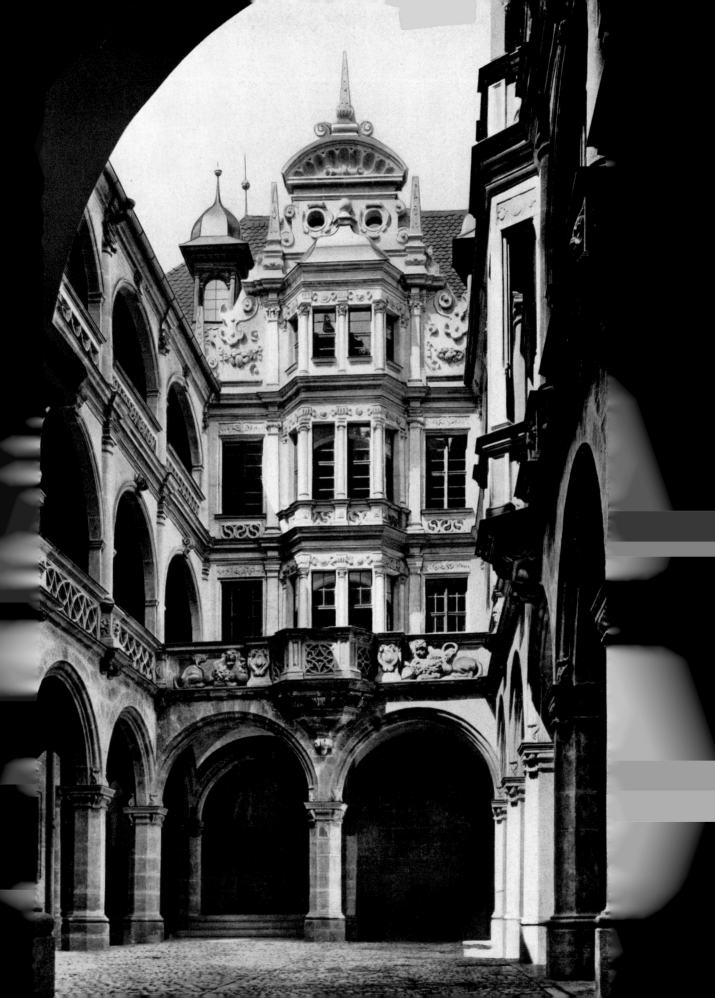

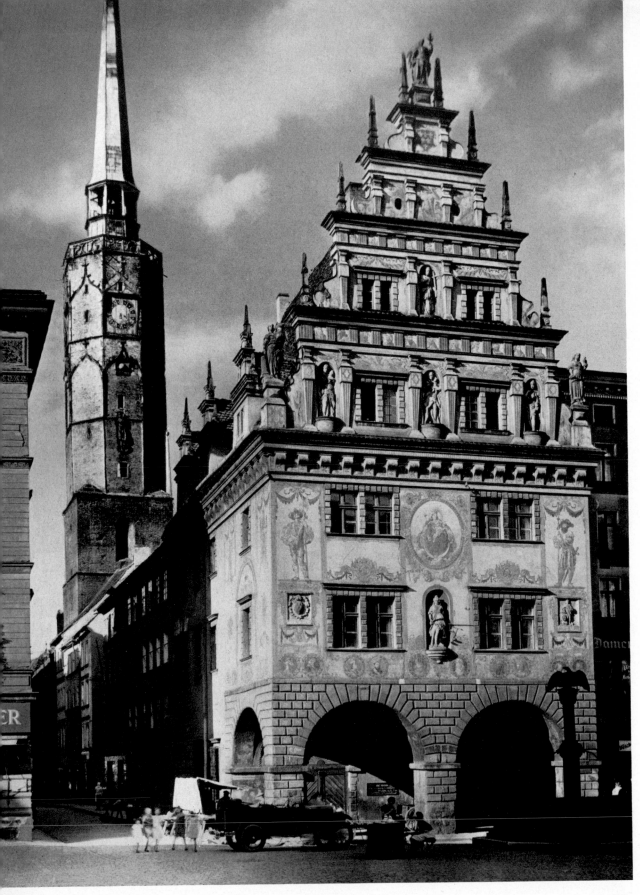

Neisse, Schlesien. Das Waagehaus (1604) mit Wandmalerei am Hauptblock, wie sie jene Zeit liebte, und einem durch starke Gesimse gegliederten Giebel.

Neisse, Silesia. The Weighing Office (1604) with frescoes on the main block, and a gable with bold cornices.

146

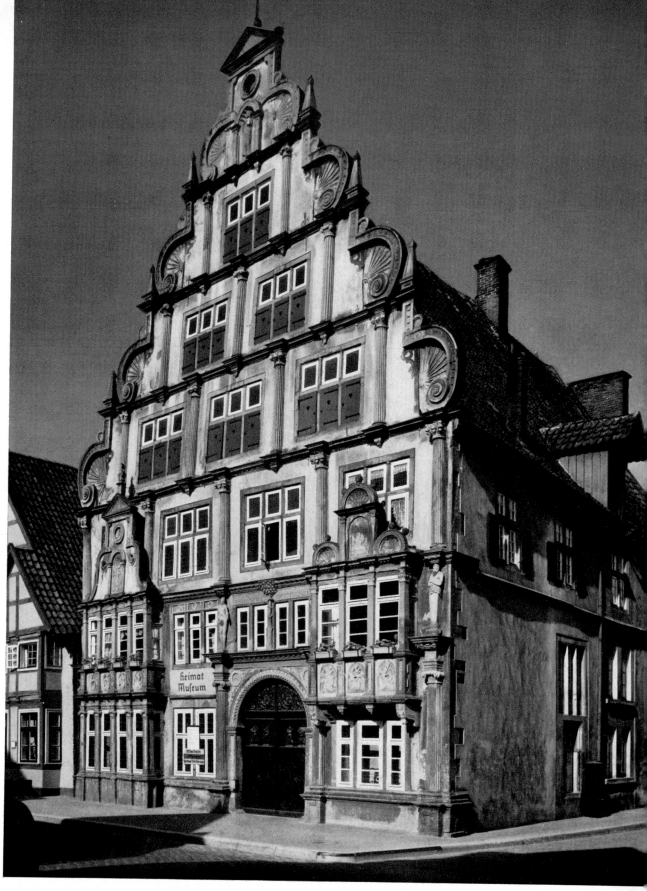

Lindemann

Lemgo, Lippe. Das „Hexenbürgermeisterhaus" von 1571. Gesimse und kanellierte Säulen, die auf Lücke stehen,
gliedern die Front, deren Giebel von kraftvollen Voluten mit einem Muschelmotiv eingefaßt ist.

Lemgo, Lippe. The "Hexenbürgermeisterhaus" dating from 1571.
The front is adorned with cornices, fluted columns and a gable bordered by mighty volutes in shell-motif.

Hannover. Das Leibnizha[us]
(jetzt zerstört) hatte me[hr]
stille Flächen als sei[n]
Vorgänger, bewahrte ab[er]
noch 1652 am Erker und a[n]
den Giebelrücksprünge[n]
die gedrängte Zier d[es]
Manierismu[s]

Hanover. The Leibnizha[us]
(now destroyed) show[ed]
more plain surfaces th[an]
its predecessors, but as la[te]
as 1652 still preserved [on]
balcony and gable t[he]
crowded ornamentati[on]
peculiar to Manneris[m]

Ehem. Staatl. Bildste[lle]

Bremen. Das Essighaus (1618)
Alle Flächen zwischen den
Fenstern sind mit Schweifwerk
überzogen, dessen Bewegung
in den Obelisken auf den
Giebelsimsen ausklingt.

Bremen. The Essighaus (1618)
All surfaces between
the windows are
chamfered as far as the
obelisks on the
gable cornices.

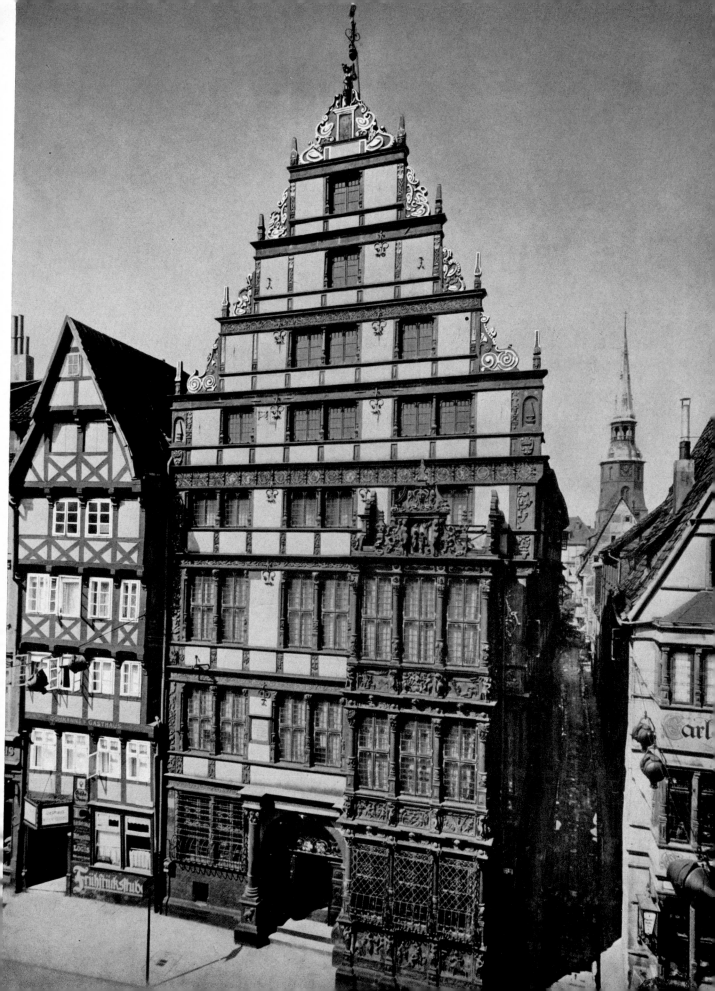

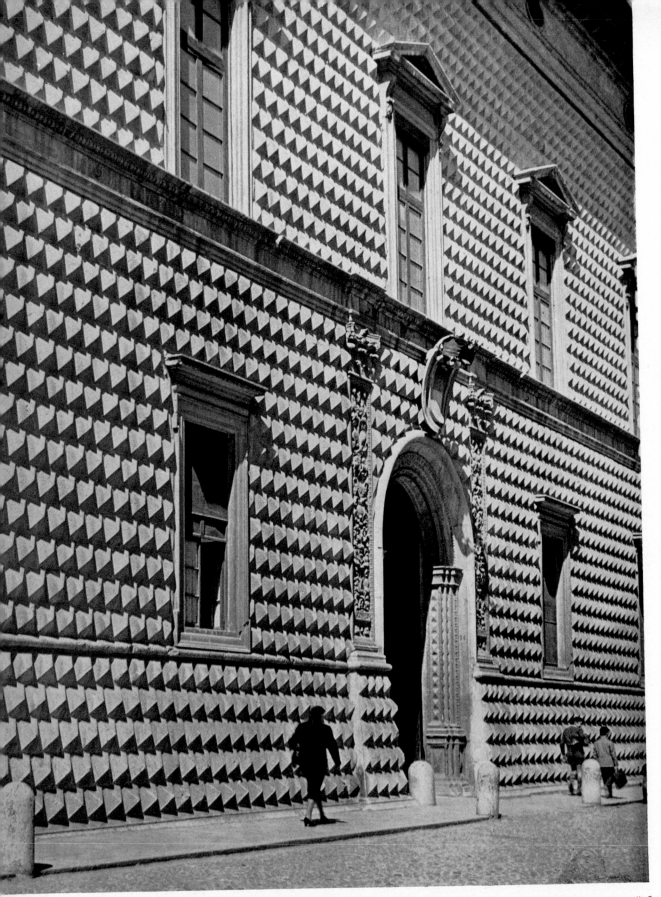

Kerff

Ferrara. Der Palazzo dei Diamanti (1492 begonnen, erst 1567 vollendet) hat seinen Namen von der Facettierung aller Quadern, die auf den Flächen ein lebhaftes Spiel von Licht und Schatten ergibt.

Ferrara. The Palazzo dei Diamanti (begun 1492, completed 1567) owes its name to its façade of faceted rustications, producing a lively effect of light and shade.

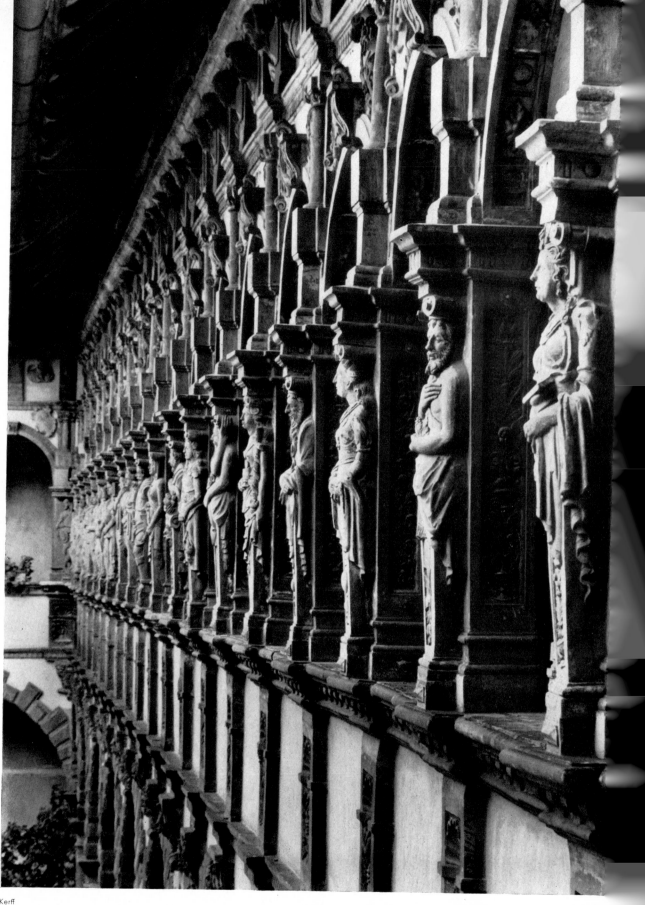

Kerff

Schallaburg, Niederösterreich. Karyatiden, wechselnd männlich und weib
als Gebälkträger im Hof der Burg (1572–16

Schallaburg, Lower Austria. Alternate caryatids and telamo
in the castle courtyard (1572–16

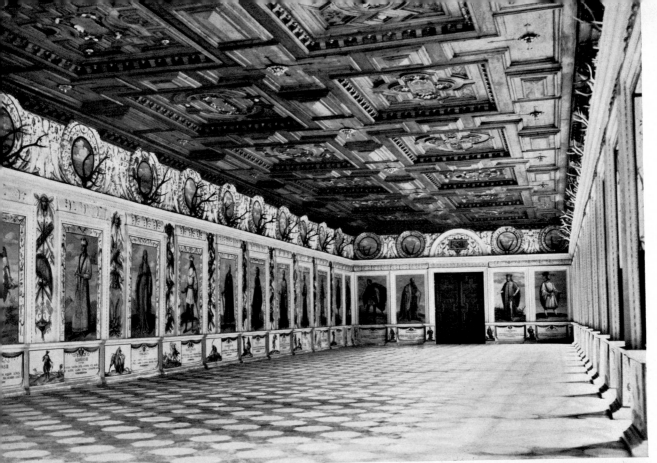

Schwenk

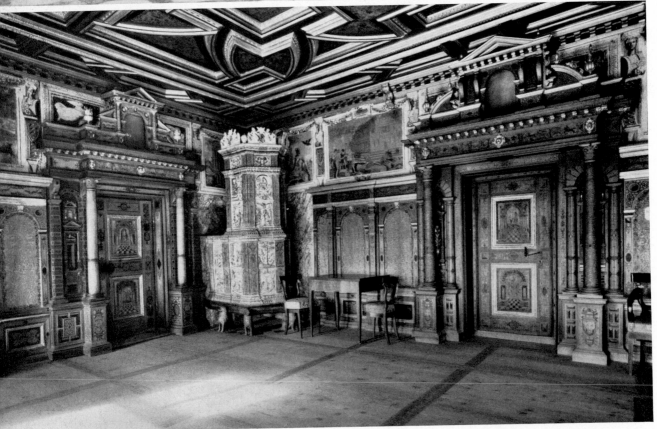

Lesley-Press

Das 16. Jh. war, zumal im Norden, ein Zeitalter höchster Blüte des Kunstgewerbes. Oben: *Schloß Ambras* bei Innsbruck.
Der Spanische Saal (1571). Unten: *Velthurns, Südtirol*. Fürstenzimmer im Schloß (1578–87) der Bischöfe von Brixen.

The 16th century was, particularly in the north, the golden age of arts and crafts. Above: *Ambras Castle* near Innsbruck. The Spanish Room (1571).
Below: *Velthurns, S. Tyrol*. Castle (1578–87), built for the bishops of Brixen. The Princes' Chamber.

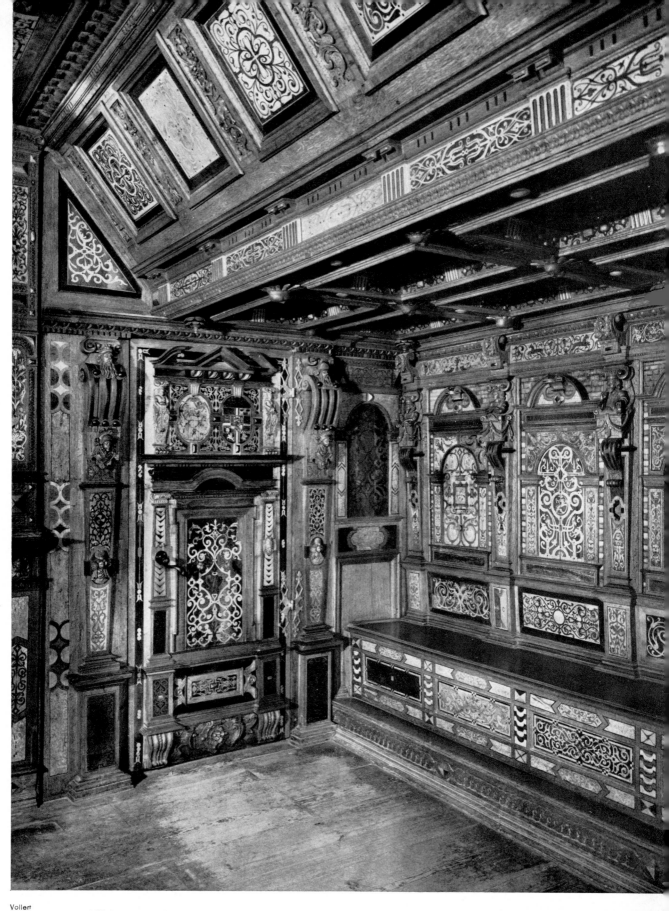

Vollert

Schloß Gottorp, Schleswig. Der sog. Betstuhl der Herzogin (1612). Reicher Intarsienschmuck, wie ihn der Manierismus zu technischer wie künstlerischer Vollendung, oft aber auch zur Überladenheit, ausbildete.

Gottorp Castle, Schleswig. The so-called kneeling-desk of the duchess (1612) with its profusion of inlaid-work. The Mannerists attained technical and artistic perfection in marquetry but often they only achieved floridity.

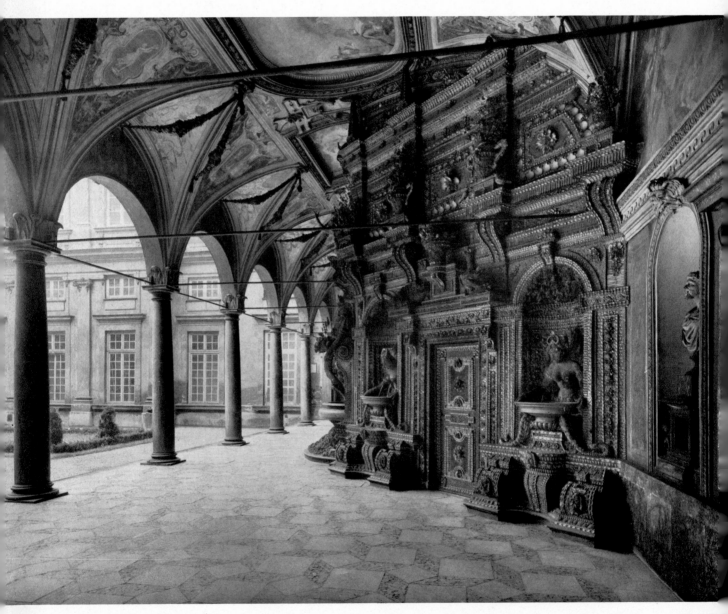

München. Der Gebäudekomplex der Residenz ist von 1569 bis ins 19. Jahrh. allmählich gewachsen. Der Grottenhof (F. Sustris, 1581–86) folgt der Gartenarchitektur Italiens. Grotesken 1588 von Ponzani.

Munich. The buildings of the Residence were slow in growth (from 1569 to the 19th century). The courtyard of Grottos (F. Sustris, 1581–86) follows the style of Italian garden architecture. Grotesques 1588 by Ponzani.

15

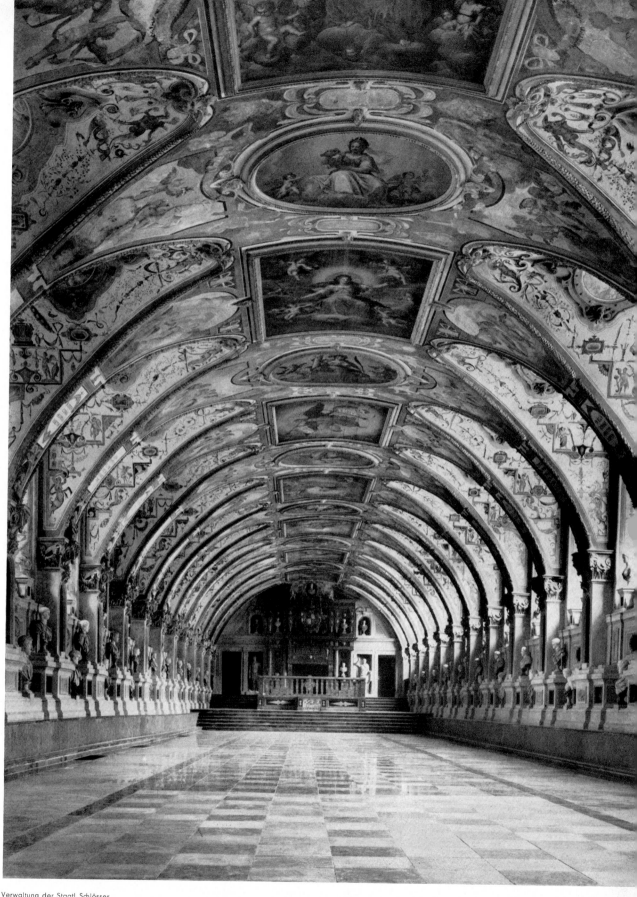

München. Residenz. Das Antiquarium (Ecke, 1569–71), für die Aufnahme der Antikensammlung bestimmt, setzt die Tradition italienischer Festsäle fort. Ausmalung durch Ponzani und Viviani.

Munich. The Residence. The Antiquarium (Ecke, 1569–71) for the Classical Collection is in the tradition of Italian staterooms. Frescoes by Ponzani and Viviani.

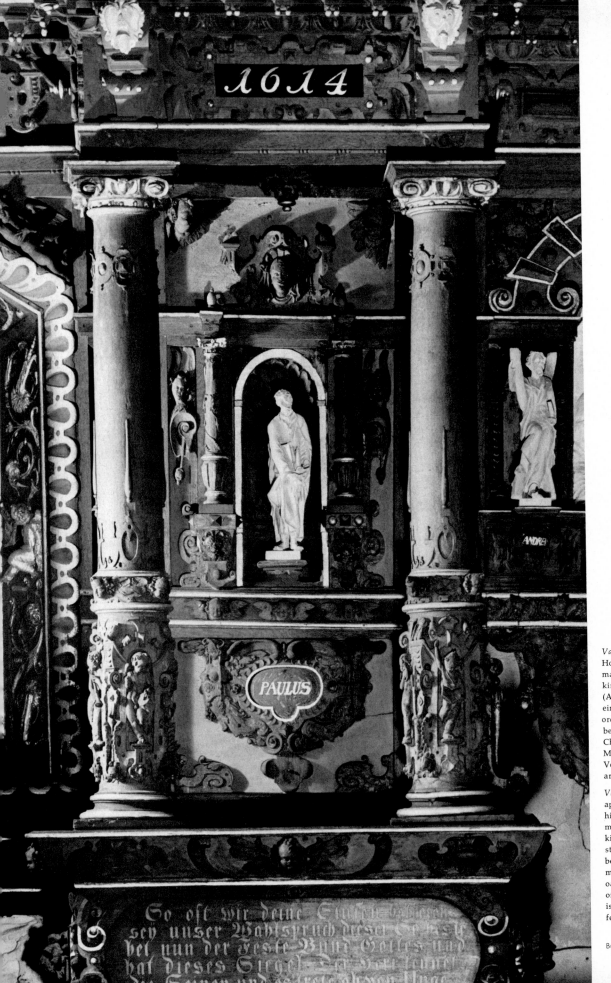

Varel, Oldenburg. Vom Hochaltar (L. Münstermann, 1614) der Stadtkirche: Apostel Paulus (Alabaster) in der Nische einer klassischen Säulenordnung aus zum Teil bemaltem Eichenholz. Charakteristisch für den Manierismus ist die Verbindung verschiedenartiger Werkstoffe.

Varel, Oldenburg. The apostle Paul from the high altar (L. Münstermann, 1614) of the Stadtkirche. This alabaster statue stands in a niche between classical columns made of partly painted oak. The combination of different materials is a characteristic feature of Mannerism.

Busch

150

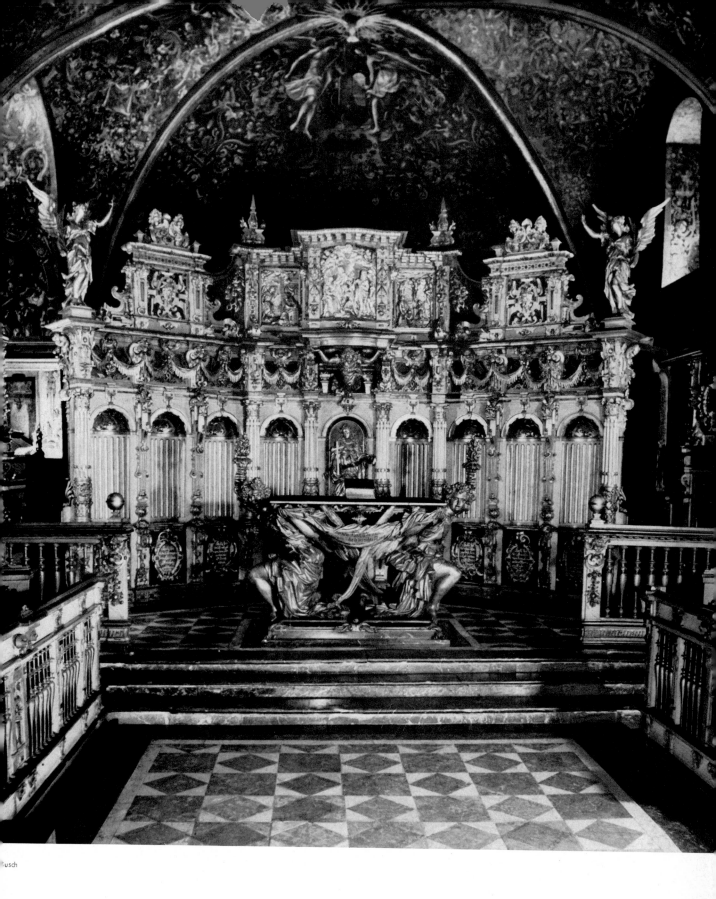

Bückeburg. Der Schloßkapelle gab Graf Ernst (um 1605) eine Ausstattung aus Holz, die zu den Meisterleistungen des Manierismus gehört.
Die Meister waren Ebert d. J. sowie Jonas und Hans Wolf.

Bückeburg, Lower Saxony. The wood-carving in the castle chapel, ordered by Count Ernest (around 1605) is among the greatest achievements of
Mannerism. The master-craftsmen were Ebert Jr. and Jonas and Hans Wolf.

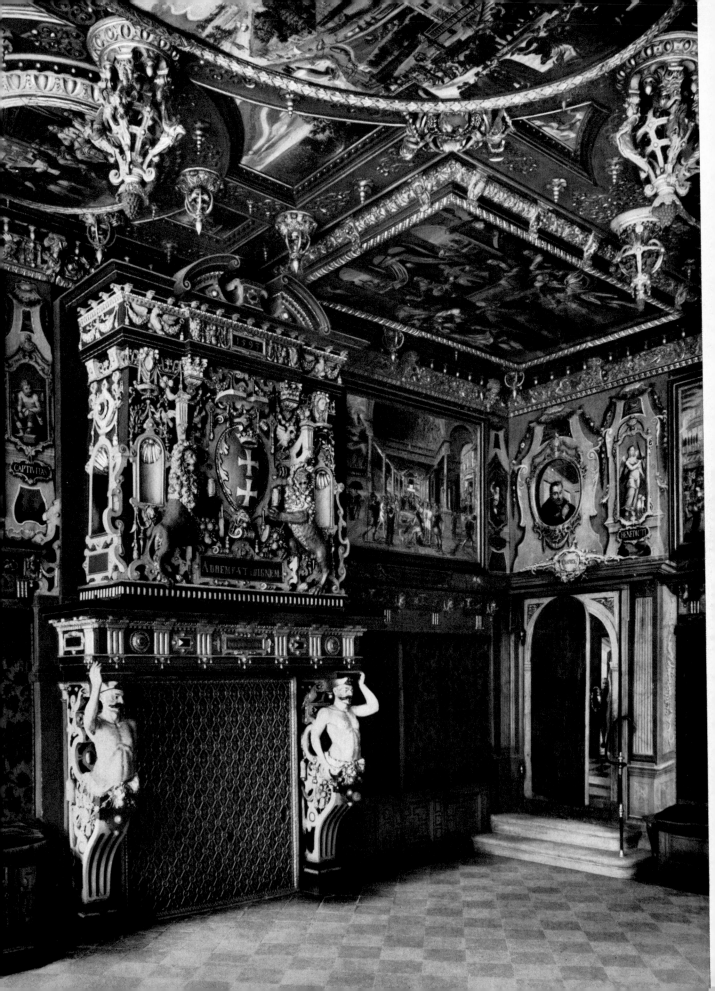

Danzig. Rechtsstädtisches Rathaus.
Die Sommer-Ratsstube (um 1595) zeigt die Freude des ausgehenden 16. Jh.
an überladener Ausschmückung.

Danzig. Town hall. Sculptors of the late 16th century
gave free rein to their taste for florid ornamentation
in the Summer Council Chamber (c. 1595).

Bückeburg. Schloß, Prunktür im Goldenen Saal (1605).
Auch hier prägt sich der manieristische „horror vacui" aus —
jenes Füllbestreben, das höchste und gedrängte Pracht entfaltet.

Bückeburg. Castle, ornamental door in the Golden Room (1605).
Here too may be seen the Mannerist "horror vacui", that concern
with embellishing every possible surface in the most splendid manner.

159

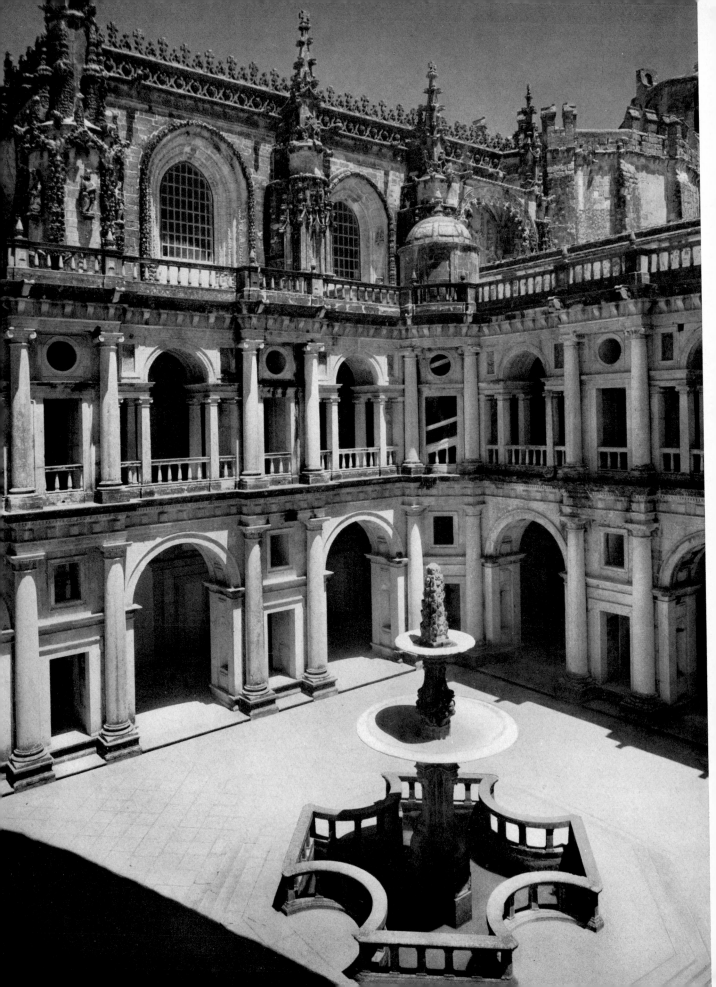

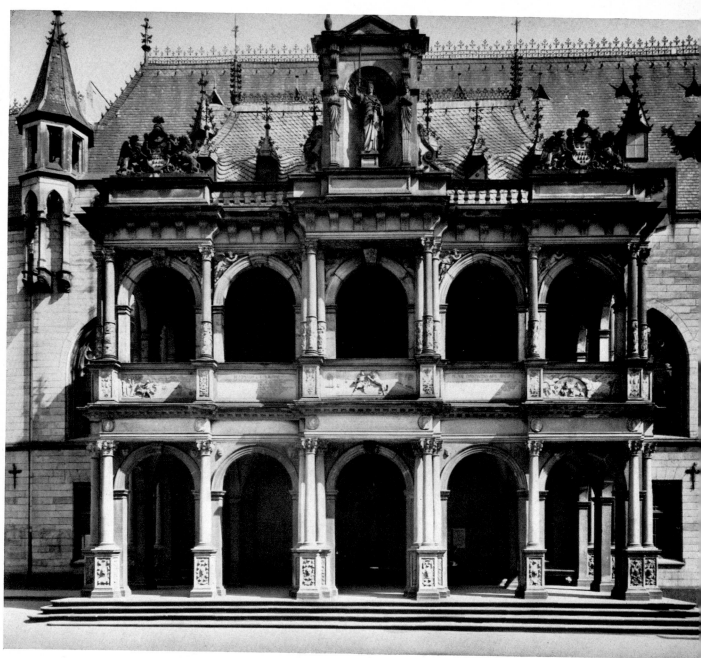

Foto Marburg

YAN

Die aus dem antiken „römischen System", der Kombination von Arkaden mit Säulen, entwickelte oberitalienische Spätrenaissance hat ganz Europa durchdrungen. Links: *Tomar, Portugal.* Ein Kreuzgang des Christus-Konvents, der „Claustro de Joao III".
Oben: *Köln,* Vorhalle des Rathauses, 1569–73 von Wilhelm Vernuiken erbaut. (Im Bild Vorkriegszustand.)

The N. Italian Late Renaissance, a development of the classical "Roman System", the combination of arcades with pillars, penetrated to the whole of Europe. Left: *Tomar, Portugal.* Cloisters in the Convent Christi, the "Claustro de Joao III".
Above: *Cologne.* Porch of the town hall, built 1569–73 by Wilhelm Vernuiken. (Pre-war photograph.)

161

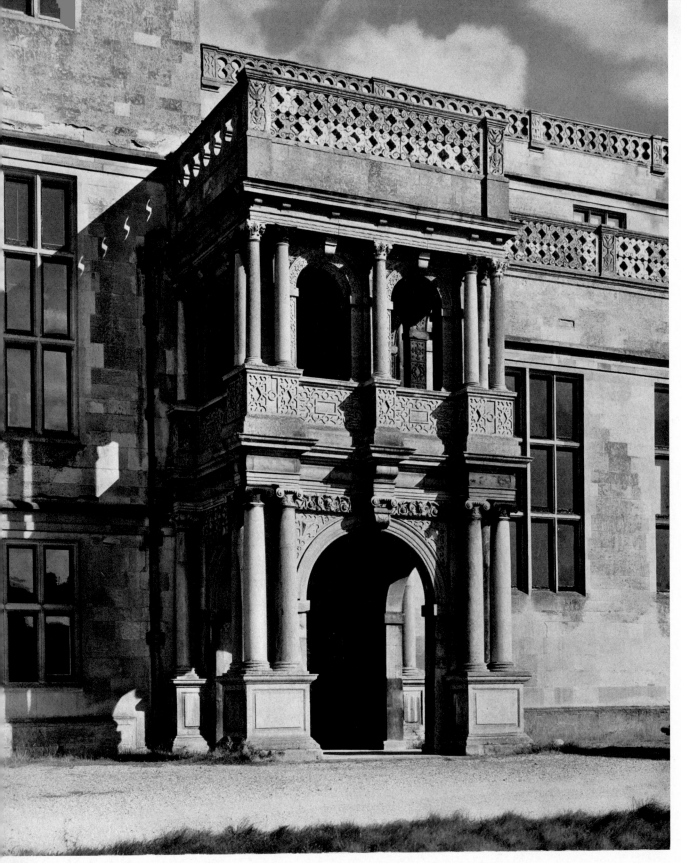

Die englischen Landsitze der elisabethanischen und der folgenden Zeit führen den spätgotischen Tudor-Stil fort, dem sich,
nach kontinentalem Vorbild, Renaissance-Motive (Bild oben) und manieristisches Zierwerk zugesellen. Oben: *Audley End*, *Essex* (B. Johnson, 1603–16).

The Tudor style still prevails in English country houses of the Elizabethan and early Jacobean age though Continental influences
may be seen in the use of Renaissance motifs (above) and Mannerist ornamentation. Above: *Audley End*, *Essex* (Bernard Johnson, 1603–16).

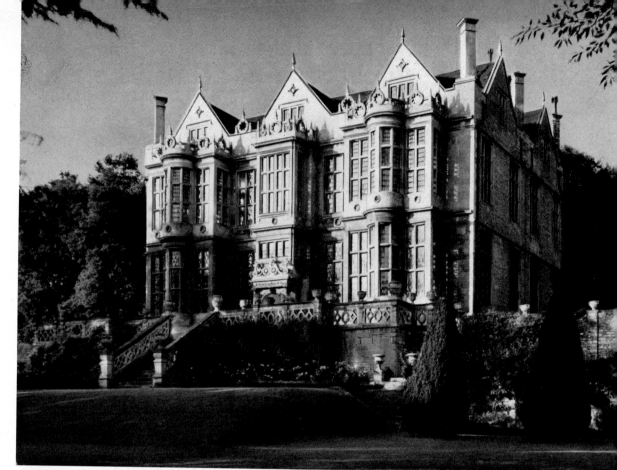

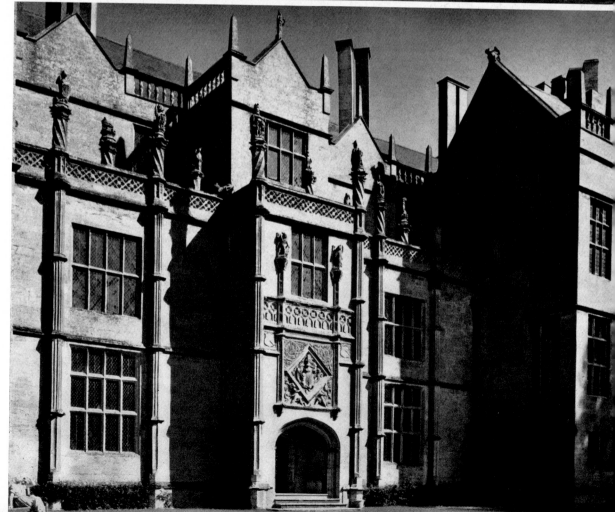

Montacute House,
Somerset (1588–1601).
Westfront.

Montacute House,
Somerset (1588–1601).
West Front.

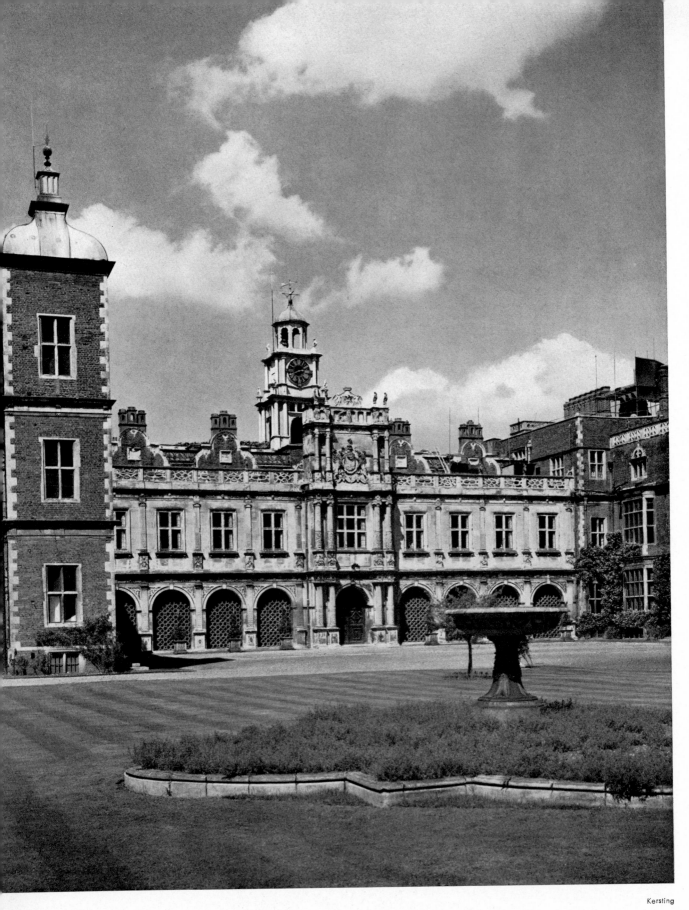

Kersting

Hatfield House, Hertfordshire (Robert Lyminge, 1608–12). Südfront.
Vornehmlich von französischen Bauten (Ph. Delorme) beeinflußt: das Triumphtor-Motiv mit gekuppelten Säulen.

Hatfield House, Hertfordshire (Robert Lyminge, 1608–12) bears a resemblance to French buildings
of the Philibert Delorme school. Note the triumphal gate motif with dual pillars.

164

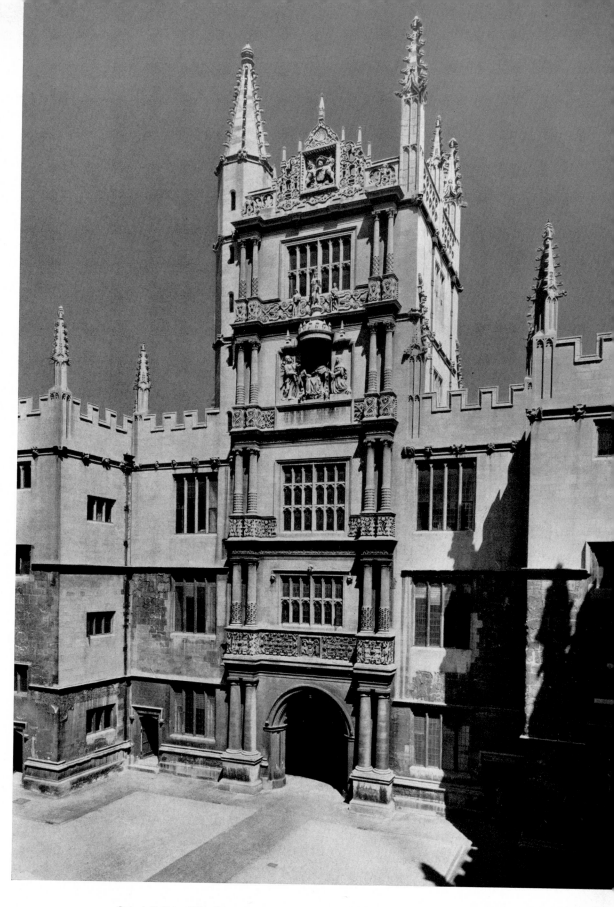

Oxford. Bodleian-Bibliothek. Die Säulen am „Turm der fünf Ordnungen" (Thomas Holt, 1625) folgen einander nach den in zeitgenössischen Baukunst-Lehrbüchern festgelegten Prinzipien. Spätgotische Fenster, Zinnen und Fialen.

Oxford. The Bodleian Library. The pillars on the "Tower of the Five Orders" (Thomas Holt, 1625) are arranged according to the principles laid down in the architectural manuals of the period. Mullioned windows, pinnacles and canopied niches.

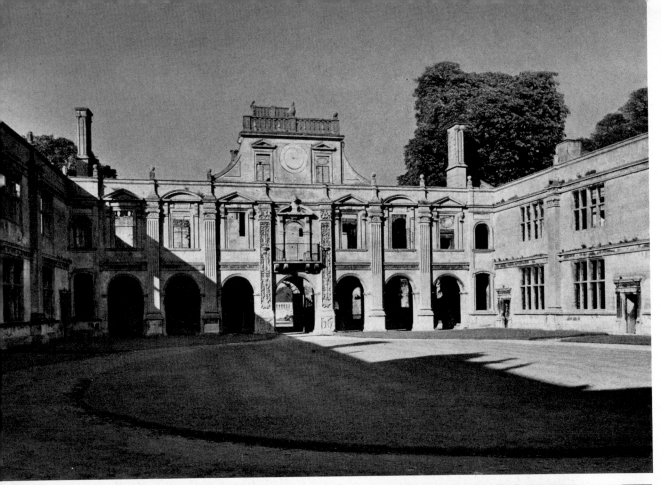

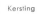

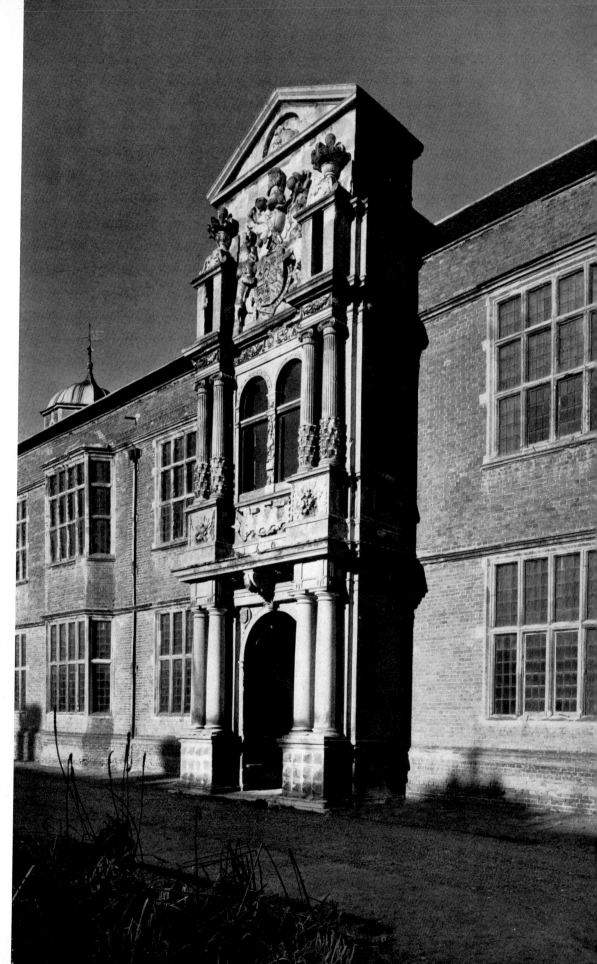

Links oben: *Kirby Hall,
Northamptonshire*. Seit 1570
von Thomas Thorpe erbaut.
Links unten: *London*.
Middle Temple Hall,
Eingangsschranke (1562–72).
Ein Beispiel für das
reiche Schmuckwerk
des Manierismus
auch in der Innenausstattung.

Left, above: *Kirby Hall,
Northamptonshire*,
built by Thomas Thorpe
post 1570.
Left, below: *London*.
Middle Temple Hall:
the Screen (1562–72),
in a richly ornamented
Mannerist style.

Rechts: *Cobham Hall, Kent*.
Vorhalle (1594)
des Westflügels
der Südfront,
von Giles de Whitt
nach einem Entwurf
von Delorme.

Right: *Cobham Hall, Kent*.
Porch in the Quadrangle
(1594), by Giles de Whitt
to Philibert Delorme's
design.

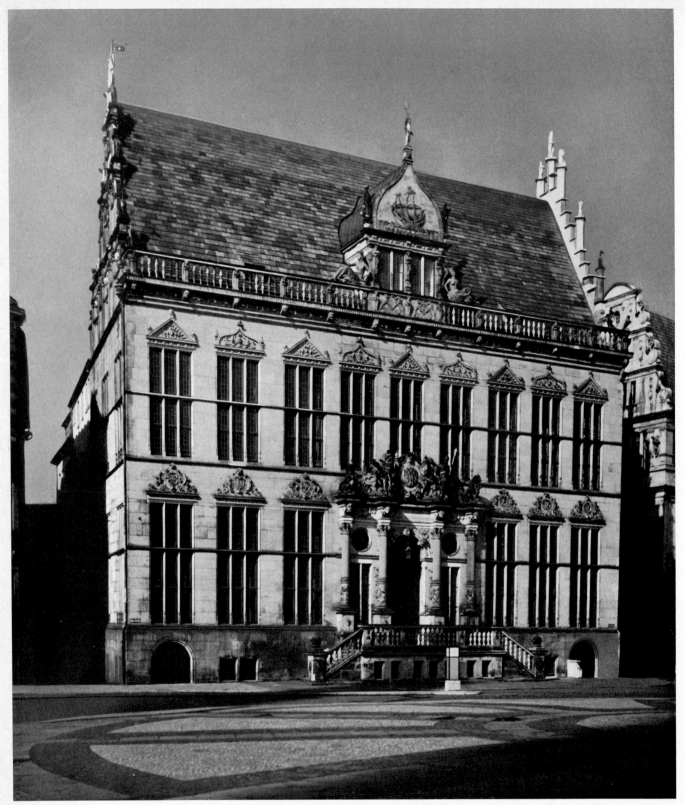

Bremen. Der Schütting (1536–38), als Amtshaus der Kaufleute erbaut.
Balustrade über dem Hauptgesims von 1594,
Portal später hinzugefügt.
Manieristisch die hohen Fenster mit spätgotischen Kielbögen.

Bremen. The Schütting (1536–38),
built as the merchants' guild hall.
Balustrade above the main entablature dates from 1594,
portal added later.

Rechte Seite, oben: *Audley End, Essex* (1603–16, s. Abb. 162). Von Südosten
Unten: *Hardwick Hall, Derbyshire* (wohl von Robert Smythson, 1590–97).
Mit der gedrängten Fülle hoher Fenster und dem Dachzierat
ein Hauptbeispiel des englischen Manierismus.

Right-hand page, above: *Audley End, Essex* (1603–16; cf. p. 162), from the S. E.
Below: *Hardwick Hall, Derbyshire* (probably the work of Robert Smythson,
1590–97), a major example of the English Mannerist school with its profusion
of high windows and ornamented roof.

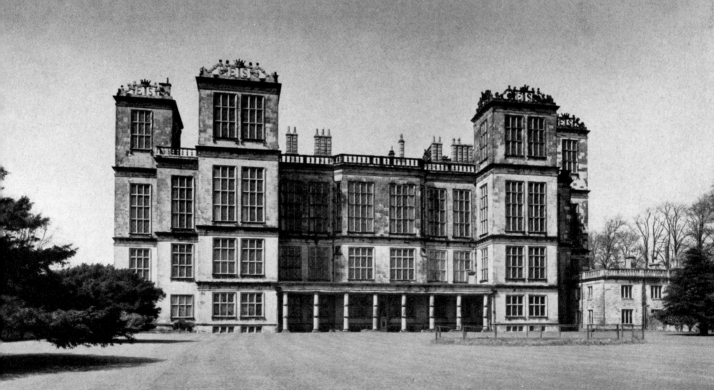

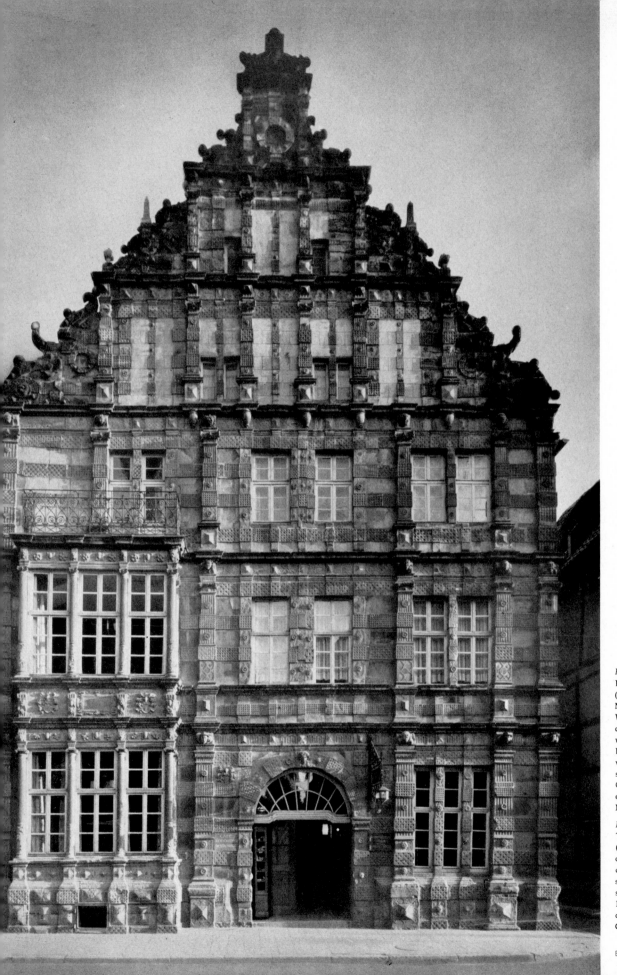

Hameln a. d. Weser.
Das „Rattenfängerhaus"
(1602). Ein besonderes
Merkmal der sog.
Weser-Renaissance,
die niederländischen
wie deutschen
Baumeistern ihre Gestalt
verdankt,
sind durchlaufende
Querbänder, oft mit
eingeschnittener
Musterung.

Hamlin on the Weser.
The "Pied Piper's House"
(1602). Crossbands,
often with patterned
carving, are a
special feature of the
so-called Weser
Renaissance, the product
of both Dutch and
German architects.

Evers **170**

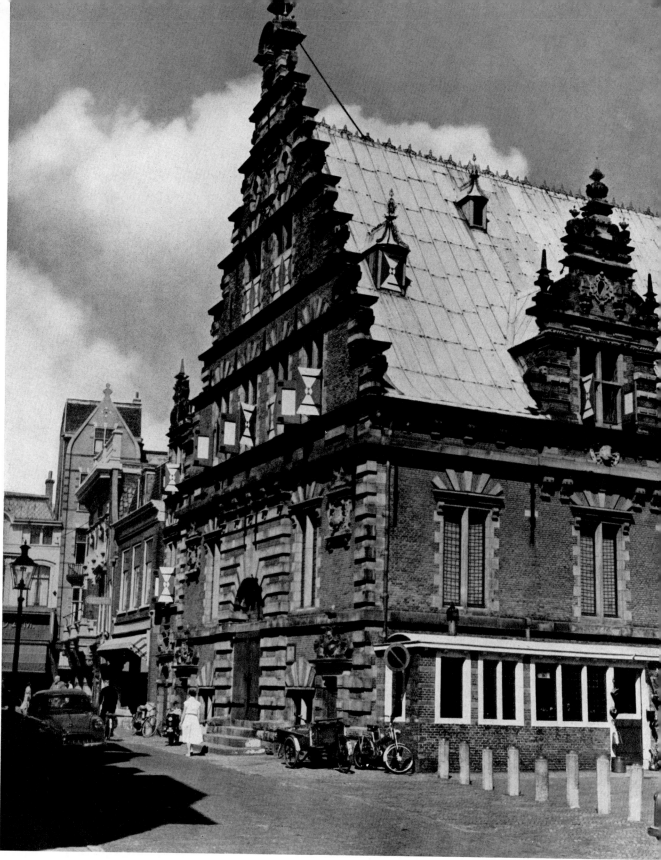

Roubier

Haarlem, Holland. Die Fleischerhalle (L. de Key, 1602–03). Wie überall im Küstengebiet Nordeuropas: Buntfarbigkeit, erzielt durch Verwendung verschiedener Steinarten.

Haarlem, Holland. The Butchers' Guild Hall (L. de Key, 1602–03). As is usual everywhere in the coastal areas of N. Europe a colourful effect is achieved by the use of different kinds of stone.

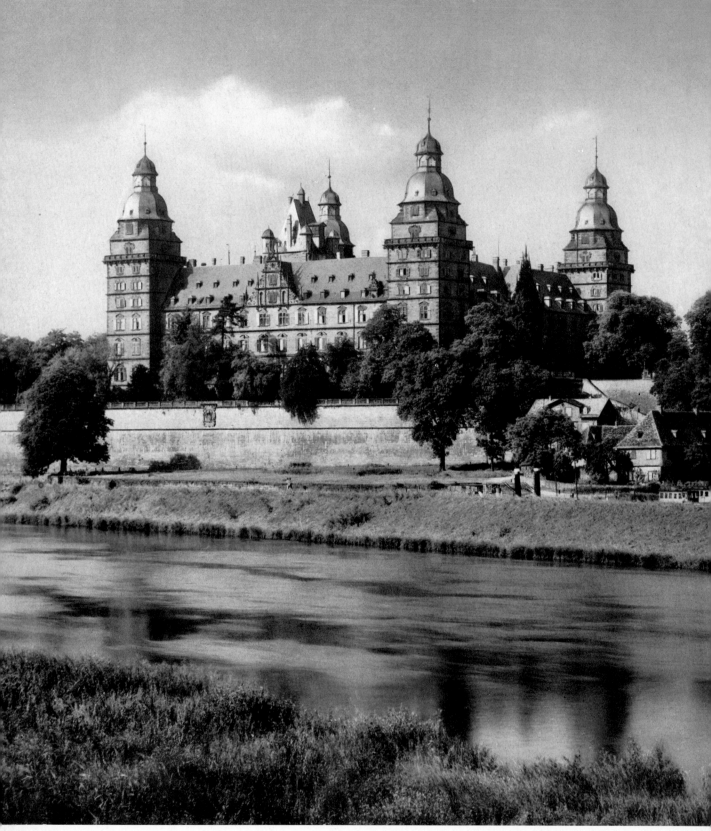

Gunderma

Aschaffenburg. Schloß (Ridinger, 1605—14).
Die regelmäßige Vierflügelanlage mit starken Ecktürmen
geht auf das römische castrum zurück.
Giebel noch manieristisch, Wände bereits wieder großflächig.

Aschaffenburg. Castle (Ridinger, 1605—14).
The regular four-winged plan with heavy corner towers
owes much to the Roman "Castrum". Gables still Mannerist,
walls already plain and generously proportioned.

Rechte Seite, oben: *Escorial, Spanien.* Zugleich Kloster und Schloß für Philipp I
von Juan de Herrera 1559—84 erbaut. Unten: *Kalmar, Schwede*
Schloß, 2. Hälfte 16. Jh. Starkes Wasserschlo
karge Zweckformen bis auf die manieristischen Giebel und Turmhelm

Right-hand page, above: *Escorial, Spai*
The huge monastery built for Philip II by Juan de Herrera (1559—8
Below: *Kalmar, Sweden.* Castle, latter half of 16th centur
Timeless utilitarian structure, sparsely ornamente

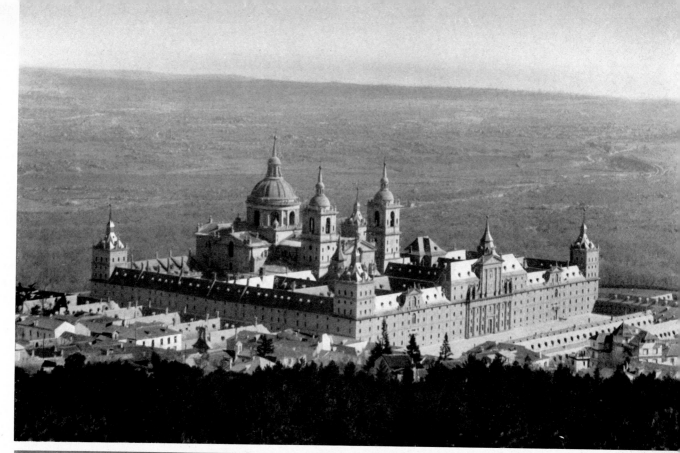

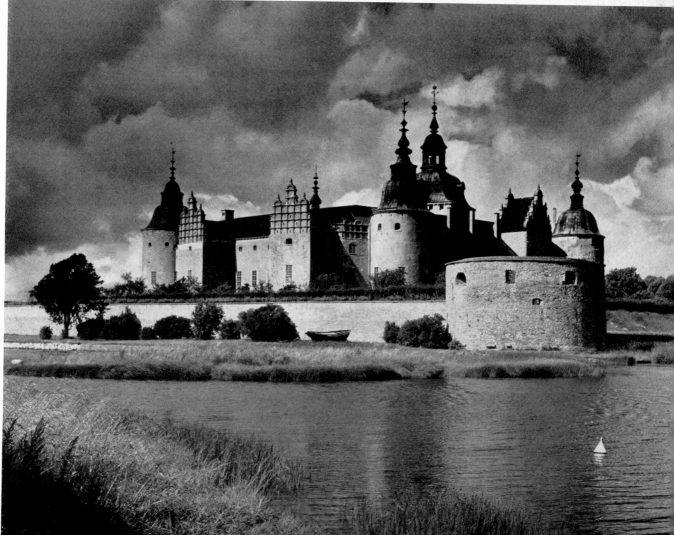

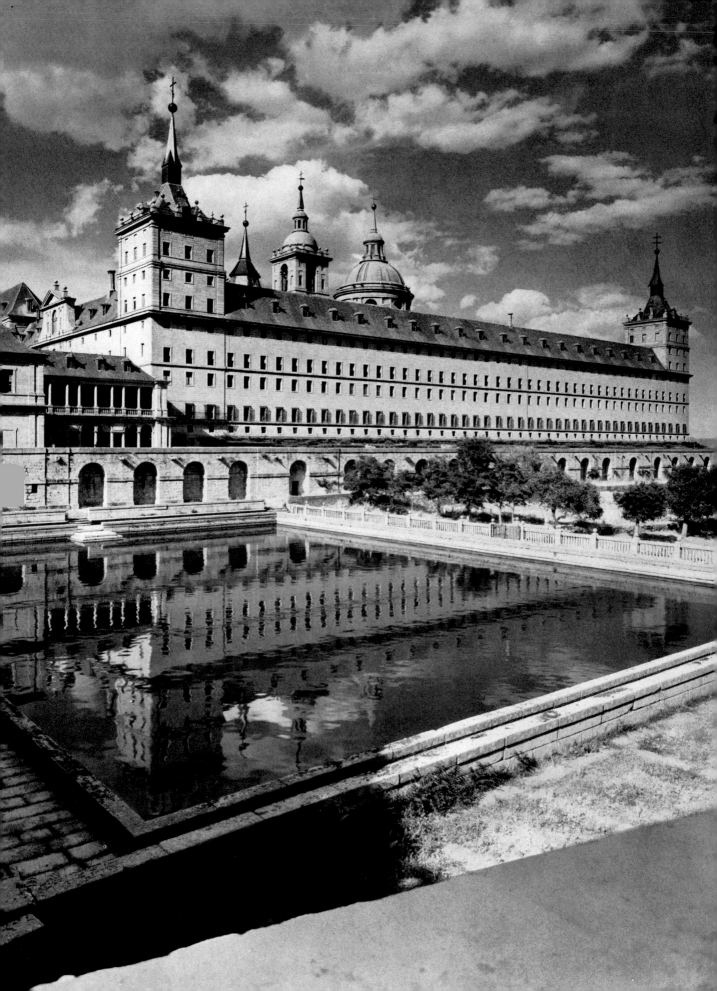

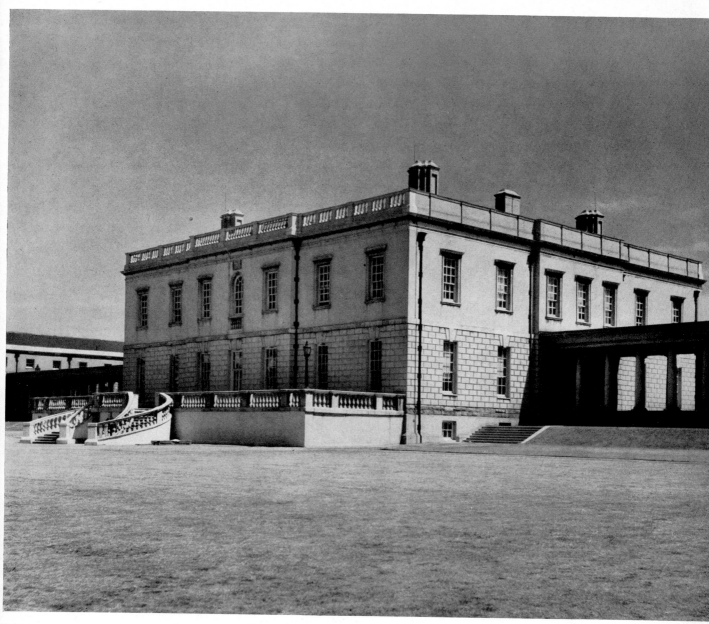

Cash

...scorial. Südfront. Mit großen, gleichförmigen Flächen
...öst dieses Bauwerk den überreich
...ekorierenden spanischen Manierismus ab.

...scorial. South Front. This structure with its vast,
...niform surfaces shows a departure from the
...avishly ornate Spanish Mannerism.

Greenwich. "Queen's House" (Inigo Jones, 1616–35). In England begründet Jones
in bewußter Anlehnung an italienische Vorbilder
einen akademisch strengen Klassizismus. Die Zeit des Manierismus ist zu Ende.

Greenwich. The Queen's House (Inigo Jones, 1616–35).
In conscious imitation of Italian prototypes, Jones founded a
strictly academic classicism in England. The age of Mannerism is at an end.

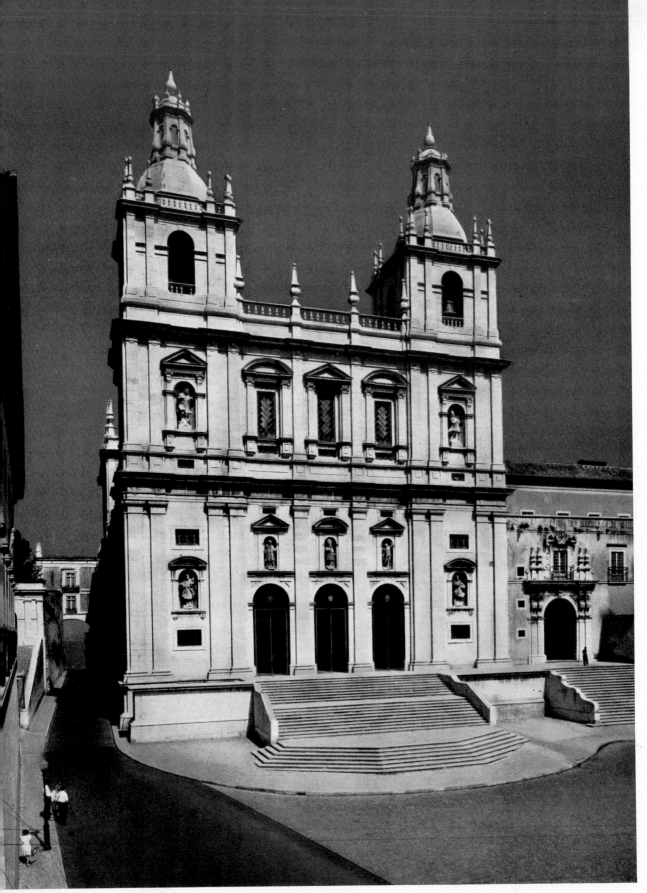

YAN

Lissabon. Sao Vicente da Fora (Filippo Terzi, 1582–1627). Die nach dem Vorbild von Il Gesù errichtete Fassade zeigt den wieder großformig stillen Stil, der in Europa um die Wende zum 17. Jh. den Barock einleitet.

Lisbon. Sao Vicente da Fora (Filippo Terzi, 1582–1627). The façade, an imitation of that of Il Gesù, reflects the style prevalent in Europe at the turn of the 17th century, heralding Baroque.

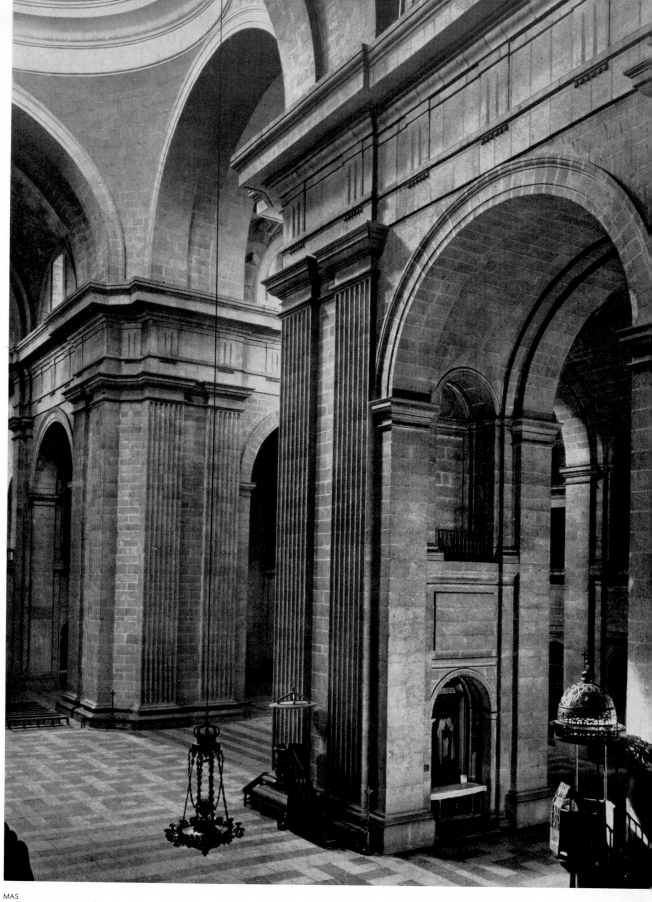

Escorial. Die Kirche (1585) des Klosters, in Anlehnung an Bramantes Entwurf für St. Peter in Rom.
Stiller Ernst der Jahrhundertwende.

Escorial. The church (1585) of the monastery, inspired by Bramante's plan for St. Peter's, Rome.
Silent gravity of the turn of the century.

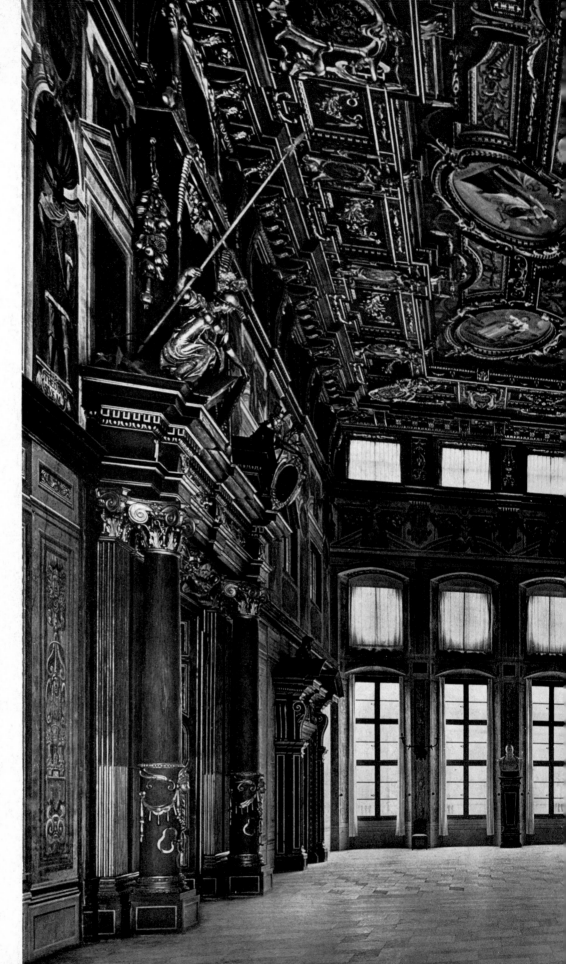

Augsburg.
Der „Goldene Saal"
des Rathauses
(Elias Holl, 1615—20).
Eine der größten
und reichsten Schöpfungen
des Profanbaus
der Renaissancezeit —
auf der Wende vom
Manierismus zum Barock.
(Vorkriegszustand.)

Augsburg.
The "Golden Hall"
of the town hall
(Elias Holl, 1615—20),
one of the greatest
and richest creations
among secular buildings
of the Renaissance period —
at the turning point
between Mannerism
and Baroque.
(Pre-war state.)

Kunstsammlungen Augsburg

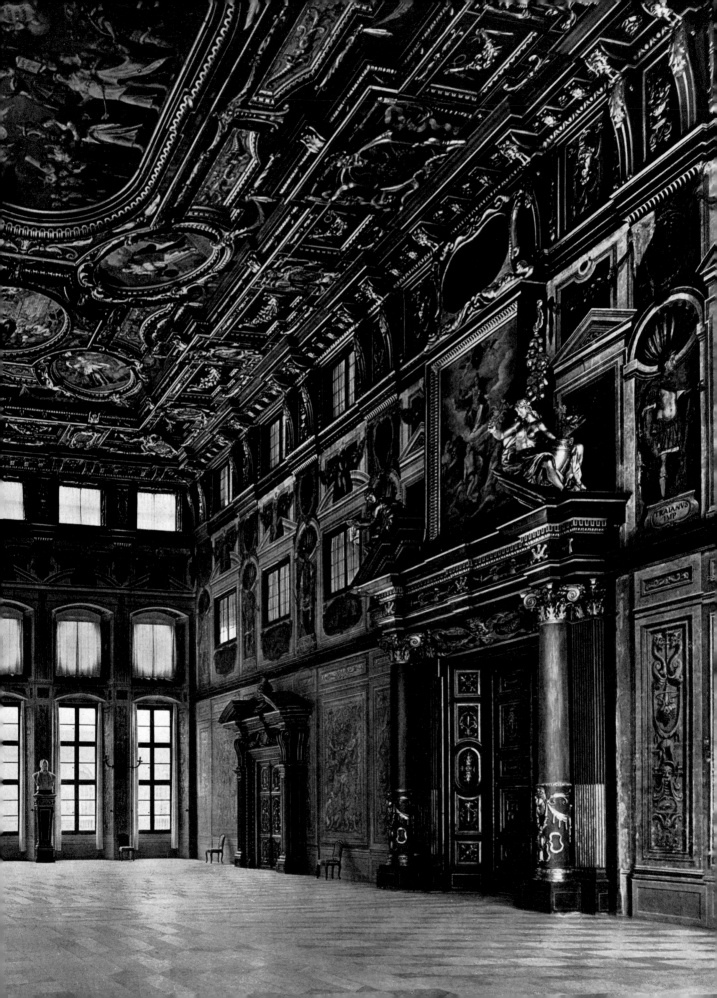

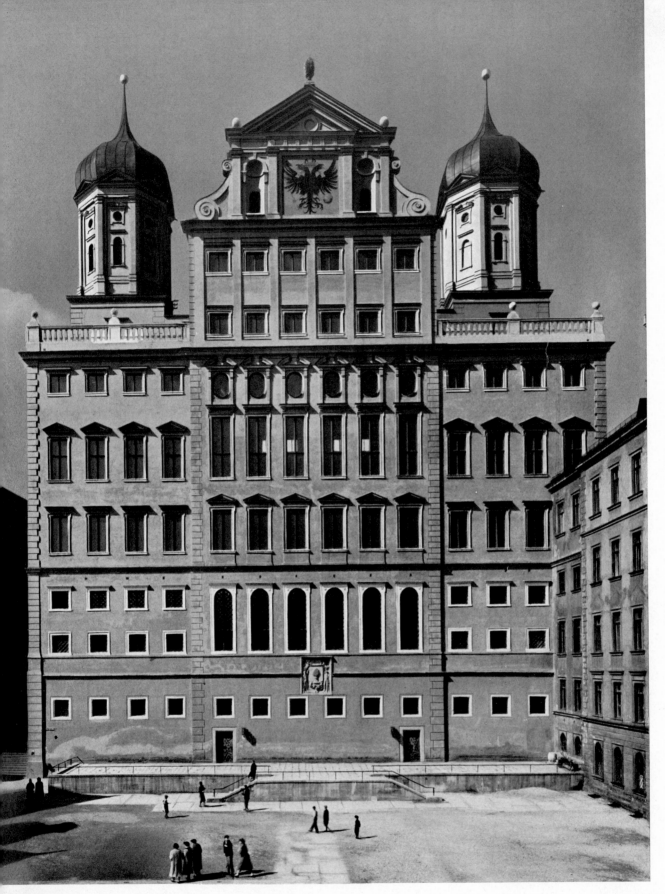

Keetman

Augsburg. Die Rückseite des Rathauses (Elias Holl, 1615–20), in Deutschland das edelste Beispiel
für jenen nüchternen und großformigen Stil, der den Frühbarock heraufführt.

Augsburg. Rear of the town hall (Elias Holl, 1615–20), the finest example in Germany of that sober yet generous style which heralded Early Baroque.